BLANCHE

BLANCHE

THE LIFE AND TIMES OF
TENNESSEE WILLIAMS'S GREATEST CREATION

NANCY SCHOENBERGER

HARPER

An Imprint of HarperCollins*Publishers*

HarperCollins books may be purchased for educational, business, or
sales promotional use. For information, please email the Special Markets
Department at SPsales@harpercollins.com

FIRST EDITION

Designed by Elina Cohen

Library of Congress Cataloging-in-Publication Data has been applied for.

978-0-06-294717-8

23 24 25 26 27 LBC 5 4 3 2 1

FOR MY LOVELY AND MUCH-LOVED SISTERS,
SUSAN GHANDAKLY AND ELLEN DAY

Women are the mirror of all things. They see and they reflect; they take in and they teach; they harbor and they hold; women were not only created to improve the world, but they populate and shape the world. . . . I am devoted and captive to women, and I would like to be their witness.

—Tennessee Williams

We have accepted as normal the persistent oppression of women. This is chronic abuse in the guise of culture.

—Tennessee Williams

CONTENTS

INTRODUCTION 1

Does Blanche DuBois Still Matter?

CHAPTER ONE 25

Portrait of a Girl in Glass: Rose Williams

CHAPTER TWO 55

The Unbearable Whiteness of Blanche DuBois:
Jessica Tandy

CHAPTER THREE 71

"Dreadfully Magnificent": Vivien Leigh

CHAPTER FOUR 91

Kitten with a Whip: Ann-Margret

CHAPTER FIVE 109

Moonlight Becomes You: Jessica Lange

CONTENTS

CHAPTER SIX 125

A Martini at a Soda Fountain: Patricia Clarkson

CHAPTER SEVEN 145

The Two Blanches: Cate Blanchett

CHAPTER EIGHT 161

The Eternal Bride: Jemier Jenkins

CODA 185

Two Obituaries and a Handful of Poems

ACKNOWLEDGMENTS 195

SOURCES 197

NOTES 201

INDEX 217

PHOTO CREDITS 229

DOES BLANCHE DUBOIS STILL MATTER?

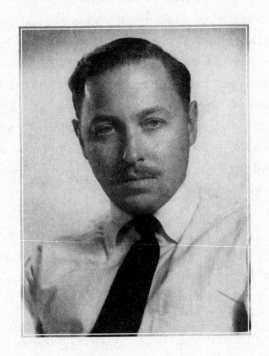

On December 3, 2022, Blanche DuBois—arguably Tennessee Williams's most enduring fictional character—celebrated her seventy-fifth birthday. She has aged remarkably well.

Ever since Jessica Tandy boldly stepped onto the stage as Blanche in *A Streetcar Named Desire* at the Ethel Barrymore Theatre in 1947 and into the history of our literature, Blanche DuBois has fascinated generations of audiences—and actresses—around the world. (Instead of the more contemporary term "actor," I use the term "actress" as a nod to Blanche's archfemininity.) Even in our more jaded age, the Southern belle *extraordinaire* known as Blanche DuBois—"French for 'white woods'"—can still bring audiences to tears, as critic Hilton Als witnessed during Cate Blanchett's performance at the Brooklyn Academy of Music in 2009.

Before the COVID-19 scourge began in 2020, *Streetcar* was being performed somewhere in the world every hour. It has been translated into a ballet, and in 1995, an opera composed by André Previn with a libretto by Philip Littell premiered at the San Francisco Opera, with no less than the great Renée Fleming as Blanche. A multiethnic cast, directed by Emily Mann with the African American actress Nicole Ari Parker as Blanche, was mounted at the Broadhurst Theatre on Broadway in 2012, and six years later, the African American Shakespeare Company of San Francisco presented the play with Jemier Jenkins as Blanche, with L. Peter Callender directing.

Streetcar is still performed regularly in Europe and Japan—more than in the United States, in fact—and it was even satirized in an episode of *The Simpsons*. ("A Streetcar Named Marge," episode 2 of their fourth season, in 1992. "Williams would have loved *The Simpsons*' hilarious version with Marge's Blanche," wrote Hilton Als.) And is the suffering, cast-out pink poodle in *Babe: Pig in the City*, in the 1998 sequel to *Babe*, another version of Blanche DuBois? In a trembling Southern accent, the bedraggled and abandoned beauty mourns, "Can you help me? I have been cruelly cast out and I have nowhere to go. Take pity on us as we are excluded . . ." There's more. Blanche also appeared in a comic send-up in Woody Allen's *Sleeper* (in which he plays Blanche and Diane Keaton plays Stanley), and as a prototype for the protagonist in his 2013 film, *Blue Jasmine*, starring Cate Blanchett, which earned the actress an Academy Award. Four years earlier, Blanchett played Blanche DuBois onstage in a celebrated performance, directed by another compelling actress, Liv Ullmann.

Jessica Lange played Blanche onstage opposite Alec Baldwin in 1992, and reprised the role on film in 1995. She always knew she would one day take on the part, and she'd kept a Blanche DuBois scrapbook in Minnesota when she was growing up. Her longtime partner, the late Sam Shepard, later teased her that young actresses want to play Blanche the way young actors aspire to play Hamlet.

Blanche's remark "Don't get up, gentlemen, I'm only passing through" made it into the Bob Dylan song "Things

Have Changed" (which won the 2001 Academy Award as Best Original Song for the movie *Wonder Boys*). More famously, the final line of dialogue Blanche utters at the end of the play, as she is escorted to the state institution, most likely in Mandeville—"I have always depended on the kindness of strangers"—has entered the lexicon.

Even now, in a more feminist age that rejects the kind of seductive vulnerability embodied by Miss DuBois, we are still fascinated by her character and her tragedy. Why? Why has she entered our bloodstream, this living figment of one of our greatest playwright's imagination, whose flirtatious airs and manipulative behavior we have come to reject?

Elia Kazan, who first directed Jessica Tandy in the original stage production in 1947 and Vivien Leigh in the celebrated 1951 film, wrote in his journal that he wondered if America was heading into the Age of Stanley or the Age of Blanche. We seem now to be firmly in the Age of Stanley—but we are still haunted by Blanche.

NEW ORLEANS OF THE IMAGINATION

Both of my parents were born in New Orleans, on either side of the Audubon Park Zoo. They both had early childhood memories of hearing the lions roar at night, which was exciting but which no doubt troubled their sleep. My father, Sigmund Bernard Schoenberger, moved as a young boy with his

family to the tiny coastal town of Buras, in Plaquemines Parish, then controlled by the notoriously racist political boss Leander Perez. The house he grew up in was on the Mississippi River, where he and his friends would sometimes swim despite the dangerous currents. I remember visiting my grandmother's white clapboard house as a girl. My two sisters and I would run from the car to the house with newspapers over our heads to escape the swarm of mosquitoes that greeted us. The house was surrounded by an orange orchard, with dark lilac hydrangea crowding the front door. I was amazed to learn from my grandmother that the color of their showy flowers could be changed from pink to blue by putting rusty nails in the soil. Some nights in the hot, humid summer, my sisters and I would sleep on the back porch, drowsing to the sounds of the cicadas and tree frogs, and bathed in the sweet scent wafting in from the orange blossoms. I woke up one night on that porch, believing I had seen a fairy with gossamer wings bending over me—of course, a dream, and I had probably been wakened by the mosquitoes that had made it into the screened porch. I also remember my grandmother's collection of lacy Spanish fans displayed on one wall in her living room, collected on a European trip. Their beauty enchanted me.

My mother, Betty Beydler, grew up on Pine Street in New Orleans, and then her family moved to the suburb of Metairie. She met my father in Baton Rouge when both were students at Louisiana State University. My father, who would have a career as a test pilot and an officer in the navy, was enrolled in ROTC, and my mother was a young beauty queen on campus.

She would drop out in her sophomore year to marry my father, so handsome in his white uniform! As Dad was a naval officer, our family moved every two years, though we returned each summer to Louisiana to visit our two sets of grandparents, in Buras and in Metairie. Both places seemed preserved in some storied past—the killing moss hanging from live oaks in Audubon Park, the filigreed balconies in New Orleans, the smell of damp cotton sheets, the dark scurrying cockroaches that seemed to lurk everywhere. Other states where we lived—California, Texas, Florida, Pennsylvania, Virginia—moved and evolved through time, but the Louisiana of my childhood, and of my imagination, never changed.

My mother kept that part of our childhood alive with her tales of the beautiful "octoroons" in the red light district, her stories about the pirate Lafitte, her memories of visiting the Vieux Carré, now better known as the French Quarter, and our annual summer visits to our grandparents and to the city's tourist havens: Jackson Square, Café du Monde, Commander's Palace, Court of the Two Sisters. Not surprisingly, perhaps, there was little or no acknowledgment of Louisiana's pernicious, long-lasting Jim Crow era or its slaveholding past (though to be "sold down the river" was a reference to the particular horror of being sold to Louisiana plantations).

Early on, my mother was a fan of the plays of Tennessee Williams, especially *A Streetcar Named Desire*, set entirely in Elysian Fields, a housing project for the poor, despite its heavenly name. The streetcar itself had been put out to pasture by 1973, when Faye Dunaway played Blanche in a production

at the Ahmanson Theatre in Los Angeles. She described a pilgrimage to New Orleans in which she set out to find the Desire Streetcar, only to stumble on it in "a graveyard for old, abandoned streetcars." She wrote in her memoir,

> *I wandered through it picking my way through the weeds, and looking for the name* Desire *that I knew would be painted on the front of the car. I thought it was regrettable, but probably fitting, that the streetcar named* Desire *was encrusted with grime and decaying in this forgotten place.*

On our visits to New Orleans, my sisters and I took the Cemeteries bus from Metairie when we went into the city. The Desire Line, which ran down Royal Street and passed through the Quarter on its way to Canal Street, had ceased to run by 1948, well before our time there. Those two names— Desire and Cemeteries—haunt *Streetcar*, dooming its heroine between death and desire.

Years later, after graduating from Louisiana State University in Baton Rouge, I lived for a summer on St. Charles Avenue, renting an apartment for seventy-five dollars a month from a retired magician, Franklin the Magnificent (if memory serves). He lived in a decaying Victorian house that had been broken up into apartments, and every month my roommate and I would visit his apartment on the ground floor to pay our rent. He sat magisterially under a giant poster bearing his name and image—a portly man with a Fu Manchu moustache and goatee. Our furnished apartment opened onto

an interior courtyard choked with overgrown monkey grass and giant ferns, where coffee-colored cockroaches breathed under the flagstones.

For Tennessee Williams, New Orleans was not a city steeped in nostalgia as it has been for me, but a city of liberation. For the first time, he encountered a subterranean gay culture where he felt at home after the repressive and stultifying world of his parents' cramped apartment in St. Louis, Missouri, where they had settled for a while after leaving his mother's idyllic, but still Victorian, childhood home in Columbus, Mississippi.

In the autumn of 1935, twenty-four-year-old Tennessee Williams traveled to New Orleans to seek work from the Works Progress Administration's Federal Writers' Project, which employed many writers during the Depression. Once there, he found that the WPA had no work for him, but he stayed on in the city, renting a room for three dollars a week at 431 Royal Street, working as a waiter in the French Quarter among other stopgap jobs. He relished the celebratory spirit of the city—the Mardi Gras parades, the bourbon-soaked cafés, different ethnicities living cheek by jowl, blues and jazz music emanating from the streets. What also spoke to his writer's imagination was the sense of mystery behind interior courtyards and spiral staircases, the exotic plants, the air of faded gentility. The city fed him and inspired his soul, while making him feel less and less the outsider that, like so many artists, he was born to be. He later wrote,

It was a period of accumulation. I found the kind of freedom I had always needed, and the shock of it, against the Puritanism of my nature, has given me a subject, a theme, which I have never ceased exploiting.

The other muse who fed his imagination was Rose.

WHAT'S THE MATTER WITH ROSE?

To tell Blanche's story one must begin with Rose Isabel Williams, Tennessee's fragile sister and the great, enduring love of his life—the person he was most haunted and inspired by.

Two years older than Tom (who would become "Tennessee" when he published "The Field of Blue Children" under that name in *Story* magazine, in 1939), Rose was high strung and emotionally troubled. At twenty-six, she had no suitors, no skills, no job, no prospects. Tom idolized his older sister from childhood, but her increasingly anxious, confused, and eroticized behavior led the family to institutionalize Rose in Missouri's Farmington State Hospital (Case no. 9014), where she was subjected to one of the early lobotomies performed in America. It was stated that Rose "had delusions of sexual immorality by members of the family." Tennessee always felt guilty that he could not save her, and he came to believe that his homosexuality prevented him from being her heroic rescuer—another source of lifelong regret.

BLANCHE AS TRAGEDY, BLANCHE AS COMEDY

Another early inspiration for Blanche DuBois was Tennessee's friend the tempestuous and very Southern Tallulah Bankhead (she hailed from a prominent political family in Alabama), but she did not originate the role. In fact, Tallulah at first turned it down, feeling it was too close to home. (She reportedly said, "How would it look—an aging, promiscuous Southern woman who drinks too much playing an aging, promiscuous Southern woman who drinks too much?") When she did finally get around to playing her in 1955 at Florida's Coconut Grove Playhouse, many thought that Tallulah was just too strong for the role and that she played it as pure camp to an adoring and mostly gay audience. "It's the only time Blanche has been played by a drag queen," Tennessee joked, but he couldn't seem to make up his mind as to whether her performance was "the worst I have seen" or one that "exceeded those of Jessica Tandy and Vivien Leigh . . ." Poor reviews, however, led to the show being closed after only fifteen performances.

A comedic use of the character of Blanche surfaced in 1999, in Pedro Almodóvar's comedy-drama *All About My Mother*. The award-winning film (including the Oscar, the BAFTA, and the Golden Globe awards for Best Foreign Language Film) explores several stops along the gender and trans continuum, with one of the characters, Huma Rojo (played by Marisa Paredes), as an actress playing Blanche DuBois in

Streetcar. The director dedicated his movie to "all actresses who have played actresses. To all women who act. To men who act and become women," underlying the drag-queen quality of Tennessee's essential heroine.

In fact, a production of *Streetcar* featuring "genderqueer actor" Russell Peck as Blanche DuBois opened in Crown Heights, Brooklyn, in May 2019. Peck said that they identified with Blanche's "complex character and fight for love. As young queer people, we're often drawn to characters that are a little damaged," who must struggle to find love.

SEVEN BLANCHES

In his *New York Times* review of Cate Blanchett and Liv Ullmann's production of *Streetcar* at the Brooklyn Academy of Music, Ben Brantley wrote, "The genteel belle, the imperious English teacher, the hungry sensualist, the manipulative flirt: no matter which of these aspects is in ascendancy, Ms. Blanchett keeps them all before us." The seven actresses I've chosen to write about—Jessica Tandy, Vivien Leigh, Ann-Margret, Jessica Lange, Patricia Clarkson, Cate Blanchett, and Jemier Jenkins—embody different aspects of this rich, multifaceted character. If Blanchett manages to keep them all before us, Jessica Tandy was more the "imperious English teacher," Vivien Leigh and Jemier Jenkins the "genteel belle" with a dollop of snobbery, Ann-Margret the "manipulative flirt," Patricia Clarkson "the hungry sensualist." In terms of

the degree of madness each reflected, Jessica Lange seems the most fragile, Ann-Margret the toughest, whereas Jemier Jenkins saw the character as basically sane but driven to disaster by her untenable position. In New Orleans native Patricia Clarkson's version, the atmosphere of the city saturates the play.

I've made these selections in part by the important mark left on the character by each actress, as well as the availability of the productions. Not all were filmed or videotaped, sadly, but in those cases I've relied on extensive reviews and in some cases personal interviews. Vivien Leigh is the most famous Blanche, of course, due to her powerful, heartrending portrayal and to Elia Kazan's enduring film. Jemier Jenkins, the least known, is one of the few African American actresses to undertake the role, with great success, according to many laudatory reviews.

There are so many other actresses worth noting, such as Tallulah Bankhead, Claire Bloom, Carrie Nye, Rosemary Harris, Shirley Knight, Faye Dunaway, Blythe Danner, Glenn Close, Natasha Richardson, Rachel Weisz, and Gillian Anderson, and there are correspondences—a kind of passing of the baton—among several of them. Vivien Leigh and Tallulah Bankhead knew each other in London, brought together by Ken Tynan, the theater critic and dramaturge of Britain's National Theatre under Laurence Olivier. Leigh attended the opening of *Streetcar* in London with Claire Bloom in the role. (Richard Burton, Claire's lover at the time, had encouraged

her to play Blanche, telling her that one day she'd know when it's time, just as a flower knows when it's time to bloom.)

Then there are the actresses who never quite got to play Blanche DuBois. Lillian Gish was one of them, as was Natalie Wood, who did manage to wear one of Blanche's gossamer dresses to a costume party, the closest she ever got to the iconic role. The late actress Valerie Harper, who once played Tallulah Bankhead in the play *Looped*, said, "If Paris Hilton and Lindsay Lohan ever got themselves together, studied and tried to be serious actresses, they might have made terrific Blanches."

As for Tennessee Williams's favorite Blanche—that's up for grabs. Rumor in theatrical circles has it that the honor goes to Alabama-born Carrie Nye, but Michael Kahn, artistic director at Washington, DC's Shakespeare Theatre Company who knew the playwright when Kahn staged *Streetcar* at the McCarter Theatre in Princeton, recalls, "Every Blanche who played it that Tennessee saw, he would tell them that they were his favorite Blanche, because each actress brought something different to the role . . . and I think he liked that." Thus, says Kahn, "there's no one Hamlet, there's no one . . . Lady Macbeth, there's no one Blanche DuBois."

Patricia Clarkson, who took on the role in 2004 long after Williams's death on February 24, 1983, never had the pleasure of his approval. "I think because I was funny," she said recently, "he might have liked me. And he might have liked that I looked good in my dresses."

Rosemary Harris recalled, "It's the loneliest part to live through that I've ever played on the stage."

Most important, however, is the way that Blanche DuBois has endured, evolving through the psyches of the many actresses who played her. As Sam Staggs wrote in his insightful text *When Blanche Met Brando: The Scandalous Story of "A Streetcar Named Desire,"*

> *Blanche is still there, where the playwright left her, as troubled and as troubling as O'Neill's Mary Tyrone, Edward Albee's Martha, or Emma Bovary or Norma Desmond. . . . DuBois belongs in the lineup of magnificent doomed women.*

BLANCHE'S TRUNK

Blanche herself was a shape-shifting actress, and her props and costumes are in the trunk that Stanley paws through, mistaking her costume jewelry and fake furs for the real thing. "Everything I own is in that trunk," she tells him. (Tennessee himself was no stranger to living out of a trunk. When he died by accidentally asphyxiating a pill bottle cap at the Elysée Hotel in Manhattan on February 25, 1983, there was some initial doubt about the cause of his death, so the police confiscated his suitcase and sifted through its contents for clues, finding none.) We learn a lot about Blanche from the contents of her trunk—her summer furs (probably shedding); her Mardi Gras costumes, trinkets, and paste jewelry; the few fine pieces she

owned, such as a silver and turquoise pin in the shape of a seahorse. And of course, reams of papers testifying to the loss of her ancestral home, Belle Reve.

The best costumers for *Streetcar* include Lucinda Ballard for Kazan's play and movie, and Thea Van Runkle, who dressed Faye Dunaway for the role. Blanche says, "Soft people have got to shimmer and glow—they've got to put on soft colors, the colors of butterfly wings." Both Ballard and Van Runkle understood that Blanche must seem to, well, float airily when the situation requires it.

Dunaway and Van Runkle had been good friends since filming *Bonnie and Clyde* six years earlier, as the costumer had created something of a fashion revolution in her stylish—if idealized—designs for Bonnie Parker, the Depression-era bank robber played by Dunaway. As Dunaway observed,

> *Thea Van Runkle . . . gave Blanche a wardrobe that ran parallel to her various emotional states in a really extraordinary way. Throughout it, Thea used very fragile materials for Blanche. Always draped softly, there was nothing severe in the clothing, and, like the character, it seemed to have moods. When I would move, the dresses would almost float around me, and when I would stop, they would cling.*

Van Runkle knew to cover Dunaway "in flimsy pastels that were exactly what this woman, with all her illusions and her fragile psyche, should wear."

But the contents of Blanche's trunk will not tell us if she's

a suicide's ghost who will not go quietly back to her bed, or a survivor who, like that other storied Southern woman, Scarlett O'Hara, will seize upon tomorrow as another, hope-filled day.

Blanche is the Old South, land of terrors and of dreams, the playwright's Eden from which he was cast out all too soon, but whose siren call still stirred his soul and ignited his imagination. He found himself, and other gay men like him, in New Orleans, that Frenchified city of filigreed balustrades where the too-sweet scent of Confederate jasmine and magnolia blossoms hung heavily in the streets, mingled with the odors of human waste. And there he set himself free.

SOUTHERN WOMANHOOD, OR THE ETERNAL FEMININE

The Southerners who have played Blanche—Tallulah Bankhead, Carrie Nye, Faye Dunaway, Blythe Danner, and Patricia Clarkson—had special insight into the impossible bargain Southern women historically made in order to thrive. How did they reconcile their society's emphasis on purity with their own sexual desires? Perhaps the character of Blanche operated as a kind of cautionary tale in the 1940s and '50s, giving rise to the urgency of feminism. And did the love of beautiful and beautifying things—flowers, manners, dresses, homes, makeup, jewelry, porcelain, furniture—operate as a distraction to the brutality that lay beneath the idealized,

Southern plantation, which had as its foundation the enslavement of Black bodies and souls? It's been suggested that magnolias were widely planted in the South because their intensely sweet blossoms hid the smell of "strange fruit"—lynched Black men and boys in the Jim Crow era. Did the exaggerated, flirtatious femininity of the Southern belle seek to distract white Southern men from the cruelties of the caste system they upheld? Did the abundance of sugary treats and sugary endearments keep Southern women childlike, easier to control?

What was Blanche's ancestral home really like, beyond being a beautiful dream (in pidgin French) and a symbol for all that Blanche has lost? In his essay on *Streetcar*, "Victims on Broadway II," the critic Daniel Mendelsohn notes that the white-columned home called Belle Reve looks at first glance to mean "beautiful dream," except that the French word "reve" is masculine, so it would have to have been "Beau Reve" to mean "beautiful dream." Belle Rive means "Beautiful Riverbank," an apt description, perhaps, for a Mississippi Delta plantation home, but not what Tennessee Williams wrote. Rather, the pidgin French captures the illusory quality of memory, and Blanche's need to sweeten reality with magic. Besides hiding her signs of aging, why else does Blanche constantly cringe from direct sunlight, placing a cheap paper lantern over the naked light bulb in the cramped, Elysian Fields apartment where she has come to reside? What does she not want us to know?

BLANCHE AS ALTER EGO

Tennessee Williams was aware of the dangers inherent in his homosexuality, especially in the repressed 1940s and '50s, including being beaten up by the "rough trade" he often cruised. The director Luchino Visconti felt that Tennessee's own courtly manners were in conflict with his sexuality, just as Blanche's are, and he sometimes called the author "Blanche." He felt that Blanche was a cautionary tale against his own fears of madness. Elia Kazan felt the same way: "I keep linking Blanche and Tennessee, as I write 'him (her)' or 'she (he).'"

One can also easily see Blanche's doomed husband, Allan Grey, as a stand-in for the playwright. After all, he is a poet (and a beautiful young man), which is how Tennessee began his writing life, and he long considered himself a poet even after he'd devoted the rest of his life to writing plays. The character is never seen onstage but exists in Blanche's memory, haunting her with increasing intensity until the memory of his suicide helps to drive her into madness. Because he is such an important character, though never seen, I've devoted a section at the end of this book to a handful of invented poems he might well have written to the girl who would become his bride. As Elizabeth Barrett Browning is evoked in the play, I imagined that his sonnets might have been inspired by her *Sonnets from the Portuguese*.

THE TRUEST BLANCHE

What did critics make of her various portrayals throughout the decades? Brooks Atkinson, Frank Rich, Ben Brantley, Hilton Als, and John Lahr (one of Williams's biographers) have all weighed in. Als, writing in *The New York Review of Books*, saw Blanche as essentially a queer character, treated with contempt by macho Stanley Kowalski and his poker-playing buddies.

And how did women critics see Blanche DuBois? The critic and novelist Mary McCarthy reviewed—and hated—the original 1947 stage production. She thought the play was too much of a stock "visiting-relative" comedy, and she seemed immune to its poetry and tragedy. Was she also uncomfortable with Williams's sexual orientation, as Hilton Als suggests, writing that the formidable novelist and intellectual Mary McCarthy "more or less characterizes Williams as a mincing faggot, dramaturgically speaking, thus unqualified to write about heterosexual lives except as a kind of pornographer." It's possible that the iconoclastic McCarthy, forging a literary career in the male-dominated 1940s and '50s, felt she needed to take a tough-minded stance and reject *Streetcar's* heroine as "thin, sleazy stuff."

Just as critical responses differed, the public's perception of Blanche DuBois has shifted over the decades: In the 1940s and '50s, the character was often perceived as primarily a liar and a tramp. Audiences sided with her antagonist, Stanley

Kowalski, although he rapes her at the end of scene 10. Some believed that Blanche was responsible for the rape, having flirted with Stanley throughout the play ("We've had this date with each other since the beginning," Stanley declares as he carries her inert figure to the bed). That was Jon Voight's interpretation in 1973 when he played Stanley to Faye Dunaway's Blanche, and he wanted Dunaway to play Blanche as "more of a seductress" in the rape scene. "Essentially he argued quite forcefully for Blanche to consciously cause the rape," Dunaway remembered. "I had spent too many hours with Blanche, getting inside her head and her heart, to buy Jon's scenario." It is certainly not the current interpretation, particularly in our #MeToo era. But Brando's powerful, game-changing performance brought sympathy to Stanley, especially for those who saw Blanche as an annoying interloper more than a tragic figure.

THE MADNESS
OF BLANCHE DUBOIS

In so many of his plays, Tennessee Williams was obsessed by the terrifying specter of madness, and by its equally terrifying cures. His one-act play *Suddenly Last Summer* involves a plot to lobotomize its protagonist, Cathy, in order to remove her memory of her cousin Sebastian's murder and cannibalization by street urchins he'd sexually preyed upon. The play allowed him to come to some understanding of Rose's

lobotomy, which haunted Tennessee for the rest of his life. Was it a necessary cure, or, like Cathy's intended fate, a way to cut out a terrible secret her family didn't want to be known or believed?

So many of the actresses who played Blanche—including the seven under consideration here—were all deeply affected by the role—you might say the tragic (and sometimes comic) character crept into their souls. Vivien Leigh, Ann-Margret, and Patricia Clarkson felt that the role came close to unhinging them. Vivien Leigh's bipolar illness began to assert itself when she played Blanche on the London stage; she found herself trembling by the end of each performance, and it was then that she began her dangerous wanderings among the demimonde of Soho. Ann-Margret, who—perhaps surprisingly—gave a surefooted, powerful performance as Blanche in the 1984 TV movie adaptation, also felt haunted, unable to easily free herself from the emotional demands of the role. Patricia Clarkson described herself as "devastated" by her time as Blanche.

BLANCHE AS WHITE, BLANCHE AS BLACK

The first African American production took place in 1953 at Lincoln University in Jefferson City, Missouri, by the Summer Theatre Company. Two years later, the Ebony Showcase Theatre in Los Angeles produced *Streetcar* at the Broadhurst

Theatre on Broadway. In 2012 there was a revival of the play with a multiracial cast, including Nicole Ari Parker as Blanche and Blair Underwood as Stanley. Its director, Emily Mann, knew from her friendship with Williams that he had "always wanted to see a major production of *Streetcar* with a cast of color," and he had often granted permission for all-Black and multiethnic theater companies to produce his play. As a Mississippian, Williams grew up surrounded by Black culture, and his beloved New Orleans was steeped in different ethnicities. Emily Mann observed,

> *He understood human beings, period, and he understood New Orleans society. And you can't understand New Orleans and the South without understanding Black people.*

He would have known the history of landowning, politically prominent Creoles in New Orleans, and how that aristocracy could be translated into his tale of a white Southern aristocrat brought to ruin.

Although Blanche DuBois is the quintessential Southern belle, she is also an outcast—evicted from her safe plantation life by her forefathers' debauchery; fired from her teaching job for inappropriate sexual contact with one of her students; thrown out of the Flamingo Hotel, possibly for prostitution or at least for entertaining too many gentlemen callers; an unwelcome guest in Stanley Kowalski's cramped apartment in the French Quarter; and finally, a broken soul, escorted to a hospital for the insane. As the African American experience

in America has long been one of abuse, casting out, and incarceration, it's fitting to envision the play as a Black saga, especially during the Jim Crow era of the Deep South.

BLANCHE'S OBITUARY

What if the *Times Picayune* had written Blanche DuBois's obituary? As each of these seven actresses bring out different aspects of Blanche, I have imagined a possible obituary, included at the end of this book. How would we imagine her life in the psychiatric institution where she's taken at the end of the play? In a conversation with Claire Bloom, Tennessee said that he imagined Blanche would make good use of her time there, seduce the doctors, and end up with her own floral shop in New Orleans. In other words, she would have survived.

PORTRAIT OF A GIRL IN GLASS: ROSE WILLIAMS

"Oh, Laura, Laura, I tried to leave you behind me, but I am more faithful than I intended to be!"

—*The Glass Menagerie*

To tell Blanche's story one must begin with Rose Isabel Williams, Tennessee's damaged, traumatized sister and the person who most haunted and inspired him.

Born in 1909, Rose was remembered as a warm, affectionate girl, but she became a nervous and angry teenager rebelling against a terrible family situation. Rose would have been aware of the frictions between her mother, Edwina, and her father, Cornelius, made worse by her father's alcoholism. Cornelius was banished from Edwina's bedroom after Edwina had suffered two miscarriages and a hysterectomy, but it had been a mismatch from the beginning. Even in the best of times, the Southern-genteel Edwina had found her husband's sexual advances crude. Lyle Leverich writes in his masterful *Tom: The Unknown Tennessee Williams,*

> With her romantically unreal notions of what love should be, Edwina simply could not respond to the attack of a crude lover. . . . She resisted Cornelius's sexual advances more and more. What began as Edwina's crying protests, Tennessee remembered, now became screams emanating from the bedroom; the impression he had was that of rape.

Those are the sounds that Rose would have heard as she came of age in that household. Her father's alcoholism, his rejection of both her and of Tom (Tennessee), his frequent absences and inability to fully support his family all added to

Rose's and Tom's sense of insecurity. Their youngest sibling, Walter Dakin (known as Dakin) fared better with their father, who bonded with him over a shared interest in sports. But for Cornelius, Tom was his suspect "writin' son," dreamy and poetic and not at all masculine enough for the often loutish paterfamilias. And Rose, perhaps, was too much like her mother—sometimes garrulous, sometimes withdrawn, fond of pretty clothes and attention, and sometimes given to dramatic displays of emotion—and perhaps too attractive for her own good.

Throughout her early teen years, Rose was remembered as a lively girl who often argued with her mother and had sought support and affection from her increasingly distant father. In contrast to Edwina's insistence on genteel propriety—after all, she was the daughter of an Episcopal minister, despite her own flirtatious, Southern-belle ways—Cornelius was a practiced rascal. He drank, he gambled, he frequented brothels, he spent months away from the family as a traveling salesman for the International Shoe Company. He rebuffed Rose's attempts to please him with little gifts and attentions, and he heaped scorn on his eldest son, sometimes calling him "Miss Nancy," perceiving in young Tom a lack of masculinity that was repugnant to him. When Tennessee flunked out of ROTC at the University of Missouri at Columbia in the summer of 1932, Cornelius pulled him out of college and put him to work at the International Shoe Company. By then, Tennessee was already writing poetry, short plays, and stories, having published his short story "The Vengeance of Nitocris" in *Weird*

Tales. What use did Cornelius ever have for poetry? Or for his two older children, for that matter?

As a young teenager, Rose liked jazz and danced to that music. She wore make-up, somewhat shocking to her peers. She adored Tom, who had begun to write by the age of twelve. (Unlike Cornelius, Edwina approved, buying her son his first typewriter, secondhand.) Tom relished his sister's high spirits and sense of fun—until it stopped being fun.

Given the peripatetic fortunes of Cornelius, the family moved often, leaving Columbus, Mississippi, where Rose and Tom were born, and—later—the gracious comfort and security of Edwina's father's home in Clarksdale, Mississippi, where Edwina would often seek refuge from Cornelius's alcoholic behavior. The Reverend Walter E. Dakin—Grandfather Dakin to Tom, Rose, and Dakin—was the well-respected rector of St. George's Episcopal Church in Clarksdale. In 1924, Cornelius moved his family to 5938 Cates Street in St. Louis, Missouri, a top-floor, duplex apartment, a comedown in status and familial comfort.

In his highly autobiographical story, "Portrait of a Girl in Glass"—a precursor to *The Glass Menagerie*—Tennessee described their third-floor apartment "on a block which also contained the Ever-ready Garage, a Chinese laundry, and a bookie shop disguised as a cigar store." The move was necessitated by Cornelius's promotion to a job in management at the International Shoe Company, where he had toiled as a traveling salesman for four years. The rest of the family ex-

perienced the move as a palpable loss of a secure and loving home with their maternal grandparents. Instead of a gracious home with "spacious yards, porches, and big shade trees," they now inhabited a cramped apartment whose rooms opened up on a sunless alley where roaming feral cats were often torn apart by dogs. Rose's room overlooked this gloomy scene, so to cheer it up she and Tom painted her furniture white and laid out along the shelves her collection of glass knickknacks, giving the room "a light and delicate appearance." Of course, those little glass objects—mostly animals—would become a metaphor for his sister's fragility in *The Glass Menagerie*, Tennessee's first successful play on Broadway. "They stood for the small and tender things that relieve the austere pattern of life and make it endurable to the Sensitive. The alley where the cats were torn to pieces was one thing—my sister's white curtains and tiny menageries were another," he wrote. Money was tight and the family would move nine more times.

For Rose as for Tom, St. Louis was a disastrous relocation. She quickly rebelled, dropping out of Soldan High, the public school they had chosen for her. As he had many times and would again, Grandfather Dakin came to their rescue and paid the tuition for Rose to enroll in Hosmer Hall, a private school for girls. She was not much happier there, and Tom bore witness to her mood changes, her self-dramatization, her increasing quarrels with both parents. Leverich quotes from a letter written by an unnamed school friend of Rose's, which bears witness to how strict Edwina was with her daughter.

"There is an adorable girl from St. Louis here. Rose Williams is her name. Ever since I arrived, I have aided and abetted her in deceiving her mother! . . . Whatever Rose asks to do, her mother says no. Then Rose proceeds to do it."

It was 1927, and the behaviors that alarmed Edwina may have been fairly typical of teenage girls at the time—the flapper era eroding the decorum of their parents' generation. They bobbed their hair, they shortened their skirts, they wore mascara and bright lipstick, they danced, they smoked. Even more shocking, they flirted and necked with their boyfriends! For Edwina, who had early on rejected Cornelius's sexual overtures and had morphed from a flirtatious Southern debutante to more of a puritanical church lady, this was all unacceptable. She may also have envied her daughter's blossoming and the male attention she attracted, reminiscent of Edwina's own debutante years. In *The Resemblance Between a Violin Case and a Coffin*, Tennessee describes "the years of [Laura's] beauty," her copper curls falling down her shoulders. When she has her hair cut short at a salon and suddenly begins to walk and move like the "grown ladies," their mother marvels, "She's like Isabel," their father's sister, famous in Knoxville for her beauty. Tennessee writes about the end of his and Rose's happier times as children in Clarksdale in this early story, mourning the loss of their playful innocence: "the magical intimacy of our childhood together, the soap-bubble afternoons and the games with paper dolls cut out of dress catalogues and the breathless races here and there on our wheels." When

the story was published in 1950, Cornelius—whose middle name was Coffin, incidentally—called Tennessee's agent, Audrey Wood, and demanded, "Tell Tom to keep my family out of his stories!"

Tom was fascinated by Rose's budding adolescence, and he spied on her first crush—a handsome boy named Richard Miles—peering at them through a crack in the door and finding himself troubled by his own stirrings of attraction. But he also felt abandoned by Rose, and when Richard died early, leaving her bereft, he witnessed and to some degree shared in the powerful emotion of loss that his sister suffered.

Tom's sense of her abandonment deepened when Rose was removed from Hosmer Hall, which had failed to turn her into a demure young lady (Edwina's wishes), and she was sent farther away, to the Episcopal All Saints' College, in Vicksburg, Mississippi. Again, it was Grandfather Dakin who had arranged it, to Edwina's satisfaction, as it was considered a "school for Southern young ladies," if light on academic subjects.

Rose continued to kick up her heels—wearing makeup and short skirts, dancing, kissing her beaus. Was Rose's rebellious, flirtatious behavior age appropriate, or a stark reaction against her mother's controlling strictness? Or was it the early sign of mental and emotional instability, as her family came to believe?

But Rose didn't fit in at All Saints' Episcopal College either, so she was enrolled in a ten-week course at Rubicam's

Business School in St. Louis. That, too, Rose found oppressive and tedious, so she stopped going to classes without telling anyone. Tennessee was well aware that Rose was unsuited to the work. In "Portrait of a Girl in Glass," he described a character based on Rose as someone who "could be classified even less readily than I. She made no positive motion toward the world but stood at the edge of the water, so to speak." He describes their mother pushing Rose into the world by enrolling her in a nearby business school, paying for it out of her funds saved from selling magazine subscriptions. "It did not work out," Tennessee writes. Rose "tried to memorize the typewriter keyboard, she had a chart at home, she used to sit silently in front of it for hours, staring at it while she cleaned and polished her infinite number of little glass ornaments. . . . She would seem to know the positions of the keys until the weekly speed-drill got under way, and then they would fly from her mind like a bunch of startled birds."

After finally dropping out of Rubicam's, Rose simmered at home, acting out her angers and frustrations with both Edwina and Cornelius. By the time she was twenty-six, she had no suitors and no prospects—unacceptable to Edwina, who had had many suitors before her ill-fated marriage to Cornelius. Rose must have missed the relative freedoms of being away at the business school, though she hated the subjects she had to take, and she found it stultifying to be stuck at home. High strung like her mother, Rose drank up to six cups of coffee a day, increasing her nervousness. Her mood swings could

be extreme, from high jinks to depression, so she may have suffered from some degree of bipolar disorder, though that was never diagnosed throughout the long journey through psychiatric institutions that soon awaited her.

Though still a very attractive girl, Rose's nervous, overly talkative personality tended to frighten away suitors, and once she was at home, apparently unemployable, she had no opportunity of meeting suitable "gentlemen callers," a situation Tennessee dramatized in *The Glass Menagerie*, modeling its shy, wounded protagonist, Laura, on his unhappy sister, as he had in "Portrait of a Girl in Glass." Their father's chronic alcoholism made everything worse, throwing gasoline on their arguments, and she would rail against her plight and her sense of failure. Tom knew from an early age that things were not right at home, and that Rose—whom he'd adored since childhood—was in a miserable state.

Cornelius came to believe the only way to handle his unhappy, rebellious daughter was to institutionalize her.

A GIRL LIKE ROSE

At first, Edwina wouldn't hear of it. For one thing, it would be a terrible scandal for the family, as any kind of mental illness and institutionalization were stigmatizing in 1935. She didn't believe that Rose needed such an extreme measure, and in this Cornelius's sisters, Aunt Ella and Aunt Isabel (for

whom Rose was given her middle name), agreed. After Rose was sent to spend some time with Aunt Ella in Knoxville, her concerned aunt wrote to Cornelius:

Rose seems perfectly well. Her mind is as clear as yours or mine, and I feel that all that is wrong with her is that she is bored to death with no interests. . . . Her friends here are all married with babies, but I hope they will come to see her and ask her out. I don't know any suitable men for her, which I am sorry about.

Aunt Isabel—the Knoxville beauty Tennessee had described in *The Resemblance Between a Violin Case and a Coffin*—agreed with this assessment, though she, too, had no idea of how to help her suffering niece through this difficult time. Aunt Isabel also wrote to Cornelius, "Certainly there is absolutely nothing the matter with her mentally or physically. Her mind is not in the very least 'bewildered' and she is not sick. I simply cannot account her 'breakdown' at home, unless it is nervous hysteria."

Edwina, however, came to believe that Rose was indeed mentally sick and in need of some kind of intervention. She wrote to her father, Rev. Dakin, passing on Ella's and Isabel's observations, but adding, "They can't seem to realize the nature of Rose's troubles. Of course she was practically normal when I sent her to them."

Later, Aunt Ella wrote to Edwina, "This is just a line to let you know that Rose is fine. I never saw her looking better or prettier. In fact she seems in better health than I ever saw

her. She says she has gained 13 pounds." But her letter also betrayed genuine concern, noting that Rose

> *seems anxious to get home. I am afraid she has had a stupid visit. . . . I wish she would study something. She needs to use her mind very badly. She has just plenty of sense and there is nothing the matter with her mind but lack of use. . . . You might talk to this Dr. Alexander [whom] Rose is always taking about. I'm sure he will tell you what I have—Rose needs an object in life, and she hasn't got it. She is going to have to exercise her brain. You can't just stop thinking.*

But soon after, Ella wrote to her brother, in part to acknowledge a check Cornelius sent to cover Rose's room and board,

> *I hate to take it, especially as the trip did Rose very little good. For the first three weeks she improved so much physically and seemed all right, but the last ten or twelve days I saw a change in her, and it troubled me very much, and frightened me too. Sometimes I would speak to her three or four times before she would hear me, and she couldn't remember anything. I feel very troubled about her—I don't believe she could possibly hold a job. She tires very easily and is obliged to lie down every afternoon. If she could find an easy job for half a day it would be great but such jobs are all but impossible to find.*

Edwina increasingly saw that Cornelius was the source of Rose's behavior problems. She knew how difficult it was

to live with her husband, who had long been alternately neglectful and abusive toward her, Tom, and Rose. On several occasions, Edwina herself had fled his abuse to stay with her parents in Mississippi. She attributed Rose's and what she described as Tom's "nervous break-downs" to the "eternal friction that Cornelius has made in the home," she wrote to her parents. "If you study Psychology you find out what that does to the nervous system and of course they had inherited poor ones to begin with."

Indeed, Edwina had described being in that marriage as "walking on eggs every minute of the day and night." Tennessee had come to hate his father. When Cornelius left on a trip to the West Coast in 1943, Tennessee was living at home in St. Louis, working on *The Glass Menagerie*, and he wrote to his friend Donald Windham, "The old man has just now left the house. . . . We hope he never comes back, but nothing returns more certainly than evil."

When Rose returned from her trip to visit her aunts in Knoxville, she found herself stuck all night in the Louisville train station due to a devastating flood. Edwina wrote to her parents,

As soon as she crossed the threshold [sic] I saw she was all off and no wonder for she had sat up all night in the station at Louisville with refugees. She began to rave as soon as she got inside. Cornelius is nervous at best and since this trouble with his ear he is worse, so he lost his temper, told her she was crazy

and that he was going to put her in the State Asylum. He will do this, too, if I don't do something else with her.

Tennessee was well aware of what was going on at home. He recorded this in his journal:

Monday Jan. 25 Tragedy. I write that word knowing the full meaning of it. We have had no deaths in our family but slowly by degrees something was happening much uglier and more terrible than death. Now we are forced to see it, know it. The thought is an aching numbness—a horror!

Rose now spent her days holed up in her bedroom, sorting through her clothes and playing with her beloved dog, Jiggs. One of the doctors she had been taken to see, Dr. Alexander, told Edwina that Rose's problem was that "she needed to get married." Edwina wrote to her parents, "She has been raving on the subject of 'sex' ever since and I was ashamed for Dakin and Tom to hear her the other night."

In the weeks that led up to Rose's incarceration, Tennessee noticed that "little eccentricities had begun to appear in her behavior. She was now very quiet in the house and I think she was suffering from insomnia. She had the peculiar habit of setting a pitcher of ice-water outside her door, each night when she retired."

In her last week at home, Rose was at times reasonable and calm but would fly into a rage against Cornelius. As

Leverich recorded, "She exhibited open hatred toward him, and her doctors warned Edwina that she was a threat to Cornelius's life."

She was hospitalized again for observation, and was advised that she needed to go to a sanitarium. "I'm quite worn out with it all," Edwina wrote to her father. "Dr Bunting thinks she needs to go to a sanitarium and I went out and looked at it to-day. It is fifty dollars a week and I don't believe any better than the State one would be, so I don't know what to do. A pity the Church hasn't a place for girls like Rose."

Yet after her short stay, Edwina admitted that Rose seemed "a hundred percent better," though she exhibited "spells of being mean now, and I never know what to expect of her. I think if we could send her away somewhere it would be the best thing for her. To be in the house with Cornelius is bad for her as he has no patience with her."

Tennessee dealt with Rose's increasing hysteria by staying away:

> *After all, one's sanity is worth something. R[ose] makes the house tragic, haunted. Must be put away I suppose. An incredible horror to face. "No one is to blame," Mother admitted. How true! But why do such things happen? There is no answer.*

He was also aware that gay love was at the time considered a mental illness, which would have made him vulnerable to a fate similar to Rose's, so he stayed away for self-preservation as well as his sense of helplessness.

The state asylum in Missouri and asylums throughout the country were often looked upon as sloughs of despair, where inmates were frequently neglected or cruelly dealt with and left to languish without hope. Aunt Isabel was alarmed at the suggestion that Rose be committed, writing to Edwina, "I want you to know that I feel just exactly as you do about placing Rose in an asylum. In the first place she is not *deranged*, but would certainly become so in an institution of that kind. *It simply must not be.*"

Aunt Ella agreed, considering it an "outrage" to institutionalize Rose, though she feared Rose might do harm to Edwina—even try to kill her. Nonetheless, Ella wrote to her sister-in-law, "Of course I will write to Cornelius, though I have no influence with him, for Rose is certainly not crazy."

In March, Tennessee wrote bitterly in his journal, "R. will probably go to Sanitarium in Asheville, N.C. The Williams family originated in N.C. So now the triumphal return." But Edwina wanted Rose closer to home, so Rose was sent to Saint Vincent's, a Catholic convalescent home, where she would be looked after by nuns. Tennessee visited her there with Edwina one Sunday. Rose let them know she didn't want to see them, but, as Edwina wrote to her parents, she "insisted upon going in, as I wanted to see for myself what condition she was in. Her face looked so yellow and bloated and she was so full of delusions about people and things that I see she has not improved. . . . The visit made Tom ill so I can't take him to see her again. I can't have two of them there."

Tom was devastated to see his once-vibrant sister so

disturbed and so altered, that he was moved to write his "El-
egy for Rose":

> She is a metal forged by love
> too volatile, too fiery thin
> so that her substance will be lost
> as sudden lightning or as wind.
>
> And yet the ghost of her remains
> reflected with the metal gone,
> a shadow as of shifting leaves
> at moonrise or at early dawn.
>
> A kind of rapture never quite
> possessed again, however long
> the heart lays siege upon a ghost
> recaptured in a web of song.

Thus began Rose's role as muse to Tom's genius, as
she would enter into some of his most troubled characters:
Laura in *A Glass Menagerie*, Catherine (Cathy) Holly in *Sud-
denly Last Summer*, and Blanche DuBois in *A Streetcar Named
Desire*. It gave the playwright a way to transform his sense
of helplessness, his guilt, and his unspeakable grief for his
ruined sister. In *The Glass Menagerie*, Tennessee was able to
find some catharsis for his grief and guilt about Rose—at
least temporarily. But for Rose, her troubles were far from
over.

RUINED GIRL

At St. Vincent's, Rose was diagnosed as suffering from dementia praecox ("premature madness"), a psychiatric term now discredited and replaced with the more general diagnostic term, schizophrenia. It was characterized by cognitive disintegration beginning in early adulthood. Insulin shock was prescribed.

The German psychiatrist Emil Kraepelin first described the condition in his 1886 textbook, *Psychiatrie*, as uncurable and probably hereditary, the product of "auto-intoxication"—brain poisoning—most likely, he believed, by sex hormones!

Indeed, part of what so alarmed Edwina was Rose's insistence that she had been sexually violated by her father.

Rose's claim was of course disbelieved—though Edwina knew how crude and brutal Cornelius could be, and she saw that he had no special concern for his daughter's well-being, but to admit such a possibility would have condemned the entire family, not just Cornelius but Edwina for not stopping it, or not knowing it. It was unthinkable for an upright daughter of a revered Episcopal clergyman to harbor such a scandal. She believed, or convinced herself, that "no one was to blame" for Rose's condition, so her daughter's accusation could not be true, and Rose's sexual rantings against Cornelius had to be the result of a diseased mind.

And yet.

And yet, why did she—as Tennessee noted—leave a pitcher

of water outside of her bedroom door, night after night, when she was living at home? He described it as an eccentricity, but could she have left it there to serve as a kind of alarm, so if Cornelius tried to enter her bedroom, he would have knocked it over, or moved it, in either case leaving a tell-tale sign she could show her mother, who refused to believe her? Her chronic, accelerating rage against her father would have had some basis in reality then, if we take the leap of believing that when Rose claimed she was sexually victimized by her father, she was telling the truth.

It may also explain why she drank so much coffee despite suffering from chronic insomnia—perhaps she *wanted*, indeed *needed*, to stay awake throughout the night, to guard against Cornelius's intrusions.

It's not hard to believe that Cornelius would be capable of such transgression. He had already been barred from his wife's bed, he had expressed no tender concern for his only daughter—she felt both rejected by him and preyed upon by him—and his chronic alcoholism would have further eroded his moral sense and his inhibitions.

It is tragic enough to confine anyone to a state institution and subject them to insulin shock therapy, but it is doubly tragic when the patient—as insisted upon by her two aunts—is fundamentally sane. Rose's sense of injury was profound, and she railed and ranted against her captivity. Aunt Isabel had predicted that just being institutionalized would *drive* Rose to madness. And Rose's anger against her mother—for not knowing, or not seeing, or not protecting,

or not believing—would have increased as she blamed her mother for her plight.

Tennessee wrote in his journal,

> *. . . drove Mother to sanitarium to visit R.—waited about an hour—M. came out crying—R. has taken a dreadful turn—become raving—won't wait—thinks she is being poisoned—can't sleep—disturbed the whole ward, so has been isolated—looks a wreck. This of course made me feel very wretched.*
>
> *Then ride with D. [Dad] who was mean as the devil—cutting remarks—felt so inadequate and helpless and hated him so.*

Tennessee recorded that Rose's screams could be heard for some distance, as they drove up to the institution, and as they drove away.

LOBOTOMY: CASE NO. 9014

St. Vincent's could no longer handle Rose, so she was sent to Farmington State Hospital. The nuns at St. Vincent's did not record Rose's accusations against her father, but, according to a 1937 Farmington State Hospital report, Rose's "first signs of madness were a reaction to delusions of sexual immorality of family." That she may have been telling the truth about her father did not seem to enter into her diagnosis.

On the recommendations of her doctors, five years after

entering Farmington State Hospital, and with Edwina's approval, thirty-three-year-old Rose Williams was subjected to a prefrontal lobotomy on January 13, 1943, a relatively new procedure at the time.

The first prefrontal lobotomy was performed by Dr. Egas Moniz eight years earlier, in Portugal, in 1935. Dr. Moniz originated the procedure and in fact would win a Nobel Prize for this achievement, which is now seen as a barbaric treatment that provided little efficacy and often caused tremendous harm. A neurologist, Walter J. Freeman, introduced the procedure to America in 1936, so Rose would have been an early recipient.

Dr. Moniz believed that mental illness could be alleviated by severing the neural pathway between the frontal lobes— the seat of reason, personality, and intelligence—and the thalamus, farther back in the mammalian brain.

Indeed, in approximately one third of cases, patients were rendered calm and symptom-free for the first time after the procedure and were able to live outside of institutions, but at the price of diminished personality and intelligence. But of the remaining two thirds of patients, many died as a result of the operation, or severe disabilities such as paralysis and extreme passivity ensued. Another odd result in some cases caused the patient to develop a huge appetite and gain tremendous amounts of weight.

At the time, it was believed that the prevailing treatments for severe mental illness were unsuccessful and that too many psychiatric patients spent their lives in institutions under

wretched conditions, so a chance to bring about cessation of the worst symptoms of mental disease—rage, delusions, hallucinations—was a step forward, even if only one third were helped.

ICE PICK

At first, Dr. Moniz and Dr. Walter Freeman performed lobotomies surgically, drilling into the skull with the patient under anesthesia, but that soon gave way to what became known as "ice pick" lobotomies (a phrase coined by Freeman). Particularly in state hospitals, patients were lined up on gurneys while a doctor or psychiatrist passed among them, inserting an instrument resembling an ice pick above the eye, penetrating the patient's frontal lobe. Freeman performed about 3,400 of these transorbital lobotomies, and he trained psychiatrists across the country to perform the procedure themselves.

As Rose Williams was one of the early patients of this new "cure," she had the surgical instead of the transorbital procedure.

By 1954, the antipsychotic drug Thorazine replaced most lobotomies as a welcome treatment, but Freeman continued to perform the procedure as late as 1967. His last patient died from a brain hemorrhage as a result, and Freeman was then barred from ever operating again. (He died of cancer five years later.)

For those who survived the lobotomy, the most prevalent

outcome was extreme passivity. As Tennessee Williams would later write in his 1958 play, *Suddenly Last Summer,* "if you're still alive after dying, well then, you're obedient, Doctor."

Tennessee cycled through feelings of guilt, helplessness, and, at first, numbness over his sister's fate. He stopped writing about her in his journals for two months after the lobotomy, then wrote a brief poem describing his odd sense of detachment:

> *Rose. Her head cut open.*
> *A knife thrust in her brain.*
> *Me. Here. Smoking.*

Part of his apparent detachment toward his beloved sister may have been a sense of relief that it was *she*—not Tom— who suffered a fate that he feared he may have been susceptible to. Indeed, it would be 1973 before the American Psychiatric Association declassified homosexuality as a mental disease in the *Diagnostic and Statistical Manual of Mental Disorders.* (The sea change came about only after a brave, closeted psychiatrist, Dr. John Fryer, disguised in a grotesque mask and wig to protect his identity, testified before a 1972 meeting of the APA to challenge the diagnosis.) Tennessee knew he was gay, his father guessed as much and cruelly taunted him, but he knew his avoidance of the fate Rose suffered depended on his secrecy.

But he rued past cruelties toward Rose, and, as John Lahr

points out in his biography *Tennessee Williams: Mad Pilgrimage of the Flesh*, he coped in part by elevating Rose to "a literary motif, an invocation, an angelic immanence, an emblem of all the brave shadowy souls too delicate and too wounded to survive life's hurly-burly." But was it more than atonement, or even grief and pity? Did he feel somewhat responsible? Did he know or suspect that Rose had been ruined by their father but did not have the strength to take her side? Did he feel that his homosexuality made him vulnerable and kept him from defending Rose from the depredations of their father, and ultimately of the psychiatric profession?

He explored those nagging fears in *Suddenly Last Summer*, which was performed with another one-act play, *Something Unspoken*, under the title *Garden District*. (The New Orleans Garden District was the most genteel area in the city, a wide street graced by stately mansions, luscious gardens, and occupied by the city's wealthy elite. St. Charles Avenue runs through it, where city streetcars ran every fifteen minutes.)

SUDDENLY LAST SUMMER

Contemporary audiences are perhaps more familiar with the film adaptation of this one-act play, under the same title, adapted by Gore Vidal, directed by Joseph L. Mankiewicz, and starring Elizabeth Taylor, Katharine Hepburn, and Montgomery Clift. It's a good thing the production utilized such

superb talent in all areas, because the subject was definitely a hard sell, especially in 1958, when it debuted on January 7 at the York Theatre in Manhattan. The movie confounded the Hayes Code, as its backstory was about homosexuality and cannibalism, not your usual 1950s fare, but won its approval when Gore Vidal successfully argued that because the gay man in the feature—a wealthy idler and poet named Sebastian Venable—is killed, the film could be seen as a moralizing cautionary tale.

Wrong. The heart of the story is not the savage ending for Sebastian—whom we never see and only know through conflicting accounts by his wealthy mother, Violet Venable, and his high-strung cousin, Catherine (Cathy) Holly. It's what happens *after* he's brutally torn apart and cannibalized by the starving street urchins he had sexually preyed upon in the fictive town of Cabeza de Lobo (a stand-in for the Moroccan seaside town of Asilah, a mecca for gay men at the time). The socially prominent Garden District matriarch Mrs. Venable (played chillingly by Katharine Hepburn) tries to arrange a lobotomy for her niece, Cathy (Elizabeth Taylor), in order to cut out of her brain the memory of her son's horrific death, and Cathy's knowledge of his homosexuality.

Or, if the memory can't be excised, Doctor Cukrowicz (aka "Doctor Sugar," played by Montgomery Clift) warns, perhaps a lobotomy would keep Cathy from talking about it. Even more sinister, as Mrs. Venable asks in the film adaptation, "After her lobotomy, who would believe her?"

The crux of the play hinges on whether or not Cathy's wild story is to be believed. Mrs. Venable has had her niece institutionalized at a private asylum, St. Mary's, but is planning to send her to the state asylum, Lion's Head, where she would undergo a lobotomy at the hands of Dr. Cukrowicz. At Lion's Head, the handsome young doctor has been practicing his new surgical technique on incarcerated criminals. Cathy's avaricious mother, Mrs. Holly, and her spoiled brother, George, are eager to inherit fifty thousand dollars left to them in Sebastian's will, now indefinitely held up in probate court. And Dr. Cukrowicz is being bribed to perform the lobotomy in exchange for a wealthy donation that would support his work, to be named the Sebastian Venable Memorial Foundation.

George and Mrs. Holly try to persuade Cathy to abandon her gruesome tale—"Are you trying to ruin us?" George asks his sister. "We'll never get out of probate till you drop that story." But she insists that "the truth's the only thing I have never resisted."

Dr. Cukrowicz seems inclined to do the task, but he needs to know if Cathy's story is indeed the truth, or if she is a disturbed fantasist, as her aunt believes. (The role was initiated onstage by Anne Meachum, played with more ambiguity and frailty than Elizabeth Taylor's more self-possessed portrayal in the film.) With that in mind, the doctor gives her a truth serum. If the first half of the one-act belongs to Mrs. Venable's laudatory memories of her son, the second half belongs to Cathy's drug-induced aria, a terrifying account of

the blazing, white hot day in which Sebastian is set upon by a group of vagrant boys and devoured.

Cathy is the embodiment of Rose, in her predicament and in her downward journey from a private to a state institution where a lobotomy awaits her. In both cases, Tennessee depicts their fate as hinging on whether or not her claims of sexual predation are believed.

The playwright Martin Sherman, best known for his groundbreaking 1979 play, *Bent*, writes in his introduction to *Suddenly Last Summer* that Tennessee "was wracked with guilt" that he could not stop Rose's lobotomy, and that by "self-lobotomizing" with drugs and alcohol, he was "in the end, . . . becoming Rose." Like Rose, Cathy is described as too "high strung" to be believed. Like Rose's two paternal aunts, Cathy's brother George says that she "isn't crazy, Mama. She's no more crazy than I am." Indeed, Cathy—and one assumes the same for Rose—is well aware of what's being planned for her. "Do you want to bore a hole in my skull and turn a knife into my brain? . . . You'd have to have my mother's permission for that." In the play, Mrs. Holly's permission is bought with the promise of delivering Sebastian's legacy; in real life, Edwina Williams signed off on the lobotomy, in part, to protect the family name.

At the end of the play, he gives Dr. Cukrowicz the last word, underlining the importance of whether or not Cathy/Rose is to be believed: "I think we ought at least to consider the possibility that the girl's story could be true." By 1957,

when the play was written, Tennessee was beginning to question Rose's psychiatric diagnosis and subsequent devastating treatment, despite Edwina insisting that no one was to blame for Rose's condition.

A STREETCAR NAMED DESIRE

Rose's transformation into Blanche DuBois represents Tennessee's fullest embodiment of his sister. In Laura, he dramatized Rose's frailty and victimization by her mother, Amanda Wingfield; as Cathy, she shares the same plight of being threatened with a lobotomy to cut out an unbearable secret. But Blanche is more full-bodied and complex—fragile yet tough, sexually flirtatious yet clinging to propriety, poetic yet scheming, intelligent yet flighty, a powerful personality who nonetheless becomes a victim.

And at the heart of Blanche's tragedy is her guilt and grief over the suicide of her young poet husband, Allan Grey, a stand-in for Tennessee himself. When Blanche finds Allan in the arms of an older man, she tells him, "You disgust me," the very words Tennessee once flung at his sister when she was too overtly sexual toward the young men he had brought over to meet her. Blanche's rejection of her husband leads to his suicide. Yet in the play, Blanche still treasures his love letters, holding on to them as a symbol of youthful love she fears she will never find again.

In Rose's life, in Cathy's plight, and in Blanche DuBois's

tragedy, much hinges on whether or not she is believed. In Rose's case, Tennessee returns again and again to "the possibility that the girl's story could be true." In *Suddenly Last Summer,* whether or not Cathy is believed will determine whether or not she is lobotomized. In *Streetcar,* Stanley's rape of Blanche is not believed by her sister, Stella, undermining Blanche's fragile hold on reality.

Rose inspired other aspects of Blanche's personality, including her love of feminine things—pretty dresses, flowers, jewelry, perfume. In a particularly poignant moment, in scene 11, Blanche prepares for a date with a former beau, Shep Huntleigh—a complete fantasy she has fallen back on after being brutalized and humiliated by her brother-in-law in the previous scene.

"That cool yellow silk," she tells Stella, just after soaking in yet another hot bath,

> *—the boucle. See if it's crushed. If it's not too crushed I'll wear it and on the lapel that silver and turquoise pin in the shape of a seahorse. You will find them in the heart-shaped box I keep my accessories in. And Stella . . . Try and locate a bunch of artificial violets in that box, too, to pin with the seahorse on the lapel of the jacket.*

BELLE REVE

What we see here is not only the twilight of Blanche's former life, in the moments before she will be escorted to a state

institution for the insane, but the twilight of what Tennessee saw as the civilized, genteel world of the Old South—the Beautiful Dream that could not be sustained in the harsh light of reality—even for members of the white ruling class. Blanche represents a kind of extreme femininity, often cloying and sometimes ridiculous, especially to modern eyes and ears. We can laugh at her prissy insistence on ladylike purity when we see she is a colossal flirt and we learn that she may have been reduced to erotomania—or prostitution—when Belle Reve was lost. We laugh at her insistence that she never has more than one drink when we see that she's teetering on the edge of alcoholism. But poetry, beauty, and beautiful things truly *matter* to Blanche. As they did to Rose, who loved clothes, who cultivated her lovely auburn hair, who was described again and again by her aunts and mother as exceedingly pretty. Perhaps Rose cared too much for that, and her need to be admired was sullied by her father's brutality.

If the girl's story is to be believed.

For the rest of his life, Tennessee used his considerable profits from the success of his early plays—over seven million dollars—to look after Rose. He eventually moved her to the Bethel Methodist Home in Ossining, New York, and visited her whenever he could. She died of cardiac arrest on September 6, 1996, at the age of eighty-six, outliving her devoted brother by eleven years.

THE UNBEARABLE WHITENESS OF BLANCHE DUBOIS: JESSICA TANDY

1947

The moment I read [*Portrait of a Madonna*], my life began.

—Jessica Tandy

When I first imagined a woman at the center of my fantasia, I . . . saw the pure and buoyant face of Lillian Gish.

—Tennessee Williams

The path to Jessica Tandy—the first actress to portray Blanche DuBois—began with the silent-screen star Lillian Gish.

In the early 1980s, Tennessee befriended the writer James Grissom, a Louisiana native who would transform their deep and wide-ranging conversations into *Follies of God*, his book about the women who had shaped Tennessee's work and inhabited his imagination. Most of those women were actresses. At one point the playwright had told Grissom, "I was freest when I could live my life, understand my life, reorder my life, through the movies, and then through drama. And my mother was the same. . . . Life only made sense to my mother through dreaming." Rose shared this inclination with Edwina and Tennessee, and the three of them loved the sweet-faced silent film star Lillian Gish. She was Edwina's favorite actress.

John Gielgud once described Lillian Gish as "tiny and alabaster white, with those enormous, lovely, empty eyes" when, at forty, Gish had played Ophelia to John Gielgud's Hamlet. (He had considered her ideal for the part.) It was probably Gish's ghostly paleness that made her appropriate to play

Blanche, whose very name means "white." In fact, in his early "Elegy for Rose" Williams described his sister as "a ghost recaptured in a web of song." But despite admiring Gish's fragile beauty, once he got to know her, he saw her as a "titanic sprite" and "violently uneducated."

Lillian Gish never played Blanche DuBois. By the time *Streetcar* opened in 1947 at the Ethel Barrymore Theatre in New York, Gish was too old at fifty-five to play Blanche, who is in her thirties, but more importantly, *Streetcar*'s first director, Elia Kazan, didn't want her.

Tennessee had sent Gish a copy of his one-act play, *Portrait of a Madonna*—an early version of *Streetcar* with a lead character, Miss Lucretia Collins, who would later morph into Blanche DuBois—and he asked her to take on the role. (The one-act play's original title was *The Moon and the Royal Balconies*.)

Tennessee would later tell Grissom that the wounded, shabby-genteel Lucretia was, for him, "an obsessive archetype," a "neurotic fabulist with delusions of grandeur; a woman divorced from reality, and in perpetual pursuit of a dreamed-for, hoped-for world of her own creation; a lost soul." In explaining the role to Gish, he suggested that Lucretia suffered from the frustration of having to wait passively for a man to arrive and to care for all of her needs, to which Gish replied, "I have no needs, and I never feel the discomfort of desire, because I always do what I should and I always have what I need."

Though Tennessee idealized Lillian Gish's ghostly fragility, he must have sensed that she was not a good fit for either Lucretia or Blanche. Her puritanism, her denial of having any desires, and her disapproval of homosexuality certainly put her at odds with the playwright and with the thwarted desires expressed by both Lucretia and later by Blanche. Nonetheless, he seemed devoted to her. As Kazan recalled,

> [Tennessee] truly believed that since hers was the vision that was his first of Blanche, he would lose the character completely without her performance of it. I have great respect for Miss Gish . . . but she quite simply failed to understand any aspect of Blanche . . . [who] was as alien to her as if she were playing a Martian. I was very harsh with Tennessee, and I told him that his play was being diluted daily by the presence of Miss Gish.

The last scene of *Portrait* is a version of *Streetcar*'s shattering conclusion. Lucretia has lost all connection to reality, believing she has been raped by a phantom lover, until she is taken away by a nurse and a doctor to a state hospital for the insane. Tennessee was surprised and frustrated to find that Gish did not see this fateful ending in the same way as he intended. Rather, the actress felt that Lucretia was the master of her own fate and was responsible for her own demise. He saw that she did not really understand the doomed character.

Nonetheless, Tennessee remained fascinated by the elfin actress—her pale, fairy-book beauty, her halo of golden hair— and, perhaps, he also wanted her approval. She arguably

represented the role Edwina had played in the playwright's difficult emotional life.

After all, Gish's genteel puritanism was a version of his mother's. "Mother was president of the anti-sex league," Tennessee's younger brother, Dakin Williams, wrote in 1987 to Lyle Leverich, one of Tennessee's biographers. After two miscarriages and a hysterectomy, and in response to Cornelius's crude overtures, Edwina stopped having sex with him. Her attitude and fastidiousness permeated the household: Tennessee was twenty-seven before he'd had a complete sexual experience; his younger brother, Dakin, was a virgin until he married in his late thirties, and as far as Tennessee knew, Rose never managed to have an appropriate romantic/sexual liaison in her entire life.

Despite her distaste for sex, Edwina was proud of being what many considered a pretty woman, with a certain status in Memphis. Tennessee once described her as "very much of her time, and she was very much aware of the role the 'fine' and 'refined' Southern woman must play in the strata." In Edwina's mind all women played a role in relation to their place on the beauty and charm continuum: "A lack of physical attractiveness and charm were deformities toward which she displayed no charity or patience," Tennessee wrote to James Grissom. "An ugly woman . . . has no reason whatsoever to be out and about. She should be ashamed of herself." Edwina assigned those women certain behind-the-scenes roles—cooks, maids, poets [!], and religious fanatics.

By the mid-1940s, Tennessee would have wanted Edwina's

blessing on *Portrait of a Madonna*, or perhaps her forbearance, assuming she recognized Rose or even herself as the inspiration for Miss Lucretia Collins. By considering Edwina's favorite actress for the role, perhaps Tennessee was hoping to inoculate himself against her disapproval of holding the family up for scrutiny.

But Gish would not originate the role of Miss Lucretia, nor would she ever play Blanche DuBois. It was undoubtedly the right decision on the part of Kazan.

By the time *Streetcar* debuted onstage in 1947, Gish, with her air of girlish innocence and her alabaster face, would have reminded audiences of those older ladies who sometimes haunt the streets dressed as Christmas fairies or little girls, caked with white makeup, twirling a parasol, their odd smiles looking as if they had just stepped out of a teddy bear's picnic. With her girlish corkscrew curls, fiftyish Miss Lucretia is not far from this type of delusionary, regressed woman, but Blanche DuBois is youthful and attractive, though sensitive about no longer being an ingenue.

Lillian Gish, however, had a toughness and practicality that belied her fairy-book appearance. She was savvy enough to realize that she had missed a great opportunity. Years later, she told Grissom, "I think Tennessee felt guilty that I didn't play that part, and I would be lying if I didn't tell you that I often wonder about my life—my professional life—if I had had the opportunity to be Blanche. Could I have done it? Could I have done it well? What or who would I be today if I had taken on that challenge?"

MOONLIGHT AND ROYAL
BALCONIES: *JESSICA TANDY*

As Tennessee worked on *Streetcar*, with Kazan acting as midwife, word got out among the theater community that Tennessee's new play—still in utero—was scorching. The wealthy Canadian actor and producer Hume Cronyn thought the role of Blanche would be a brilliant showcase for his actress wife, Jessica Tandy. The couple asked Kazan for a copy of *Streetcar*, and since it wasn't yet completed Kazan sent them the one-act *Portrait of a Madonna*.

"And the moment I read it," Jessica Tandy later recalled, "my life began. I was, for the first time in my life, unafraid to be ruthless in order to get something I wanted." At thirty-seven, the London-born, delicately featured actress had struggled with an almost crippling shyness, and only came into her own when she could inhabit a character other than herself.

"I'm the first to admit how idiotic it appears that a morbidly shy and ashamed person should choose to go on the stage, but my fear of recognition was as the person Jessica Tandy, not as a character. Characters were what I was hiding behind."

Her father's early death from cancer had plunged the family into poverty, but her mother managed to scrape together a living as a teacher, encouraging her shy daughter to attend various classes, including a public-speaking class that introduced Jessica to Shakespeare's sonnets. That's when

Tandy found her calling. The class led to acceptance at the Ben Greet Academy ("No RADA or Central School, I assure you"), where, she recalled, she was "the most polite young girl in any acting school of that time."

She was on her way to becoming "a very ordinary repertory actress" with "a dribble of talent," in the stinting words of John Gielgud (he thought she was too focused on her diction and was too artificial onstage), but two life-changing events altered her trajectory: she met and married Hume Cronyn (her second husband), who became her champion and confidence booster, and she took on the role of Miss Lucretia, which would lead to Blanche DuBois. Both characters shook her to her bones and changed her into a deeper, more compelling actress.

Tennessee had dedicated *Portrait of a Madonna* to Gish: "Respectfully dedicated to the talent and charm of Miss Lillian Gish," but he didn't seem to mind the part being originated by Tandy (though she had to be aged by stage makeup to play the role).

It's hard to know what so excited both actresses about playing Miss Lucretia Collins, who presents so ghoulish and deluded a character that at first it's hard to sympathize with her. The Southern gothic, which borders on satire, looms beneath the surface of the play and threatens to take over, as the haggard, ex–Southern belle—a fiftyish spinster and church lady—presents a pathetic and rather frightening figure. She's

much too old for the pink-ribboned corkscrew curls she favors; her frilly negligee has seen better days. (Later incarnations of this character type would be Big Edie and Little Edie Beale of *Grey Gardens*, whose delusions and ruined splendor evoke tears of laughter, astonishment, and, finally, pity.) With her over-the-top Southern mannerisms and diction, her insistence on her purity, and her obsession with the belief that she's been continuously raped by an old beau whom she claims has impregnated her, she at first seems a figure bordering on the ridiculous.

The play's title, *Portrait of a Madonna*, is of course ironic, as Miss Lucretia is so far from the idealization of saintly motherhood that, again, one could mistake the play for satire. Miss Lucretia is a frightful figure, the object of pity by her apartment house's porter and the object of ridicule by the elevator boy. Only the apartment manager, Mr. Abrams, sees her plight as tragic, though it is he who has arranged for the doctor and the nurse to remove Miss Lucretia from her dilapidated apartment and institutionalize her.

What would have drawn these two intelligent actresses to a sad character who borders on the gothic? Jessica Tandy is made to look older, haggard, and *hunched* for the role (a word Tennessee used to describe Rose as she drifted deeper into unreality). Though her plight and her Southern airs are similar to Blanche DuBois's, Miss Lucretia lacks Blanche's relative youth, beauty, humor, and genuine charm, and Lucretia's mental instability is apparent from the beginning of the play. She seems less a moth fatally drawn to the flame and

more a woman already ruined by too much sunlight. Yet, the character so dominates the one-act that it could very easily be seen as a one-woman show, with a few extras who help move the plot along.

What makes Miss Lucretia a compelling figure worthy of pity and terror, finally, is the poetry of her monologues. After all, Tennessee began his writing life as a poet, and his rich, lyrical language deepens and distinguishes most of his theatrical work, as it does here. Through her remembrance of walking under the grilling sun past the home of the young man she obsessively loves and his pregnant wife, Evelyn, Tennessee has given Lucretia an indelible inner life:

> *I used to think I'd never get to the end of that last block. And that's the block where all the trees went down in the big tornado. . . . Impossible to shade your face and I do perspire so freely! . . . not a branch, not a leaf to give you a little protection! You simply have to endure it. Turn our hideous red face away from all the front-porches and walk as fast as you decently can till you get by them!*

Her memory of a Sunday School faculty party one summer, when her rival, Evelyn, first "rassled together" with Richard while "they cooled the watermelons in the springs," reveals a wound never healed, an intimate glimpse into Miss Lucretia's world of regret and thwarted passion—a plum for an actress hoping to deepen her emotional range.

• • •

Hume Cronyn was among the first of Kazan's theater friends to fully recognize Tennessee's talent, and when Kazan sent him a copy of *Portrait of a Madonna*, he staged a performance at the Actors' Lab in Los Angeles, a venue created by the Group Theatre to give its actors stage work while they were in Hollywood waiting for film roles. Kazan speculated that Cronyn knew that Tennessee was in California at the time and he would see Tandy's performance. He hoped the playwright would be struck by Jessica's portrayal, and that would put her in the running to play Blanche once *Streetcar* was completed. Kazan later wrote,

> *The timing was perfect and Hume was an enterprising theatre man with the most practical devotion to his actress wife. We all went to the show and we were, as Hume had hoped, completely taken with Jessie. She'd solved our most difficult problem in a flash. . . . Jessica wanted the part [of Blanche], we wanted her, we had her.*

The rehearsals of *Streetcar* were a joy—which wasn't what I expected," wrote Kazan in his memoir, *A Life*. The casting was a bit out of sync, with Jessica the only British-trained actress among the Method actors closer to Kazan's heart ("my strange ducks out of the Studio" is how he described them).

But the magic wasn't just because of the English-trained actress; right away, his gamble on a young actor making waves in a small role on Broadway would completely shift the

dynamics of the play. That young actor was Marlon Brando, Kazan's choice to play Stanley, with Williams's enthusiastic approval. Kazan wrote that he'd anticipated a certain amount of tension surrounding Brando.

> He had mannerisms that would have annoyed hell out of me if I'd been playing with him. . . . I believed this might drive Jessie up the wall, or send her running to me for help. But she never complained, even about his mumbling . . . there were more days when she felt what everyone else in the cast felt, admiration for the scorching power of this man-boy. Jessie . . . knew actors give better performances when they work with partners whose talents challenge their own, and that she had to be very good indeed to hold stage with Marlon.

By the third week, Kazan allowed Hume Cronyn into the theater to watch the rehearsal ("I was very fond of this man and glad to have his opinion"). Kazan feared that Hume would think he was favoring Brando, allowing Jessica to be overshadowed, but it was Kazan's intention to make Blanche "difficult," so that the audience would be with Stanley in the first half of the play, only to have their sympathy reversed by play's end. But he didn't explain that to Cronyn, who was right to be concerned that his wife, in the starring role, would be overshadowed by this brash, brilliant, and unconventional actor.

"She can do better," Cronyn told the director. "Don't give up on her. Keep after her. She can do it." Kazan recognized

that the difference between the two actors was that Jessica was always polished and professional ("every moment worked out, carefully, with sensitivity and intelligence"), but with Brando, "every word seemed not something memorized but the spontaneous expression of an intense inner experience." Brando's Stanley was something new and galvanizing in the theatrical world, a performance "full of surprises and exceeding what Williams and I had expected. A performance miracle was in the making."

It would be Brando, not Jessica, who stole the play's thunder and emerged as the breakout star.

Jessica graciously told Kazan that she thought Marlon was "marvelous," but Cronyn didn't like what he was seeing. "He hung around the back of the auditorium, looking at me with both encouragement and impatience. He'd brought us Jessie and couldn't allow me to be disappointed." Kazan came to believe that the two actors' contrasting theatrical styles actually helped the play, underlining the gulf between the refined, upper-class Blanche, though now on hard times, and the rough-and-tumble working man from the Vieux Carré of New Orleans.

After tryouts in New Haven, Boston, and Philadelphia, *Streetcar* opened on December 3, 1947, at the Ethel Barrymore Theatre. The reviews were ecstatic, especially for Brando, though he came to feel that both he and Jessica Tandy were miscast.

"Jessica is a very good actress," he wrote in his memoir,

Songs My Mother Taught Me, "but I never thought she was believable as Blanche."

> *I didn't think she had the finesse or cultivated femininity that*
> *the part required, nor the fragility that Tennessee envisioned.*
> *In his view, there was something pure about Blanche DuBois;*
> *she was a shattered butterfly, soft and delicate, while Stanley*
> *represented the dark side of the human condition. . . . It's true*
> *that Blanche was a liar and a hypocrite, but she was lying for*
> *her life—lying to keep her illusions alive.*

From then on, the sympathy of audiences would be divided. When the MGM Studio mogul Louis B. Mayer attended the performance, he described Blanche as that "awful woman" who arrives to break up "that fine young couple's happy home." Part of this unintended sympathy derived from Brando's shattering and original performance, but future audiences would also be divided in their sympathies, applauding when Stanley punctures Blanche's grand delusions with a well-timed "Hah!"

Brando felt that, ultimately, Jessica Tandy was "too shrill to elicit the sympathy and pity that the woman deserved. This threw the play out of balance." He felt that people laughed inappropriately because Blanche had been turned into "a foolish character, which was never Tennessee's intention." Though Tandy told their director that she thought Brando was marvelous, she was furious every time the audience laughed with Stanley—at her expense.

· · ·

All we have today of Jessica Tandy's performance of Blanche DuBois is a radio play adapted from the Broadway production, roughly twenty-nine minutes of *Streetcar*, and a re-enacted scene for television with Tandy as Blanche and her actor/spouse, Hume Cronyn, as Mitch.

Tandy herself was a pretty woman, but in the radio adaptation, her Blanche is not the coquette we've come to recognize. She seems more canny, more manipulative, more aware of what she's doing, and more of a schoolmarm than an outcast Southern belle. However, in a 1955 recreation of her date-with-Mitch scene, broadcast live on Alastair Cooke's CBS program *Omnibus*, Tandy is charmingly coquettish, giving weight to the idea that she really does like the unlikely Mitch and is not just seeking to be rescued by him. She's girlish and she's enjoying his company, going along with his silly offer to punch him in the stomach to prove how strong he is! She does not seem lost, at first, in the illusory dreams spun by memories of a briefly sweeter past. But, later on, she is overpowered by Brando's Stanley, not just in the final act of the play when the rape occurs, but by the sheer force and originality of his acting, which outdazzled her.

If Brando is to be believed, Tandy did not fully grasp Blanche's dreamlike fragility, nor the struggle between her sense of propriety and her unmet desires, so she did not fully inhabit the role as Tennessee imagined her. Rather than making her mark on Blanche DuBois, it was Blanche who left her mark on

Tandy. She was arguably deepened by playing so shattered, complex, and heartbreaking a character. Tandy would go on to perform in plays and films with Hume Cronyn, culminating in her late-in-life Oscar for playing another aging Southern woman—Miss Daisy in *Driving Miss Daisy*.

But even before this Oscar-winning performance, Jessica Tandy is unforgettable in a small but important role in Alfred Hitchcock's *The Birds*. Playing the hero's mother, Tandy conveys her nearly Oedipal grip on her handsome son Mitch (played by Rod Taylor). Part of Hitchcock's genius was to cast Tippi Hedren as Mitch's love interest and Jessica Tandy as his mother—two cool, pale beauties who physically resemble one another. Because Tandy's character is a no-nonsense, somewhat grudging, and practical woman, she presents an important counterweight to the reckless heiress played by Hedren, and to the bizarre, otherworldly behavior of the marauding birds that have terrorized Bodega Bay, a small California coastal town. Her cool disbelief is shattered when she visits a friend, only to find that his eyes have been plucked out by invading seagulls. The sight of Jessica Tandy soundlessly running out of his cottage, her mouth an O of terror, speaks to the depth that she was able to convey in a wordless scene. A "very ordinary repertory actress," in Gielgud's words, would hardly have had that impact.

"DREADFULLY MAGNIFICENT": VIVIEN LEIGH

1951

Vivien Leigh gives one of those rare performances
that can truly be said to evoke pity and terror.

—Pauline Kael

[A] bored nymphomaniac.

—Kenneth Tynan

Part of Blanche's staying power has to do with the searing performance of Vivien Leigh in Elia Kazan's 1951 film adaptation, using much of the same cast as his earlier stage production, including—crucially—Marlon Brando as Stanley, Kim Hunter as Stella, and Karl Malden as Harold "Mitch" Mitchell. Missing from this list was Jessica Tandy, who was replaced by Leigh.

When it came time to cast the film adaptation of *Streetcar*, none of the Hollywood moguls behind the production—Charles K. Feldman, Jack Warner, and Darryl Zanuck—wanted Tandy to reprise the role of Blanche. Despite her fine if unexciting performance on Broadway, she was deemed just not sexy enough. Even Kazan, who admired her, did not go to bat for Jessica. Kazan later wrote that he felt "stale on the play, [and] needed a different actress for Blanche . . . a high-voltage shock to get my motor going."

Tennessee Williams was not completely behind casting Vivien Leigh, and Kazan had not seen her London performance in the role. However, he relied on the opinion of Irene Selznick, who had produced the Broadway play but not the movie and who supported the choice wholeheartedly. As Leigh was already internationally famous for starring in the

widely popular *Gone with the Wind*—and winning an Academy Award—it was a smart business choice as well. And—as Sam Staggs pointed out—she could be gotten for "a mere $100,000," a bargain. And so, when we even think of Blanche DuBois, Vivien Leigh's delicate, strained beauty usually comes to mind, gussied up in Mardi Gras feathers and fake jewels, her blond curls the relic of girlhood, evoking an antebellum past glorified and remembered through a shimmering veil of tears.

Leigh's performance so brilliantly evokes Williams's most famous and tragic character that all subsequent actresses have had to, in some way, reckon with it. That we have her performance in Kazan's luminous film makes her even more daunting to her successors, preserved for as long as we value film, set like a fire opal in an heirloom brooch. Where did this performance come from, and where does its power reside?

When we first see her, Blanche emerges from a cloud of steam from the train that brought her from Mississippi to New Orleans, like a ghost made of smoke. On first seeing her sister at the local bowling alley, she confesses that she's on "the verge of lunacy," though in that exaggerated way that undercuts the truth of that statement.

When Blanche tells Stella that their ancestral home, Belle Reve, has been lost, she reproaches her sister for leaving her to deal with the mounting losses of death and debt. She later makes a reference to "Margaret," though it's not clear whether

she's a servant, a family retainer, or a relative—who died "in that horrible way." We can only guess at what she means.

Vivien Leigh—born Vivian Mary Hartley in India in 1913—was primarily a stage actress whose marriage and theatrical partnership with Sir Laurence Olivier gave her lofty status and opportunity. In London, they came to be known as Lord and Lady of the Theatre. But Leigh was often left playing second fiddle to her great, if sometimes overbearing, husband. The role of Blanche DuBois would change that dynamic, especially as it followed her award-winning role in *Gone with the Wind*, which catapulted Leigh from the London stage to the universe of film and international fame. Cast as Scarlett O'Hara in 1939 in a role she had set her cap for, she had beat out Paulette Goddard despite being English and not American-born.

One can see real comparisons between Blanche and Scarlett—the idealized, flirty, gracious, yet gritty Southern belle of the ante- and postbellum South, and the flirty, gracious, yet desperate and despoiled Southern belle of post-World War II America, after all had been lost—the status, the money, the stately home. Both roles won Vivien Leigh Academy Awards for Best Actress, both are indelibly stamped with Leigh's Anglo beauty and insouciance, and both can be seen as companion pieces—the Southern belle at her peak and at the end of her inevitable decline.

LONDON CALLING

Before Kazan's famous film, Leigh had initiated the role on the London stage. A big problem with the Olivier-Leigh 1949 production at the Aldwych Theatre in London's West End is that Olivier didn't really understand the play he had undertaken to direct. Nor did he admire it, agreeing to the production because he knew how much Vivien wanted to play the part. He knew it would be a great opportunity for her, and he also was impressed by the success of Kazan's Broadway production.

Tennessee Williams had his own misgivings, disliking an earlier London production of his first Broadway success, *The Glass Menagerie*, directed by John Gielgud and starring Helen Hayes as Amanda Wingfield. Alan Strachan, in *Dark Star: A Biography of Vivien Leigh*, wrote that Gielgud had bathed the play "in lambent soft focus throughout," draining it of its robustness. Williams felt that "the British had an inherent incapacity to interpret a play soaked in an atmosphere particularly American such as *Menagerie's*"—surprising, perhaps, as the American South was so heavily populated by descendants of English, Scots, Welsh, and Irish. But Williams himself was impressed by the prestige of an Olivier-Leigh production, and the play's producer, Williams's friend Irene Mayer Selznick, who had produced the Kazan stage incarnation, felt that Leigh's success as Scarlett O'Hara had well equipped her to play Blanche DuBois. Selznick would keep an eye on the London production.

However, both Williams and Selznick were taken aback when Olivier asked if he could edit down some of the dialogue, a request they answered with adamant refusal. Olivier was concerned that the censorious Lord Chamberlain's office would object to several of the play's themes and speeches, most notably references to Blanche's promiscuity and her description of finding her young, poetic husband, Allan Grey, in the arms of another man. Lord Chamberlain's office suggested changing the "older man" to "a Negress," a cringeworthy suggestion to which Vivien immediately objected.

Nonetheless, despite Williams's and Selznick's refusals, Olivier made cuts to the text. And though he used the same poetically evocative set design created by Jo Mielziner for Kazan's Broadway production, he decided to bring in his own costumer, Bumble Dawson, instead of the brilliant Lucinda Ballard, whom Kazan had used. With Dawson, Olivier clothed his Southern belle in prim English tweeds of shoddy quality, which undercut Blanche's flirtatious Mardi Gras gaiety and again showed little understanding of her milieu and her girlishness.

As Vivien knew, Blanche's wardrobe and the contents of her trunk are a key to her character, and Kazan wisely used Ballard again in costuming Leigh for the film.

BLANCHE'S TRUNK

To carry all of one's belongings in a trunk bears witness to an end-of-the-road desperation. For Blanche, a life once lived

at the pinnacle of Southern society has come to this: a trove of faded Mardi Gras gowns; cheap, knock-off jewelry; some ratty furs; and papers attesting to mounting debt, the funerals of family and family retainers, and the final loss of their Mississippi mansion, Belle Reve. When the beautiful dream is over, what's left? No wonder Blanche repeatedly hides the harsh, naked light bulb of day with paper lanterns, not just to soften her slightly aging beauty (she's only in her mid-thirties!), but to soften the terrible reality to which she has been brought.

And to travel with a heavy trunk is to be dependent upon the help of strangers—mostly Black porters who carried luggage for passengers in exchange for tips. When porters were in short supply, as was often the case at busy airports and train stations, the burdened female passenger had to bully, cajole, or flirt to secure the help she required just to get on with her journey. One needed patience—and cash—in order to secure assistance, two things Blanche had little of. But she had a plethora of charm. A skilled and experienced flirt, she did know how to manipulate men of all classes, and for Blanche, this would prove to be an existential necessity. If you have no money or status, the ability to manipulate might be the only means of survival you have left, at least in mid-twentieth-century America.

Once Blanche arrives at the cramped, two-room apartment at Elysian Fields in the French Quarter, her brother-in-law, Stanley Kowalski, wants to know what's in that trunk. He expects to find finery and jewels and perhaps even cash, all

derived from the sale of the family estate, which he believes he is owed half of under Louisiana's Napoleonic Code:

> STANLEY: *[He pulls open the wardrobe trunk . . . and jerks out an armful of dresses.]*
>
> Open your eyes to this stuff! You think she got them out of a teacher's pay? . . . Look at these feathers and furs that she come here to preen herself in! What's this here? A solid-gold dress, I believe!

To Stella's horror, Stanley callously paws through Blanche's belongings, throwing the contents of her trunk around the room. Stella and Blanche have to convince him of the truth—that her gowns are costumes, her jewelry is paste, and the papers attesting to the sale of Belle Reve are a chronicle of loss, failure, despair—"the long parade to the cemetery."

Hard to realize that one's sanity may be dependent upon such simple things as good clothes, cash at hand, and some way—or someone—to relieve loneliness, three things Blanche lacks.

Like Pandora's box, the trunk containing the remains of Blanche's life sits in the middle of the two-room apartment, portending misfortune, and the only glimmer of hope will come in the form of a stalwart and romantic oaf called Mitch.

As the London stage rehearsals wore on, Vivien obediently followed her husband's direction, though Olivier later wrote in his memoir, *Confessions*, that his suggestions

were mostly technical. But he also told the book's collaborator, Mark Armory (in a passage that didn't make it into the book), "If it hadn't been for me Vivien would have been no good in *Streetcar*. . . . I know a hell of a lot about the business. I'm very, very good at giving people the right advice." But the changes he made in the text did not sit well with cast members—especially Vivien—nor, of course, with Williams and Selznick. Bernard Braden, who was somewhat miscast as Mitch in the London production, saw that "our distinguished director was systematically altering the script and, on occasions, cutting it," and he witnessed Vivien's vehement objections. "They went at it hammer and tongs," he recalled. If Olivier didn't understand Blanche DuBois and perhaps shared Ken Tynan's harsh review of her as "a bored nymphomaniac," Vivien understood her extremely well.

MIXED NOTICES

Despite many unfavorable reviews by London critics who generally looked down upon Williams's masterpiece as unsavory, the play was a box-office success, no doubt riding on its explosive Broadway debut a few years earlier and Leigh's powerful performance. The usually astute Ken Tynan, who would become the dramaturge of the National Theatre under Olivier's direction, was among those not impressed by the production, the play, or Vivien's performance. Like Olivier, Tynan didn't understand the thread of comedy that ran through this

"flyblown melodrama," and he completely missed the tragedy of this trapped Southern belle driven to madness by circumstance and loss. He had been hard on Vivien's earlier stage performances as well, and he felt that English actors were "too well-bred to emote effectively on stage." He thought the play should have been titled "A Vehicle Named Vivien."

Olivier, though he didn't quite grasp the Southern-drenched psychology of his doomed heroine, did rush to defend the play against its critics. To an audience member, he wrote in a private letter,

> *You misapprehend the play. . . . It is a tragedy . . . in the purest sense of the word . . . the basic object of pure tragedy is to shock the soul . . . to* upset *the audience, to beat, to harrow the mind so that it will spread and become familiar with new realms of thought.* A Streetcar Named Desire *is a fine piece of work. The fact that it can be accepted as a piece of salacious sensationalism is a reflection upon the audience, not upon the author.*

Despite misgivings about the play, most critics praised Vivien's performance, and two of her friends, Lady Diana Cooper and Noël Coward, thought she was magnificent in the role. Many noticed, however, the toll it took on Vivien, night after night, throughout its eight-month run. Another friend, theater and film critic Alan Dent, found her after one performance "shaking like an autumn leaf . . . her lips trembling. She clutched me and put her head on my shoulder and

said in no more than a whisper, 'Was I all right? Am I mad to be doing it?'"

BIPOLAR EXPLORATION

Perhaps she *was* mad to be doing it. Vivien's nascent bipolar illness uniquely suited her to fully embody Blanche, but she herself later said that the role had "tipped her into madness." Actually, she had suffered her first full-blown attack of mania in 1937 while filming *Fire Over England* with Olivier, three years before their marriage. There had also been some furious outbursts on the set of *Caesar and Cleopatra*, and a possible suicide attempt while filming *Gone with the Wind*, ten years before *Streetcar*, but as Strachan noted in his biography of Leigh, "Of all her roles Blanche was the one which stretched the fragile protective shell of her psyche to the most extreme, twisting it out of shape at times."

Laurence Olivier biographer Terry Coleman asks, "Why then, in 1949, did Olivier direct his wife in such a play when he knew that her own sanity was none too sure? . . . He had known for years." Vivien's strong desire to play the role, and Olivier's wanting the critics to finally give her credit "for being an actress and not go on forever letting their judgements be distorted by her great beauty and her Hollywood stardom" overcame what fears he might have harbored for her somewhat fragile sanity.

Indeed, there were troubling behaviors during the run of the play, such as Vivien dismissing her car at the end of the night's performance to walk home from the Aldwych Theatre through Soho, at the time a notably louche section of London, where she often stopped to talk with prostitutes ("several of whom had been to see the play," Strachan noted). There were even rumors that Vivien "at times sought sex with strangers or taxi drivers."

A feature of bipolar disease is hypersexuality during manic phases. As writers and psychologists such as Kay Redfield Jamison have noted, manic phases can spur tremendous outbursts of creativity, as exemplified by twentieth-century American poets such as Robert Lowell and Theodore Roethke, but at a tremendous cost. For Lowell, his bursts of creativity were often accompanied by sexual adventurism, to the despair of his second wife, Elizabeth Hardwick, who eventually divorced him after he took up with the heiress and writer Caroline Blackwood. Ken Tynan, who had been so uncharitable in his reviews of Vivien's performance in the play, would later chronicle some of her trysts in his journals, including her attempt to seduce him.

Staggs makes a distinction, however, between Vivien Leigh's bipolar illness and what he describes as Blanche's anxiety neuroses. "We don't see Blanche depressed, nor in a state of mania. Excitable, yes. She is, as many Southern ladies once were, 'nervous.' Medically, the condition was then known as 'neurasthenia.'" To complicate matters, Blanche also verges on alcoholism (so did Vivien Leigh). However, Kazan himself

wrote in his August 1947 notebook, "The more I work with the character of Blanche the less insane she seems."

Staggs suspects that Blanche's frequent hyperventilation, her inability to catch her breath, was Williams's own disorder—a breathlessness bordering on panic. (In scene 5, Blanche tells Stella, "I want to breathe quietly again!") Yet if all she is suffering from is an anxiety neurosis, that doesn't explain her dangerous promiscuity, damning in an unmarried, upper-class Southern woman in the mid-twentieth century. Indeed, it's her past promiscuity that finally destroys her, as rumors of such reach the ears of the one man she has found who might rescue her by marrying her and giving her respectability—the stalwart mama's boy, Mitch.

Though the audience may see Mitch as below Blanche in status and education, Blanche seizes upon him as a way out of her dilemma, and a person on whom she can practice her wiles and find confirmation of her desirability. The fact that he treasures a cigarette case given to him by a deceased sweetheart, complete with a verse by Elizabeth Barrett Browning, assures Blanche (and the audience) that he well might be a suitable match. In their first meeting, they discuss the lines of poetry engraved on his cigarette case, and Blanche feels that he is indeed a cut above Stanley and his poker buddies.

Her romance with Mitch briefly flowers, and Blanche feels safe enough to tell him about the tragedy of her early marriage and the suicide of her husband. In a way, they are

brought together by poetry and loss, and by mutual need. Both are lonely. Mitch wants his invalid mother, with whom he lives, to know he's settled with a wife before she dies. In the same way, Blanche desperately needs the security of a marriage—any marriage—to rescue her from her current status as Stella's homeless and impoverished sister.

In almost every scene, Blanche is obsessed with her appearance. She will not show herself in bright sunlight or any kind of harsh lighting, grateful for the paper lantern Mitch brings her that she immediately uses to cover a naked light bulb. This is the vanity of the Southern belle just past her sell-by date, unmarried, perhaps unmarriageable, painfully aware that her beauty and her charm were what defined her. In her thirties, she still dresses like a debutante or a girl at a birthday party in order to appear younger.

One way to see if her beauty and charm are still intact is to flirt with the men around her—including Stanley when he and a neighbor bring in her heavy trunk. She manipulates, cajoles, and flatters them to assert her illusion of youth and beauty. It seems that she does know truth from fantasy, because she will later tell Stanley, who can't stand her cloying ways, "If a thing is important, I tell the truth."

If Vivien's indiscretions and dangerous liaisons were mostly kept from the public, what did audiences make of Blanche DuBois's reputation as a local woman of ill-repute, having

apparently resorted to prostitution to survive the loss of her home? Was she a sex worker, or just driven to her "many intimacies with strangers" in her small Mississippi town "by loneliness and the isolation after Belle Reve's loss—a belief that 'the opposite of death is desire.'" After all, the streetcar that lends its name to the title goes from the Desire Projects to the Cemeteries—as it still does. But an unaccompanied woman having affairs in a small Southern town—no matter the reason—would always have been a notorious source of scandal. Add to that the schadenfreude of seeing a once exalted member of society debased and scorned.

It's Stanley who tells Mitch about Blanche's notorious past, not wanting to see his friend caught up in his desperate sister-in-law's moonlight web of half-truths.

At first, Mitch refuses to believe it, and he turns against Stanley. But when the fact of her notoriety sinks in, he brutally turns against Blanche, standing her up at a birthday party dinner given in her honor, and then showing up late, hostile, demanding explanations. When asked about her checkered past with other men, Blanche realizes she can't keep up the pretense of innocence, and she answers, "I had many intimacies with strangers . . . to fill my empty heart."

Mitch then attempts to have the sex with her he feels she's been promising all along. Now that he sees her as damaged goods, he feels he's within his rights to assault her, an assault she fights off, running into the street to seek help. It's a sad demise of their hopes and dreams—for both of them, as Mitch

would have found a measure of happiness with Blanche, and Blanche might possibly have come to love Mitch's poetic and tender side.

For Vivien Leigh, her affairs and misadventures were mostly kept quiet. Early on, she and Olivier made sure to hide their adulterous relationship until each had secured a divorce and were thus able to marry. Later, Vivien was protected by her status, her fame, and her association with Olivier as half of London's Royal Couple. But Blanche DuBois, who believed in rescuers (such as Shep Huntleigh, the gentleman caller she believes will come to save her but who never appears), is left unprotected and alone.

It's understandable why audiences of the Broadway play often sided with Stanley against Blanche, seeing her as manipulative and disruptive. After all, to live with a slightly dotty sister-in-law in two rooms for five months would try anyone's patience—especially when Blanche's contempt for Stanley's lack of any refinement is made abundantly clear. He's "rough trade," a term Blanche would not have known but Tennessee certainly did, and of course Stella is deeply attracted to her beautiful, animalistic specimen of a husband. Yet he strikes her! When his poker game is broken up by Blanche playing the radio and dancing with a clumsy but smitten Mitch, and

Stella goes to Blanche's defense, Stanley pushes her onto the porch and slaps her.

It's done discreetly, mostly off-camera, but we see it, and her neighbor, Eunice, whisks her upstairs to safety. Blanche is horrified and assumes her sister will not return to her brute of a husband—despite being pregnant with his child. Typical of most abusers, Stanley cries and begs forgiveness, and Stella forgives him. Blanche asks Stella why she would stay in such a marriage, to which Stella answers, "Haven't you ever ridden on that streetcar?"

Stanley's rape of Blanche is also done off-camera, so we don't see the details, but we do see its effect on her. The day after, she is broken, docile, frightened. Stella has had her baby and has come home from the hospital to hear Blanche's accusation against her husband. "I can't believe Blanche's story and keep living with Stanley," she cries out, once again escaping to the relative safety of her upstairs neighbor.

WHO IS TELLING THE TRUTH?

The crux of the matter, again, depends upon whether or not Blanche's tale of rape is believed, just as Rose's fate was sealed by the disbelief of her charges against her father. In both cases, their fates are the same—incarceration in a mental institution. Blanche's famous line, "I have always depended on the kindness of strangers," uttered as she leaves the apartment on

the arm of a psychiatric doctor, takes on added resonance after hearing her say, "I had many intimacies with strangers . . . to fill my empty heart."

VIVIEN'S TRIUMPH

Pauline Kael perhaps said it best when she wrote, "Vivien Leigh gives one of those rare performances that can truly be said to evoke pity and terror . . . you're looking at just about the best feminine performance you're ever going to see."

> *Elia Kazan's direction is often stagy, and the sets and the arrangement of actors are frequently too transparently "worked out," but who cares when you're looking at two of the greatest performances ever put on film and listening to some of the finest dialogue ever written by an American?*

Leigh won her second Academy Award for *Streetcar*, but she seemed eager to rush back home to London and return to the stage alongside Olivier. Winning two Academy Awards for Best Actress (ten years apart) was a boon to Leigh, but not to Olivier, who never duplicated the Academy Award he had won in 1948 for his *Hamlet*, which would have brought him even greater fame, beyond London's West End. For the first time, he saw Vivien Leigh's fame eclipse his own.

They decided to take the slow way home, a five-week journey on a French freighter with just three other passengers.

The once white-hot honeymoon phase of their relationship was mostly over, and as they slowly chugged toward Southampton, Olivier became aware of the depression that hung over both of them, like a hangover after a riotous night. He wrote in his memoir, *Confessions of an Actor*,

> *For the first time the idea of suicide had its attractions and I found myself more and more drawn to the ship's rail and the fascination of the foam sweeping by.*

KITTEN WITH A WHIP: ANN-MARGRET

1984

We were taught manners, but not how to survive.

—Mary Emily Crumm

Where Kazan's film is gauzy, poetic, filmed in half-light with cramped interiors, John Erman's *Streetcar* teleplay begins with actual, real-time footage of the French Quarter, where Blanche begins her journey into darkness. From the opening daylight scene of the actual Desire streetcar bustling along St. Charles Avenue on its way to the Vieux Carré, and the sight of Ann-Margret stepping down from the streetcar looking impeccable in a white summer dress and summer hat, we immediately have a more realistic interpretation of the play. At first, it doesn't *feel* like a tone poem, or a mood piece, or a tragedy about to unfold. (The play itself is written in eleven scenes, not broken into three or five acts, so although it builds to crescendo, the play can also be read as a tone poem.) Later, the light fades to a more sepia tint, as Blanche slips more and more into fantasy.

Filmed in New Orleans for an ABC made-for-television movie, the street Blanche walks through in search of Elysian Fields is lively with Black singers and vendors; blues and jazz permeate the Quarter; the local gaiety contrasts with Blanche's apparent primness. She's dressed for a luncheon at the Court of the Two Sisters, perhaps, or a meeting with any of the legion of law firms and bankers that nibbled away at Belle Reve until it disappeared.

At one point, Blanche passes a prostitute lounging in a darkened door, a telling moment that will resonate toward the

end of the play. If Kazan's (Vivien Leigh's) *Streetcar* is impressionistic and dreamlike, Erman's (Ann-Margret's) feels more believable, more solid, more lit by sunlight than by moonlight (despite Blanche's own preference). Just as we bring to Leigh's performance a memory of her charming but ruthless Scarlett O'Hara, so we bring to Ann-Margret's her history as a veteran of show business, a survivor, a dancer with a dancer's perfect posture, and her sex-kitten persona in earlier films like *Kitten with a Whip*. All of that gives her a confident sexuality, a toughness belied by her blue-eyed, doll-like features. And it will lead us to wonder about Blanche's past: Was she a nymphomaniac, a sexual libertine, a sex worker by necessity, or was she hypersexualized as a feature of bipolar disorder? Until the final scene of the play, which sees Blanche's total disintegration, this Blanche seems confidently self-possessed.

When Kazan wrote in his diary, "The more I work with the character of Blanche, the less insane she seems to me," Ann-Margret's Blanche seems troubled but fundamentally sane—until she is raped by her brother-in-law. If Jessica Tandy brought out the schoolmarm quality of Blanche, as Marlon Brando and Karl Malden thought, Ann-Margret brings out her survival instincts. She knows exactly what she's doing, how far she can push Stanley, and how much she can flirt with him to try to get her way in their battle for Stella's soul. She seems less a wounded bird and more of a steel magnolia, not happy with where fate has left her but determined to find a way home, wherever that home may be.

ORIGIN STORY

The reviews of Ann-Margret as Blanche DuBois were enthusiastic, if a bit surprised. "For those who still think of Ann-Margret as a glittering sex kitten who has spent too much of her career in Las Vegas–type entertainments and a string of mostly forgettable movies," wrote *New York Times* television critic John H. O'Connor, "she may seem a peculiar choice to play Blanche. But, over the years, Ann-Margret has been impressively proving her mettle as a dramatic actress." Nominated for a Best Supporting Actress Oscar earlier for her work in Mike Nichols's *Carnal Knowledge*, and (for Best Actress) for her campy, over-the-top performance in Ken Russell's *Tommy*, she was nominated for an Emmy Award (along with Beverly D'Angelo as Stella and Randy Quaid as Mitch), and she won a Golden Globe Award for Best Performance by an Actress in a Mini-Series or Motion Picture Made for Television.

"Tennessee Williams wanted me to do this seven years ago," Ann-Margret told the journalist Michael E. Hill in an interview for *The Washington Post*. "Our schedules wouldn't let us do it. It's one of the finest parts ever written for a woman. I thought, What qualities of mine are like Blanche's? Which are not?" She was never able to get Tennessee's answers to those questions because the playwright died unexpectedly three days after she signed the contract. "I never had a chance to talk to him about how he envisioned Blanche, how my qualities integrated with hers," she told Michael Hill.

Without Tennessee's guidance, she did a great deal of research and preparation, working with dialogue coach Sam Reese for seven hours a day for six days. "I wanted to make the accent as much a part of me as possible," she said. Reese invited her to Montgomery, Alabama, where the actress listened to the speech patterns of Alabamans and tape-recorded them. At a brunch organized by Reese, she met a woman named Mary Emily Crumm, a former debutante who had been born and raised in Montgomery. "I zeroed in on this woman at the gathering," Ann-Margret remembered. "I based a lot of my portrayal on her." She recalls Crumm telling her that "We were taught manners, but not how to survive." That rang true for the actress. "I screamed when she said that. It's perfect! So many of us were not taught to survive, no matter where we're from."

Unlike Ann-Margret, Vivien Leigh was coached by a native of Louisiana—the eccentric aristocrat Marguerite Lampkin, who married a British lord, moved to London, and later devoted her life to progressive causes. Lampkin had also coached Elizabeth Taylor for her role as Cathy in *Suddenly Last Summer*; her work with Leigh was perhaps a bit misguided, as Blanche, of course, is not from Louisiana but from Mississippi. Somewhat refreshingly, Ann-Margret doesn't employ Leigh's honey-dripped Southern accent, so she seems less of a manipulative flirt than a woman using her charm to navigate an increasingly impossible situation. It was important to Ann-Margret to create a Blanche who would not remind viewers of Vivien Leigh—a daunting task.

Ann-Margret continued to study the tape recordings she'd made when she returned to Los Angeles. She recalled in her 1994 memoir, *Ann-Margret: My Story*, "I . . . met one of Tennessee Williams's good friends in a bar, and as soon as he heard me talk in my Southern drawl, he said, 'Indeed, you're what he imagined.'"

Ann-Margret threw herself into the role, rehearsing with Treat Williams, Beverly D'Angelo, and Randy Quaid for three weeks before heading to New Orleans for location filming. "By the time the production arrived in Bayou country," she wrote, "I was a quivering wreck. Down ten pounds. . . . I felt dazed and psychologically beaten. Just as I had in *Carnal Knowledge*, I retreated inside the character, which was frightening for the others in the cast." When it came time for the rape scene—which was portrayed more graphically than in the Kazan movie due to the Production Code restrictions at the time—the actress insisted that Treat Williams "really grab and physically pummel me. As black-and-blue marks surfaced on my skin, Treat apologized profusely and backed off the hard stuff."

She persisted. "Don't," she told him. "We've got to do it this way. Otherwise it won't look real."

The toll it took on her surfaced on the second-to-last day of shooting. "I froze," she recalled. "I wouldn't leave my dressing room. John [Erman] was quickly summoned, and found me in a chair, twisted and shaking, confused, agitated, and staring ahead in a daze. I'd lost my grip on reality."

Her director took her hands in his and told her, "This is just a movie! You have to realize that this is just a movie!"

UNWASHED GRAPE

In this production, Blanche's scenes with Mitch are particularly revealing, and at times, even funny and sweet. Poetry brings them together when she discovers a quotation from one of Elizabeth Barrett Browning's *Sonnets from the Portuguese*, Sonnet XLIII—"And, if God choose, / I shall but love thee better—after—death!" engraved on a silver cigarette case that had been given to him by a girl who died soon after. "She knew she was dying when she give me this," he tells Blanche. "A very strange girl, very sweet—very!" It's an unexpected counterweight to Stanley's rough poker buddies, and it confirms Blanche's view that Mitch is somehow more refined than the rest of the crew playing cards in the tiny apartment. One hopes that he will have the refinement to see Blanche as she is, and care for her. It seems as if it might happen that way.

Mitch is a difficult character to pull off. He is a working-class fellow, part of the poker gang who also works with Stanley and is on his bowling team, but perhaps it's because he lives with and cares for his invalid mother that he lets out his tenderer, more gentlemanly side. He's big and awkward, and a lot of the humor in the play comes from his attempts to be the wooing swain, clumsily dancing briefly with Blanche in their

first scene together, and later showing off his firm belly and telling Blanche how much he weighs. Yet Blanche seems delighted by all of that, or is she just flirting with him because she's homed in on him as a possible rescuer?

Their date is both comic and touching. Blanche really does seem to care for Mitch, and he's delighted by her rarified ways. "I like you to be exactly the way that you are," he tells her, "because in all my—experience—I have never known anyone like you." But he's also motivated by wanting to fulfill his mother's wish that he be "settled" soon, before she dies.

Randy Quaid was nominated for a Primetime Emmy for his portrayal, which deftly navigates Mitch's arc from a somewhat oafish figure to a more sensitive soul—and back again—possibly a good match for Blanche after all, until he reverts to a wounded suitor appalled to discover his girl has a very notorious past. If he's a dancing bear in their first scene together, he's a wounded bear in their last.

Blanche feels enough at home with him on their date to relive her experience of losing Allan Grey, and she tells him the story of Allan's suicide, which she will increasingly relive throughout the rest of the film, in the grip of an unresolved post-traumatic disorder, to use current parlance. She begins softly, remembering the first blush of love:

> *He was a boy, just a boy, when I was a very young girl. When I was sixteen, I made the discovery—love. All at once and much, much too completely. It was like you suddenly turned a blinding*

light on something that had always been half in shadow . . . but
I was unlucky.

But that girlish reverie is shattered when she comes to realize that "there was something different" about Allan, a suspicion confirmed when she came into a room where "the boy I had married and an older man who had been his friend for years" were in a deep embrace. They all pretended that nothing had happened, and the three of them drove to Moon Lake Casino where they laughed, drank, and danced.

What haunted Blanche the most, however, was her cruelty when they were dancing and she suddenly told him, "I saw! I know! You disgust me . . ." And then Allan ran out of the casino to the edge of the lake where he put a revolver in his mouth and fired, blowing off the back of his head.

This scene is the first retelling of those terrible events, and it gives us our fullest look into Blanche's sense of guilt, regret, and loss. Though it's not until the final scene of the play that we see her crumble, we see how fragile she has been all along.

Mitch, surprisingly, is touched by her remembrance. He draws her into his arms, telling her, "You need somebody. And I need somebody, too. Could it be—you and me, Blanche?" They kiss and Blanche breaks into cathartic sobs.

She answers, "Sometimes—there's God—so quickly!"

This is the most hopeful—indeed, only hopeful—moment in the play, and it's brought about by a suitor who at first

seems an unlikely match for Blanche but who has shown, at least for now, a genuine empathy and appreciation for her.

It has moved her into a deeper place in her psyche, this dreadful memory now shared and given light of day—or at least the light of the moon. By the end of the play, after she has been abandoned by Mitch and broken by Stanley, she has entered a zone of pure poetry, the last solace of a desperate soul. In a strange reverie, she delivers a particularly moving aria:

I can smell the sea air. The rest of my time I'm going to spend on the sea. And when I die, I'm going to die on the sea. You know what I shall die of? [She plucks a grape] I shall die of eating an unwashed grape one day out on the ocean. . . . I'll be buried at sea sewn up in a clean white sack and dropped overboard—at noon—in the blaze of a summer—and into an ocean as blue as my first lover's eyes!

This film adaptation of Williams's play was written by Oscar Saul, adhering closely to the playwright's language, structure, and vision. This aria marks the moment that Blanche must abandon desire for what she calls its opposite, death's waiting arms. She has already recoiled from a Mexican woman selling flowers for the dead—"*Flores! Flores para los Muertos!*"—as if to say she's not ready, but now she recognizes that those flowers are ultimately meant for her. She suddenly realizes that she's stepped off the Desire streetcar for good, and has transferred to the Cemeteries bus, and landed at Elysian Fields, the biblical realm of the dead.

Ann-Margret is sublime in this scene, having undergone a sea change in which her earlier optimism has been replaced by despair alternating with fantasy—the fantasy that an old beau named Shep Huntleigh is arriving any minute to take her on a cruise to the Caribbean. Of course, he never appears, except in the mistaken guise of the courtly psychiatrist who escorts Blanche to the car waiting to take her to the state mental institution.

Among the plangent poetry in this scene, we suddenly have the appearance of a drab, no-nonsense psychiatric nurse who has accompanied the doctor. Her words to Blanche are like cold water thrown in her face: "These fingernails have to be trimmed. Jacket, doctor?" The reference is not to Blanche's Della Robbia blue jacket but to a straitjacket for her transport to the mental hospital.

SISTERS

"I could feel the loneliness of being the dutiful daughter who stayed behind as everyone died off," Ann-Margret said about her portrayal. In scene 1, in which she first reunites with Stella, Blanche berates her sister for abandoning the family and Belle Reve:

> *Well, Stella—you're going to reproach me, I know that you're bound to reproach me—but before you do—take into consideration—you left! I stayed and struggled! . . . I'm not*

meaning this in any reproachful way, but all *the burden descended on* my *shoulders.*

. . . you are the one that abandoned Belle Reve, not I! I stayed and fought for it, bled for it, almost died for it.

Beverly D'Angelo is particularly persuasive as Stella, beginning with a physical resemblance to Blanche and a strong sexual presence that underscores the battle lines between Blanche and Stanley. We see her leaping into Stanley's arms, wrapping her legs around him. Treat Williams is suitably hirsute and handsome, effectively embodying this boy-man who insists on his rights and will do anything to keep his wife's love and affection, though he's not above striking her. We see that Stella is Blanche's only lifeline, her only connection to a troubled past that nonetheless formed Blanche into the disappointed and nearly destitute woman she has become. Blanche tries to recapture their girlhood friendship, linking arms as they go out to dine together at Galatoire's. Stella repeatedly defers to her older sister, waits on her, allows her to use the only bathroom to take lengthy, perfumed baths, turns a blind eye to her drinking, and even rushes down to the drugstore to buy Blanche a lemon coke. Later, when she asks Stella to put a shot of whiskey in her coke, then says ingenuously, "You mustn't wait on me!," Stella answers, "I like to wait on you, Blanche. It makes it seem more like home."

Waiting on Blanche is an extension of their childhood, presumably a happier time. Later, when Mitch stands up Blanche at her birthday dinner, a dreadful evening ensues that

ends up with Stanley "clearing his plate" by hurling his dishes against the wall. Stella defends Blanche to her husband, telling him, "You didn't know Blanche as a girl. Nobody, nobody was as tender and trusting as she was. But people like you abused her, and forced her to change." That memory of a sweet and loving sister is why Stella puts up with Blanche's far too disruptive visit. That is the Blanche that Stella knows and remembers, and she can't bear to see her unravel.

When Stanley has Blanche escorted to a mental hospital, Stella either believes that she's just going away to recuperate in some kind of rest home, or she's willing to do anything to reject Blanche's claim that she was raped by Stanley. If Blanche claims that Stanley raped her, she must indeed be crazy, in an echo of Rose Williams's fate.

PROMISCUITY, A BRIEF HISTORY

Ann-Margret's confident sexuality—far from the wilting, dissembling Blanche in Leigh's performance—adds backbone to the role. It shades our understanding of Blanche's past as a notorious woman in Laurel, Mississippi, where recruits in the nearby army camp would buzz around Belle Reve whenever they could, shouting her name and entreating her favors. The implication that she was prostituting herself at the notorious Flamingo Hotel (whose management "asked Dame Blanche to leave," as Stanley says in scene 7) seems less the acting out of a deluded, promiscuous soul than the survival instincts of

someone who is not ashamed to use her body to make her way in the world, especially as the world—the Old South as embodied by Belle Reve—has crumbled around her.

There are at least two ways of looking at Blanche's notorious past. One is that, in Ann-Margret's words, despite her sympathetic portrayal, Blanche is "a nymphomaniac, an alcoholic, and a psychotic." Nymphomania, though still a diagnostic label often associated with bipolar disorder, borderline personality disorder, and dementia, has been rethought and recast by feminist scholars, such as Carol Groneman in *Nymphomania: A History*.

"Nymphomania is a metaphor, which embodies the fantasies and fears, the anxieties and dangers connected to female sexuality through the ages," she writes. In the nineteenth century, it was considered an organic illness, treated with egregious insults to the female body—such as "bags of pounded ice applied to the genital region, and leeches to the uterus, presumably to draw off the noxious blood," even, in rare cases, clitoridectomy. Women who indulged in flirtatious behavior, lustful glances, and even the wearing of perfume were sometimes considered suffering from "mild nymphomania" in the Victorian era. Believing that women were less sexually oriented than men, extreme and overt female desire was considered a disease; "a nymphomaniac's fate was prostitution or the insane asylum," two grim fates met by Blanche.

In the Freudian era, nymphomania was redesignated as the product of a "disordered psyche," or a personality disorder, a view that flourished in the early twentieth century.

Rose's fate was partly a product of this way of thinking; her insistence that she had been raped by her father and her frank sexual talk alarmed Edwina, who came to believe that the only cure for her apparent hypersexuality was institutionalization. And, ultimately, a lobotomy.

Flaubert once famously wrote of his eponymous character Madame Bovary, "C'est moi." Tennessee Williams could well have made the same confession. He was well aware that his sexual orientation made him an outcast in the genteel, Southern society he had been born into, and he created in Blanche a character who reflected his own sexual yearnings, in fact naming Stanley Kowalski for a man of that name that he had known and admired in St. Louis. "There was some physical likeness," notes biographer Lyle Leverich, and it appears the two friends had a relationship of idol to hero-worshiper." Like Blanche's, his desires were deemed inappropriate and a threat to society—"degenerate," as Stanley describes Allan Grey's proclivities. We learn that Blanche lost her teaching job after seducing a seventeen-year-old student; we also see her flirting with and kissing the teenager who comes to collect for *The Evening Star*. It's easy to see those transgressions as Blanche's attempts to recapture her youthful love for her lost husband, and the way in which her past has threaded into her present. But could it also be her sense of privilege as an upper-class white woman used to having her own way, and unable to face her loss of status and her perceived fading of youthful beauty?

Is her inability to control her sexual longing Blanche's

fatal flaw? Stanley's overpowering sexuality is not lost on her ("My sister has married a *man*," she tells her brother-in-law in their first scene together). But whatever stirrings of desire she may have felt for Stanley quickly turn to contempt, fear, and a struggle for survival.

AFTERMATH

Like Vivien Leigh, Ann-Margret was deeply affected by playing Blanche. Leigh, slowly losing her grip on reality during the long run of the play on the London stage, found herself trembling like a leaf after each performance. Ann-Margret told the late *Chicago Sun-Times* film critic Robert Ebert that "*Streetcar* [is] the finest role I've ever had, and it's taking the most out of me. I'm not a technical actress, I'm an emotional actress, and if Blanche DuBois feels something, I do."

Michael Hill noted that for seven years she'd lived with the idea of taking on Blanche in a remake of Kazan's famous film, but when filming started, she "plunged into the part so deeply that she turned to a psychiatrist to pull her out." She also asked the psychiatrist—a woman—to instruct her on psychotic behavior, and to be present on the set when they filmed her final disintegration.

At one point, Ann-Margret called her doctor at 2:00 a.m. "I was losing it," she recalled. She felt as if the psychiatrist were "speaking from another planet."

I tried to focus on her and couldn't. She said I was in a psychotic state and would remain there for a few hours. But she assured me I was still Ann-Margret Smith. I had to stay in that state for five more hours. When the filming was over, John [Erman] embraced me for a long time. He said, "It's okay. You're still Ann-Margret." It stayed with me for eight weeks. I'd have flashbacks. I'd heard stories of actresses who'd been affected by parts. But I never knew anyone who'd been through that. I was Blanche. It still comes back.

Immediately after filming the last scene of the movie, Ann-Margret left on a lengthy, onstage tour and found herself suddenly gripped by anxiety and stage fright. "I had just stepped on stage at the Golden Gate Theatre in San Francisco," she recalled, "when Blanche decided to make a public appearance. . . . Suddenly, everything blurred in front of my eyes. I forgot the steps. I couldn't hear the music. With a frightening abruptness, I just stopped and stood in the center of the stage with a glazed look on my face, trembling." She was ushered offstage, where her husband, the former actor-turned-manager Roger Smith, comforted her before she was able to go back onstage and continue.

She knew if she couldn't conquer that fear, she would never be able to perform live again.

MOONLIGHT BECOMES YOU: JESSICA LANGE

1995

When you get down to the core of her being, her essence, what the Actors Studio used to call the "spine" of the character, it is this horrible aloneness.

—Jessica Lange

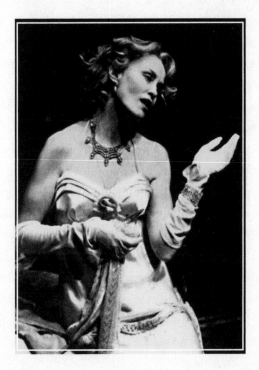

There has never been a part that has ever fascinated me like Blanche," Jessica Lange told journalist Susan King in an interview with the *Los Angeles Times.* The actress discovered the character while a high school student in Minnesota. "I think maybe for a man it's 'Hamlet'—an actor feels this *need,* this *desire,* this incredible *compulsion* to play 'Hamlet.' I am sure most actresses feel that way about Blanche. I know I surely did."

Lange would play Blanche DuBois twice—first in 1992 in a Broadway revival of *Streetcar,* which opened at the Ethel Barrymore Theatre, the very theater that housed the first production of *Streetcar* forty-five years earlier. With Alec Baldwin as Stanley Kowalski and Amy Madigan as Stella, the revival was praised for restoring the most faithful version of Williams's play to date. (In Kazan's classic 1951 film, the rape scene was confusingly played off camera, and references to Allan Grey's homosexuality were softened.) Lange's Blanche, however, garnered disappointingly mixed reviews. Frank Rich writing in the *New York Times* criticized Lange's "lack of stage technique" and unconvincing Mississippi accent, and audiences complained that they had difficulty hearing her—a disaster for a stage actress. Although Lange had done summer stock, she was primarily a film actress, and she knew how to act for the camera—which also came into criticism as Rich noted that she seemed to be playing to an imaginary camera. Alec Baldwin was praised for his onstage portrayal of Stanley, and it was felt that Lange paled in comparison:

Actors have to be half-mad to star in Tennessee Williams's drama on Broadway, where the glare is unforgiving and the ghosts of Elia Kazan's original 1947 production, as magnified by the director's classic 1951 film version, are fierce. Stacked against Marlon Brando, the first Stanley Kowalski, and Jessica Tandy and Vivien Leigh . . . who can win?

The exciting news from the Ethel Barrymore Theat[re], where Gregory Mosher's new Broadway staging of "Streetcar" arrived last night, is that Alec Baldwin has won.

He went on to describe Lange as Baldwin's "unequal partner in unhinged desire. . . . Ms. Lange's Blanche leaves the play pretty much as she enters it: as a weepy, uncertain yet resourceful woman who has endured some hard knocks rather than suffered a complete meltdown into madness."

But few perceived how particularly taxing it was to play Blanche onstage night after night. "It's a very haunting character to play," Lange later said. "The fact that you put your heart and soul and physical body and mind through that experience relentlessly . . . your body doesn't understand it's make-believe. Do you know what I mean? Emotions take the biggest toll on our body."

Lange had played disturbed, complicated women before— the troubled film star Frances Farmer in *Frances* in 1982, and the bipolar wife, Carly, in *Blue Sky*, for which she won an Oscar for Best Actress. But to play Blanche eight times a week for the monthslong run of the play was deeply challenging. She credited her children with helping her get through the ordeal.

"This is what actors do this for: to play these kinds of parts. But I don't think I could sustain it. I don't think I would want to sustain it again, that kind of emotional intensity for that length of time. You walk on stage at the brink of a nervous breakdown and then it goes downhill from there. I don't think there is anything more emotional and physically exhausting than this part for a woman."

Performing for the camera just wasn't as emotionally exhausting because, for film, after "a really devastating emotional scene," you're finished with it. Onstage, you relive it again and again. "Had I been a more experienced stage actor," she later said, "maybe I could have had a few more defense mechanisms in place, a way to protect yourself a little bit more."

Lange was hurt by the mixed to poor reviews. "I hate not getting performances right," she said years later. "I didn't understand stage the way I did film." Nonetheless, the production moved to London, and when the time came to reprise her role for a three-hour presentation on CBS *Playhouse 90* in 1995, she was willing to try again. She was glad that the film didn't happen until three years after the Broadway play because that gap of time "let everything settle in."

It was like everything settled down and gave us enough time to come back to it and still know it, know it deep down in your bones. But you could approach it in a way that was completely fresh. To tell you the truth, to be able to do it on film was really a thrill. I like working in front of the camera. It gives me much

more to do. I am sure that there are stage actors who vehemently disagree with me, but I find it much more liberating to work in front of a camera because it's so intimate and personal. The work feels more natural.

Lange said she didn't *change* her approach to Blanche as much as honed her performance. "Because of the intimacy of doing it on film, I was able to do a lot more than I did on stage," she explained.

A SECOND CHANCE

Lange was pleased when Glenn Jordan, who had directed her in the Emmy-nominated *O, Pioneers!*, came on board to direct the film production, in part because "he understood the play very well. He had done it before on stage long ago." She was sorry that Amy Madigan didn't reprise her role of Stella for the television movie, but she was very pleased with Diane Lane, who replaced Madigan, and with John Goodman's performance as Mitch. Goodman, who had previously worked with the actress in 1988 in *Everybody's All-American*, was full of praise for Lange's performance in *Streetcar*. "She would do stuff and I would be in the middle of a take and I would just sort of drop my jaw and pop my eyes out—cartoon-style. She just amazed me." Diane Lane also recalled that "being off camera and watching Jessica and Alec—it was great. It was almost distracting. I would have to close my mouth and

remember I had a line coming." Lange also felt that performing again with Baldwin as Stanley "was perfect . . . we were both much easier with it. So we kind of enjoyed it. On stage, you have to sustain that energy for months and months—that horrible conflict and tension."

Jordan's production of *Streetcar* opens at dusk, with the sound of a soulful jazz trumpet hovering over the streets of the French Quarter. A neon sign for the "Four Deuces" bar penetrates the dusk and will be visible from Stanley and Stella's Elysian Fields apartment. We first see Stanley arrive with Mitch returning from a bowling game, in high spirits. The black-clad, Mexican woman selling flowers for the dead passes by, and Stella welcomes her husband with a huge embrace. Cut to Blanche finding her way through the colorful and confusing streets of the French Quarter, dressed impeccably in a fresh ensemble with a pale violet ruffle, complete with hat and gloves. Already she does not belong in the casual, sometimes raucous, blue-collar world of the Quarter.

When she arrives at Elysian Fields she meets Eunice, and we learn that Eunice and her husband own the entire duplex apartment house, living upstairs from Stanley and Stella. As soon as Blanche enters the two-room apartment, she quickly finds and sneaks a bracing drink of Stanley's liquor. As in all the incarnations of *Streetcar* before and since, her denying that she hardly drinks at all—"one's my limit!"—juxtaposed with her secret and avid drinks whenever possible, is a source of continuing humor—until it isn't.

Another source of humor: Blanche's snobbery, especially

in an impecunious woman now living at the mercy of her sister and brother-in-law. She loves to refer to Stanley as a "Polack," noting "that's like Irish, isn't it, only not as high-brow." Stella absorbs the insults directed at her husband.

Blanche quickly tells her sister the agony of losing Belle Reve, in a harrowing speech describing her ministering to a long line of dying relatives and the horrors of the sick room. She reproaches Stella for having escaped that fate in the ten years since Stella left for New Orleans. "Death is expensive, Miss Stella!" she tells her sister, and we'll learn just how emotionally expensive death is. Her unjust accusations against Stella make her sister cry.

Diane Lane is especially appealing as Stella. Like Ann-Margret and Beverly D'Angelo, her doe-like beauty makes her believable as Lange's sister. (Jack Nicholson once bizarrely described Lange's wide-eyed face as "a deer crossed with a Buick.") Lane's—Stella's—refreshingly down-to-earth manner is a good foil for the trembling hothouse flower that is Blanche. "I made my own way" in the world, Stella says in her own defense, the polar opposite of Blanche, who is constantly looking for rescuers, who needs the attention of others—mostly males—to help her get by. Stella also tells her sister, "I just got in the habit of being quiet around you," an evocation of what their childhood must have been like.

It's a telling scene that outlines the sisters' relationship, just as Blanche's first scene alone with Stanley is revealing, as she overtly flirts with her sister's handsome husband. "You men with your big clumsy fingers," she teases. "Can I

have a drag on your cig?" she asks, in an obvious ploy for his attention—she'll use the same gambit on Mitch when she meets him in a later scene. When Stanley accuses Blanche of lying about the fate of Belle Reve, she maddeningly replies, "A woman's charm is fifty percent illusion." Lange puts her nervous giggle to good use in this scene, and elsewhere.

When Stanley paws through the contents of Blanche's trunk, looking for a bill of sale for Belle Reve or evidence of fraud, Blanche becomes deadly serious, especially when her brother-in-law rifles through a pack of letters he's discovered in Blanche's trunk. Horrified, she snatches her precious letters from Stanley, claiming that his handling of them has defiled them. This is the first time we hear about the death of her husband, whom she describes as a "boy," and we learn that they are his love letters, containing poems written to her. Despite the disaster of that early marriage—which we will learn about in good time—she still treasures his letters and poems, vestiges of her youth, her idealism, her first love.

The poker game that takes place in Stanley's apartment shows off how rough and macho Stanley can be. He makes sure his poker buddies know that he's boss of his own household, though at first he's overwhelmed by Stella and Blanche in their finery—Blanche's jasmine perfume wafting in the air—as they prepare to leave for a night out, dinner at Galatoire's and a movie. When Stanley protests that *he's* not dining "at no Galatoire's," Stella informs him that she's left him a plate of cold cuts for his dinner. Stanley throws himself into the poker game, which will last long into the night, ending in

disaster. Mitch, one of his poker buddies whom we meet again in this scene, tells Blanche that "poker should not be played in a house with women."

A DATE WITH MITCH

In his otherwise laudatory review in the *New York Times*, John J. O'Connor dismissed John Goodman's Mitch as "a wonderfully lumpy Mama's boy." True, Mitch is somewhat feminized compared to his poker playing buddies as he lives with his mother, unmarried, devoted to nursing her through a fatal illness. But Goodman, who rather underplays the part and works against type by reining in his comedic chops, provides a winning level of authenticity. For one thing, his is the most authentic New Orleans accent we've heard so far in the role. No surprise—though born in Missouri (where Tennessee unhappily spent much of his teenage and college years), Goodman is no stranger to Louisiana and to New Orleans. When he filmed *Everybody's All-American* with Jessica Lange and Dennis Quaid, he met his wife, Annabeth Hartzog of Bogalusa, at the famed music venue Tipitina's in New Orleans. They've lived in the Garden District for some time (where *Suddenly Last Summer* was set). And he further embraced the city's zeitgeist when he played a Tulane English professor in *Treme*, the post-Katrina TV series about a handful of characters trying to put their lives back together after surviving that devastating hurricane.

The challenge for an actor playing Mitch is to make him seem plausible as a husband for Blanche. Her education, refinement, and upper-class birth make the pairing seem incongruous at first, and we know that she's desperately looking for a "cleft in the rock of the world" that she can hide in. But if Mitch is just a function for her—someone who can rescue her from her current plight—then that makes Mitch a dupe of Blanche's machinations. Is it possible for us to root for Blanche and still respect Mitch and care about what happens to him? And can we believe that these two lonely would-be lovers could actually connect in a meaningful way? Will Mitch live up to Blanche's assessment of him as somehow more refined, more sensitive—a cut above Stanley and the rest of his beer-swilling poker buddies?

With his boyish smile and eagerness to please, Goodman makes Mitch a likable suitor. More importantly, they first bond over lines from an Elizabeth Barrett Browning sonnet engraved in Mitch's cigarette case. Here is a man not unfamiliar with poetry. We know that a young woman he cared about died young, just as Blanche has tragically lost her first love. Both the lines of poetry and the sense of loss immediately draw them together. A large man—at the time Goodman weighed over three hundred pounds, at six foot three—his attempt to dance with Blanche can't help but be rather comic, yet his sheer delight in meeting her brings charm to the role.

Their date in scene 6 brings them closer together and reveals not just a likability in Mitch but the depth that allows him to truly understand and appreciate Blanche. Both are

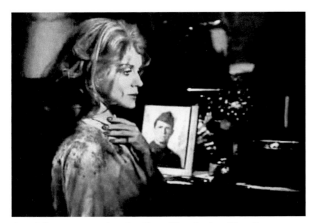

Ann-Margaret was deeply affected by playing Blanche, turning to a psychiatrist to help her through the final scenes of the play. *(Alamy)*

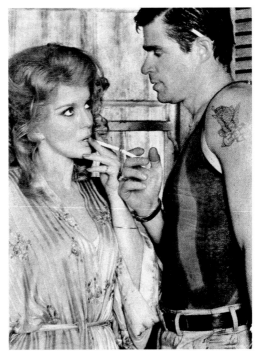

The Southern belle and the working man: Ann-Margret as Blanche, Treat Williams as Stanley. *(Alamy)*

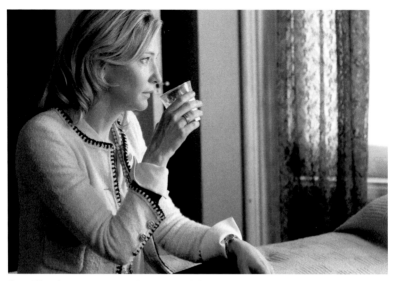

Cate Blanchett won an Academy Award for playing a character based on Blanche DuBois in Woody Allen's *Blue Jasmine.* *(Alamy)*

A true New Orleanian, Patricia Clarkson brought her Southern *joie de vivre* to the role. *(Photo by Joan Marcus, courtesy of the Kennedy Center Archives)*

Patricia Clarkson thought
Tennessee Williams would have
approved of her "because I was
funny . . . and he might have liked
that I looked good in my dresses."
*(Photo by Joan Marcus, courtesy of the
Kennedy Center Archives)*

Elizabeth Taylor as Cathy in *Suddenly Last Summer*,
threatened with a lobotomy to remove a dreadful
secret. *(Alamy)*

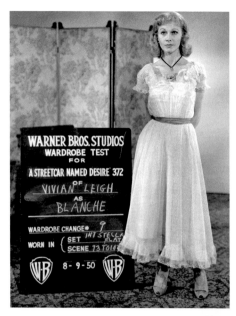

Elia Kazan replaced Jessica Tandy with Vivien Leigh in his 1951 film. Leigh in a wardrobe test for *Streetcar* (note her name is misspelled on the slate). Leigh would be long identified with—and haunted by—Blanche DuBois. *(Alamy)*

Cate Blanchett as Blanche with Robin McLeavy as Stella in the 2009 Sydney Theatre Company production of *Streetcar*, directed by Liv Ullmann. *(Getty Images)*

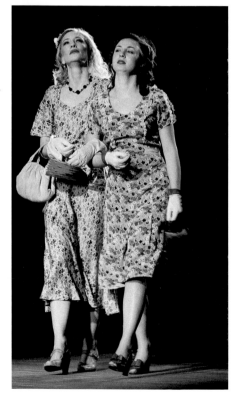

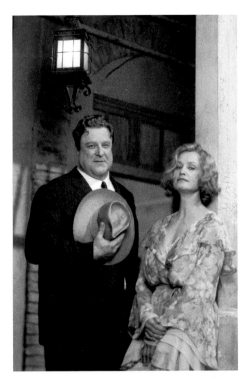

Jessica Lange as Blanche with John Goodman as her awkward suitor, Mitch, in the 1995 television adaptation for CBS Playhouse. *(Getty Images)*

Jemier Jenkins as an ethereal Blanche DuBois in the African American Shakespeare Company of San Francisco's 2018 production, directed by J. Peter Callender. *(Lance F. Huntley)*

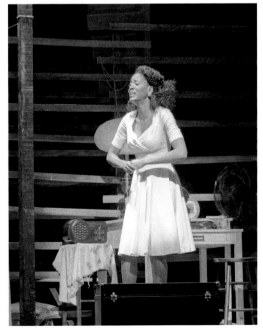

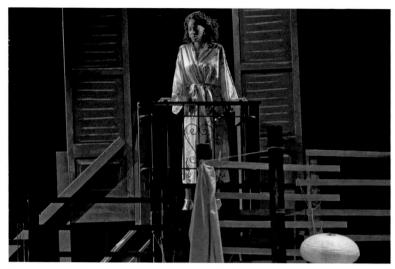

Jemier Jenkins. By the end of the play, when Stella refuses to believe her sister's tale of rape, Blanche loses her last remnant of safety. *(Lance F. Huntley)*

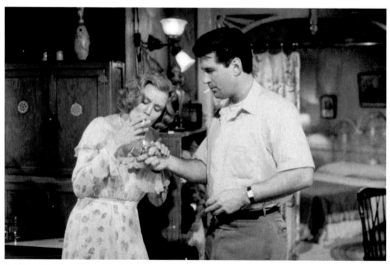

Critics felt that Alec Baldwin as Stanley outshone Jessica Lange as Blanche onstage in 1992, but in a 1995 television adaptation, Lange triumphed in a powerfully moving performance, directed by Glen Jordan. *(Photofest)*

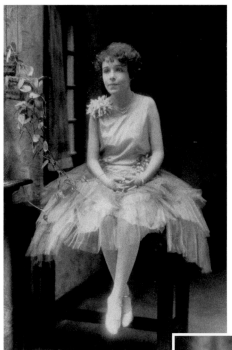

Tennessee's tragic sister, Rose, before her lobotomy. A pretty young girl, she cultivated her auburn hair. *(Harry Ransom Center, the University of Texas at Austin)*

Two icons: Marlon Brando in a game-changing performance as Stanley, Vivien Leigh as a funny, flirtatious, and ultimately tragic Blanche DuBois. *(Photofest)*

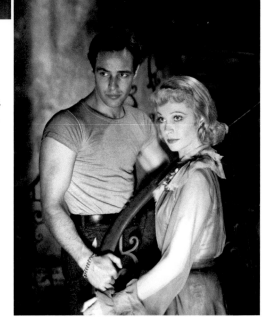

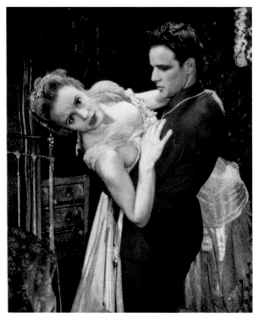

Brando and Jessica Tandy in the rape scene in *Streetcar*, which tips Blanche into madness, in Elia Kazan's Broadway premiere of the play in 1947. *(Photofest)*

Jessica Tandy first took on Williams's one-act play, *Portrait of a Madonna*, playing Miss Lucretia, a prototype for Blanche DuBois. *(Photofest)*

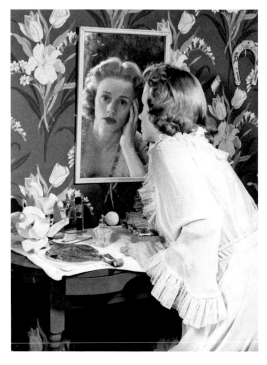

lonely. Both need someone, not just for expediency—Blanche to save her from penury and disgrace, Mitch to fulfill his mother's wish before she passes away. But their mutual loneliness makes it seem that yes, this could be possible. Love could flower. When he tells her, "I like you to be exactly the way that you are, because in all my—experience—I have never known anyone like you," that is a genuine declaration of love.

So when Mitch violently rejects her after hearing and finally believing Stanley's tales of Blanche's sexually rapacious past, Blanche cannot absorb that loss. That bitter disappointment, followed by Stanley's raping her, pushes her into the abyss, a state of mind that has awaited her since she first set foot in Elysian Fields.

THE MADNESS OF MISS DUBOIS

Frank Rich described Lange's stage portrayal of Blanche as a woman who had been roughed up by life but did not succumb to madness, but in Jordan's film, in a medium she fully inhabits, Lange's Blanche does indeed go mad, touched by the moon's lunacy. She had always shrunk from harsh daylight, and now moonlight becomes her. Here Jessica Lange is superb. Broken by Stanley, she appears as deluded as Miss Havisham in *Great Expectations* or Norma Desmond in *Sunset Boulevard*. Trapped in a fantasy of the past, Blanche dances alone to a melody only she can hear, dressed in the tattered finery of an old Mardi Gras gown. She has disappeared into

her memories; the past has claimed her and left her isolated, completely alone. Lange described Blanche at the end of the play:

> When you get down to the core of her being, her essence, what the Actors Studio used to call the "spine" of the character, it is this horrible aloneness. . . . This devastating, terrible aloneness that she suffers. That thing about her being haunted by these deaths. She says the Grim Reaper set up his tent at our doorstep. She talks about the opposite of death being desire. You just read it and you think, "God". . . . Williams must have just been touched by the gods when he wrote that piece.

Jordan, who rehearsed his cast for three weeks before filming, was somewhat in awe over Lange's performance. He commented,

> Isn't she extraordinary? It was wonderful because we seemed to be on the exact same wavelength of the character. . . . Whatever emotion or whatever small nuance you want, she is like a supermarket. Her shelves are stocked full and it's all accessible to her. Jessica, at the moment, is absolutely at the top of her form as an actress.

Writing in *Variety*, critic Jeremy Gerard praised Lange's Blanche: "Lange gives this wounded creature an inner glow of resiliency; without it, Blanche could never lay such a powerful claim to our sympathies. Vivien Leigh captured that

otherworldliness in the film; Lange is every bit her equal here." And in a vindication of her less-than-stellar stage performance, Gerard continues, "It's doubtful whether any but hardcore theater buffs will stay on this 'Streetcar' for the entire three-hour ride. Those who do however, will see Lange . . . giving one of the best performances of her career."

That performance—though infinitely less harrowing than repeating it onstage night after night—was still tremendously challenging for Lange, as it was for all the actresses who came before and after her in the role. She later testified how Blanche "gets under your skin. . . . She is so haunting in a way that it physically takes its toll on you." When asked if, and why, *Streetcar* still holds up after forty-eight years, she answered that it's because it "has so much texture, so many layers."

"It's the kind of thing you can never, as an actor or even as a viewer, completely exhaust. The fact is that any piece of literature should hold up through the ages because human conditions never change . . . what he's talking about is exactly what we are dealing with now. This fear of death and this thing of aloneness and this desperation to belong somewhere and to someone. To be connected. To be safe. That *never* changes."

SEVEN-CARD STUD

Elia Kazan once asked if we were living in the Age of Blanche or the Age of Stanley. Williams himself would have believed

the latter, while pining for the poetry of Blanche's era. Although the play ends with Blanche's plaintive cry, "Whoever you are—I have always depended on the kindness of strangers," followed by Stella's anguished "Blanche! Blanche! Blanche!" and Stanley's attempt to both comfort his wife and make love to her, the last line of the play is given to Stanley's poker buddy Steve. He is overheard to say, "This game is seven-card stud," as the poker game resumes. End of play. Curtain.

Is this to say that the modern man, depicted here as brutalizing and impervious to poetry, will win out in the end? After all, an early draft of *Streetcar* was titled *The Poker Night*, worked on while on a welcome vacation in Key West with the playwright's beloved grandfather, Rev. Dakin. In this version, Stanley is an even rougher character named Ralph, but Blanche and Stella appear mostly as they do in *Streetcar*. Blanche is suffering not just from the loss of her ancestral home but the loss of her husband, who "loved me with everything but one part of his body." Kazan described Stella in his director's notebook as a "housewife" in a "narcotized sleep," a captive of Ralph/Stanley, "glazed" and "always day dreaming." The earlier play is set in a generic, inhumane cityscape—not yet New Orleans, not yet Elysian Fields—and as biographer John Lahr notes, Ralph is described as "a mutant breed, a person who had successfully adapted to this vacant barbarous habitat . . . in other words, a primitive."

Ever since Brando first put his stamp on Stanley, however, that "primitive" has deepened into a more complex character

capable of at least some of the audience's sympathy (and in the 1940s and '50s, a preponderance of the audience's sympathy). So, too, does Alec Baldwin turn Stanley into a more sympathetic character, at least until the final rape scene. Under Jordan's direction, Stanley has more of a discernable arc, willing to put up with his batty sister-in-law until he overhears Blanche's speech describing him as an ape. From that moment on, the two are at war over the possession of Stella's loyalty and love. We also see him weeping and begging Stella's forgiveness after he's struck her in a drunken frenzy, egged on by his fury toward Blanche. We know that's a pattern of abuse—violence followed by tearful contrition and vows of love—yet we are still moved by the sight of so proud and virile a man weeping in the arms of his beloved.

In this war of the sexes, *Streetcar* ends with the triumph of men. The widespread ages-old belief among men that marriageable women should be "pure" has ended Mitch's engagement to Blanche, once Stanley has blackened his sister-in-law's reputation. (As late as the 1970s, the term "B-girl" was used to depict a sexually active woman one had fun with but would never dream of marrying.) Additionally, this is a world in which women are not to trust other women when their men are at stake. Stella is left having to suppress Blanche's story of rape in order to stay married, especially now that she has an infant to care for.

At the end of the play, the poker game continues. Stanley and his world have triumphed over the hyperfeminine, ethereal world of Blanche DuBois.

A MARTINI AT A SODA FOUNTAIN: PATRICIA CLARKSON

2004

It destroys your life when you play that part, you never really recover from it, and everybody who's ever done it knows. It's the Blanche language that you speak.

—Patricia Clarkson

Patricia Clarkson played Blanche DuBois in a production titled *A Streetcar Named Desire in Two Acts* at the Kennedy Center's Tennessee Williams Explored Summer Festival in 2004, opposite Adam Rothenberg as Stanley and Amy Ryan as Stella. The play was helmed by the Irish director Garry Hynes, one of the handful of women directors who have taken on the challenges of Williams's iconic play. Her previous success directing Martin McDonagh's comedic drama *The Beauty Queen of Leenane* won her a Tony Award in 1996.

Tall, blond, elegantly fine-boned with a porcelain complexion and a husky, honey-soaked drawl, Patricia—Patti—Clarkson is an actress you'll never forget once you've seen her. Her thirty-year career has brought her Oscar and Golden Globe nominations and several Emmys, most lately for her turn as the treacherous Southern matriarch Adora Crellin in HBO's episodic series *Sharp Objects*, adapted in 2018 from Gillian Flynn's novel. The role earned Clarkson Golden Globes, SAG, and Critics Choice awards. As one reviewer noted, "She's brought unconventionality to the mainstream," beginning with her breakout role in 1998 as Greta, a heroin-addicted German lesbian in *High Art*, written and directed by Lisa Cholodenko.

Clarkson is a prolific stage, TV, and film actress, having appeared in—among other films—*All the King's Men*, *Far from Heaven*, *The Green Mile*, *Shutter Island*, *Vicky Cristina Barcelona*, *Lars and the Real Girl*, and *Pieces of April*, for which

she won an Emmy Award. She won two Primetime Emmy Awards for her recurring character on *Six Feet Under*, and was nominated for a Tony Award for the 2014 Broadway production of *The Elephant Man*, opposite Bradley Cooper.

A native of the Algiers section of New Orleans, Patti (as she is known to her friends) is one of a handful of Southern actresses, alongside Tallulah Bankhead, Carrie Nye, and Faye Dunaway, who brought to the role of Blanche her own experience of what it meant to be a Southern woman.

"I didn't grow up in a white-column house with a big verandah in New Orleans," she says, "but in the suburbs with my mother and father and four sisters. Yes, and a Toyota in the driveway and a Maverick." In fact, she admitted that she "didn't immediately respond to Tennessee Williams. I found him not quite true to my life, to my environment. I grew up very middle class, very suburban. I went to a big public high school. [Williams] felt like the world as other people viewed us—not how we lived."

Nonetheless, there is a quintessential New Orleans quality about Patricia Clarkson. It has to do with her joie de vivre, her love of her family and her ancestors, her outspoken, often lyrical conversation. "Have you ever had bourbon, ginger, and orange?" she asks. "It's my favorite drink, and [I love] drinking it out of my grandmother's highball glasses. We drank the same thing. She kept her bourbon and her white wine in the fridge. Those were her staples—and somewhat mine!"

Though Williams's plays did not reflect Clarkson's and her family's milieu, she says, "I understood the beauty of him,

and I understood the *emotional* life of his characters more than I understood their life." Before taking on the role of Blanche in 2004, she had never acted in any of his plays. She was in her early forties when she first read the character of Blanche in *Streetcar*, in an early edition of the play with a shirtless Marlon Brando on the cover.

She recalls that she'd lived through

many, many things at this point and I started looking at the play—just page one—and I realized, I've made the same mistake that everybody else has in that I've thought of [the play] as poetic realism, but forget the hardcore reality that sometimes gets sifted out. And I think it's a grave disservice to Williams because this was a man who lived hard and loved hard and suffered incredible heartbreak and tragedy in his life. But he also had tremendous humor.

THE CITY OF NEW ORLEANS

Because a beloved and colorful grandmother had lived an uptown life in New Orleans, Clarkson had a connection to that world. What she found joyous in *Streetcar* is how

the whole city becomes part of her. Here I am, a real true New Orleanian, and I'm in "my city," letting it infiltrate me and take hold of my performance. And so Garry [Hynes] had the brass bands playing, because they really are in the French Quarter

where there's music twenty-four seven—there truly is! That's not some cliché, and it's great music. There's no bad food, no bad music ever in the history of New Orleans. It's all kind of summoning you. I think it lifts Blanche, the vibrance of this city. She loves suddenly having this life around her. She's able to let go of Belle Reve, and she's suddenly thrust into this kind of dream. It's going to save her.

That vibrancy, Patti believes, propels her through the play. She can hang on, she "can shift this. I mean, [she's] living in this place that is well beneath her, but Blanche was already in a bad place to begin with. So how bad is it? The city starts to come into this play, and suddenly even the supporting characters are vibrant and essential."

BLANCHE DUBOIS, ENGLISH TEACHER

Ben Brantley described Clarkson's portrayal of Blanche as "wry, dry and ruefully self-aware . . . like crisp martinis in a soda fountain." She brought a sardonic intelligence to the role, he wrote, though "wryness and dryness are not commonly associated with beauty-seeking, desperate Miss DuBois . . . her Blanche is unlike any you've seen before."

For one thing, Clarkson saw Blanche as an "exceptionally bright woman" who was probably "a very good teacher. Especially in that day and age, she was highly educated, highly

well read. She was just magnificent—this beauty in a small town who was smarter than anybody. I think she used it to her advantage, but not in a mean way. She lived well until everything just turned for the worse." Though we only have reviews, a half-hour radio performance, and a brief, televised reenactment of her scene with Hume Cronyn as Mitch, it seems we can compare Clarkson's depiction to Tandy's: Blanche as a smart, comparatively well-educated high school teacher who has fallen on very hard times.

Indeed, Clarkson played Blanche as someone who knew what she was doing when she started to "sleep with everybody. I think of her as part hooker and part schoolteacher—I think they go hand in hand! She's not this crystal pure person by any stretch of the imagination, so I didn't play her like a frail moth. Her past becomes her present, and she brings all of that with her to New Orleans." The critic Charles Isherwood wrote in *Variety* that Clarkson brought a "knowing, flinty quality to her performance. . . . Until the last stages of her dissolution, you get the feeling that, for all her protestations of helplessness, Blanche has a few unused tricks up her sleeve."

STELLA FOR STARLIGHT!

Clarkson notes that when Williams first wrote *Streetcar,* he described it as a drama about two sisters. And then Stanley made it into a trio, and Mitch made it into a quartet. "I really

believe when it is properly done, it *is* a quartet. Everybody has an equal place in this play. Garry started to break down the walls that we tend to build with Williams—*Streetcar* often feels claustrophobic to me when I watch it—and I think that's antithetical to Williams."

With everything else gone, Blanche has come to New Orleans to be with her much-loved sister, Stella, played "immensely touchingly" by Amy Ryan, in Isherwood's assessment. As we know, Blanche had first lost her sister when Stella left home to make her own way in the world. Blanche then loses her mother and whatever family and family retainers are left, through illness and the long parade to the graveyard. She loses the only home she has even known—slowly, acre by acre, first through her ancestors' debaucheries and debts, and then through the taking out of mortgages that could never be repaid.

Blanche's sisterly love, perhaps typically, is laced with teasing criticism, when she notes that Stella has put on weight (not yet knowing that she's pregnant)—criticism that becomes more pointed and resentful when she accuses Stella of having abandoned Blanche to face alone the horrors of the sick room. After first meeting Stanley and registering his animal appeal ("My sister has married a *man*"), she quickly dismisses him as below the DuBoises socially, culturally, and intellectually. She accuses Stella of a lapse in taste and judgment, until her sister has to forcefully remind her that she's not in anything she wants to get out of.

The battle with Stanley over Stella's love begins early

on, reaching a point of no return when Blanche warns Stella not to "hang back with the brutes!" Throughout it all, Stella walks a fine line between defending her sister and placating Stanley, putting up with Blanche's hours spent soaking in hot, perfumed baths in the apartment's only bathroom and her goading of Stanley to his face, while wickedly criticizing him behind his back. Blanche even hatches a plan to get Stella to leave her husband. As mentioned earlier, five months *is* a long stay to endure from an interfering relative in a cramped, two-room apartment. Somehow Stella manages the fraught trio, though it takes a brutal toll on her emotionally, as she tries to protect her sister from Stanley and tries to keep Stanley from throttling Blanche. We can see when he strikes her in anger what he's capable of. Isherwood, again, notes that "Stella's last cries of remorse"—once she fully realizes that she's allowed Stanley to commit Blanche to an insane asylum—"are as painful to hear as any of Blanche's anguished arias."

BLANCHE'S DRESSES

Throughout Blanche's unraveling, "she's still got her fineries," Clarkson observes. They may have seen better days, but "she never gave up her beautiful clothes and her beautiful shoes."

"Clothes are my passion," Blanche tells Stanley early on, and she needs those costumes to help her weave her spells of magic. "They're everything to her, and she looks good in them! I had the most gorgeous clothes ever in the world,"

Clarkson says about the skill and artistry of the play's award-winning costumer, Jane Greenwood.

> *[She] cut them to me to perfection. We decided that [Blanche] had not lost her figure. Nothing had faded. And the one thing she could do was still just put a dress on and knock somebody out. The few times in my life that I, as a woman, have knocked men's socks off coming down a staircase or entering a room in a fabulous dress—I know what that feeling is. That's what I think Blanche still could do.*

As a Southern woman who grew up in a matriarchy of sisters born to a powerful, charismatic mother (Jacqueline "Miss Jackie" Brechtel Clarkson, a former city councilwoman and much-admired figure in New Orleans), Clarkson felt that Blanche's anxiety about her appearance was neither neurotic nor frivolous. It was more a recognition of how her beauty and her bearing had often protected her from the slings and arrows of the world, and to see them begin to fade made her suddenly vulnerable. Her impeccable clothing—though now a bit worn—shored up her class status as one of the few things she had left to cling to. Her old Mardi Gras gowns, and the personal beauty for which she was long praised, were not only part of her identity but her way of being in the world in order to attract the men who might help and protect her. When Blanche says don't look at me until I can have a bath and freshen up, she's really saying, you never show up unless you look your best, the vestiges of her upper-class upbringing.

"When you grow up in the South," Clarkson explains, "you never show up [without looking your best].

> It's not about makeup and hair. It's about always want[ing] to present the best face, the best part of you. She's coming in and she hasn't seen her sister; she knows she's going to be meeting people she does not know. She's been traveling so her hair probably does not look the best. Maybe she tried to iron her clothes herself because there's nobody there to help her. . . . It's not something frivolous. It's something that is ingrained and hard core inside of a Southern woman. And it's just something you're born with and you struggle with it every goddamn day of your life. My mother would go out naked before she'd go out without lipstick.

Part of the sly humor of *Streetcar* is Blanche's fish-out-of-water role as a frilly, fastidious, cultured woman swanning her way through Stanley's rough, working-class world—one that can only see her as an exotic flower or a pretentious phony. When she passes through the men playing poker on her way to dinner with Stella and says grandly, "Don't get up, gentlemen, I'm only passing through," the line is hilarious in its context. First of all, these sweat-stained men are not "gentlemen." Second, they have no intention of rising from their seats for a lady. They are not trained in the class niceties of proper parlor behavior. And it works both ways—if Blanche is the butt of the joke in this scene, Stanley is seen as completely clueless when he rummages through Blanche's things,

mistaking one of her costumes for "a solid gold dress, I believe!" and her paste jewelry for a deep-sea diver's treasure.

Yet the very same line that makes us smile at Blanche's expectations early on—"Don't get up, gentlemen . . ."—resonates with a darker meaning at the close of the play, when she is being escorted out on the arm of a psychiatrist whom she thinks is her gentleman caller. "I'm only passing through," she says, and this time we know that her hopes and dreams have been ephemera all along, and that her life has had neither substance nor staying power.

A DATE WITH MITCH

"The whole scene with Mitch is so funny!" Clarkson says. "Talk about lowbrow, but he's a big, strong, capable man who could save her, and she's going to follow that wherever it leads her. She's in survival mode."

Scene 6 is the longest in the play, underscoring the idea that *Streetcar* is essentially a quartet with all the characters carrying their weight, as Clarkson suggests. Blanche's date with Mitch runs the course from humor at the incongruously mismatched pair, to Blanche's fullest retelling of Allan's suicide and how it haunts her, to the revelation of mutual need and the closest thing Blanche will hear as a declaration of the love she hungers for.

Clarkson observes, "She's got very, very little left in the

tank, so when Mitch comes along, she plays it beautifully. And what's so funny is their incredibly juvenile conversation."

First, the humor. We see them at 2:00 a.m., dragging their way home after going to the amusement park at Lake Pontchartrain. Mitch is carrying a plaster statuette of Mae West, which can be seen as a downscale, carny version of Aphrodite. Blanche teases him throughout the dregs of the evening, acting a bit coy, insisting she has to be careful of her reputation while inviting him in French, *"Voulez-vous coucher avec moi ce soir?"*—because she knows he doesn't speak French. And then, when Blanche suggests he remove his jacket on such a warm night, he demurs, saying that he sweats too much. What follows is a conversation about Mitch's girth ("You are not the delicate type. You have a massive bone-structure and a very imposing physique," she flatters). He explains that the gift of a gym membership has transformed his life, and he invites her to punch him in the stomach to see how tough he is. She does so! He then brags, "I weigh two hundred and seven pounds and I'm six feet one and one half inches tall in my bare feet—without shoes on. And that is what I weigh stripped."

As Clarkson observes, "She'd rather be discussing philosophy or having some beautiful conversation about a great poet, you know? Instead, she's complimenting Mitch on being a big man with big bone structure and allowing him to lift her to guess her weight.

"She knows how to play it perfectly. That's the beauty of her—she can adapt to whatever she needs to be. Her fierce intelligence leads her to be a chameleon, and she is capable of

becoming whatever she needs to be in that moment because she's outthought everybody."

But there are lyrical moments, too, as when Blanche looks up and sees the Pleiades—the Seven Sisters. Later in the scene, Mitch confesses that his ailing mother wants him to settle down before she passes away, in a hoarse voice that conveys his sorrow at the thought of losing her. They both speak of loneliness.

> Blanche: You will be lonely when she passes on, won't you? I understand what that is.
>
> Mitch: To be lonely?
>
> Blanche: I loved someone, too, and the person I loved I lost. . . . He was a boy, just a boy, when I was a very young girl.

Blanche becomes lost in the memory of Allan Grey's suicide, after she had found him in the arms of an older man, after they had danced the Varsouviana at Moon Lake Casino, after he had "stuck the revolver into his mouth, and fired—so that the back of his head had been—blown away!"

It's the fullest recounting of that dreadful night, of that secret that has haunted Blanche all along. But it draws Mitch closer to her. We know they are a mismatched pair. We know that he's not her equal socially and intellectually, but we sense that he is a solid, decent man, capable of love. For the first time, we understand that Blanche's relationship with Mitch is not merely transactional, but may actually offer the saving grace she longs for.

IS BLANCHE A WHORE?

We end scene 6 on a hopeful note, that Blanche will find a home of her own at last, loved and protected by Mitch. And then Stanley changes all that with his revelation of how Blanche spent her time in Laurel after losing Belle Reve—presumably turning tricks at the notorious Flamingo Hotel. He informs Mitch, who at first refuses to believe him. But once Mitch accepts Stanley's accusations, he rejects Blanche, standing her up at her birthday party, only to brutally confront her later on, in scene 9, accusing her of not being "clean enough to bring in the house with my mother." He then attempts to crudely claim the physical love she has denied him all summer, and she runs screaming into the street to escape him.

Thus Blanche's dream of a possible love evaporates. As Clarkson notes,

> She's already fragile because of Mitch falling apart on her, and being accused of probably the worst thing she could ever be accused of—being a whore. She knows she's slept around. She knows what she did. But she knows exactly the hypocrisy involved, that nobody is living this pure life in New Orleans, right off Bourbon Street. Are you kidding? With naked ladies swinging in windows and a hooker on every corner?

But there's a moment in her confrontational scene with Mitch when she taunts him with the line "Flamingo? No! Ta-

rantula was the name of it! I stayed at a hotel called the Ta-rantula Arms! . . . Yes, a big spider! That's where I brought my victims. Yes, I had many intimacies with strangers."

In that moment she heaps scorn on men's puritanical fear of the all-engulfing power of female desire. It's a triumphant side we have not yet seen of Blanche—she takes hold of her past and refuses to be shamed for it. Clarkson sees that moment as a sign of her essential sanity. She could never be as quick witted and swift of feet had she been "purely crazy."

But something does break her.

Stanley, of course, takes advantage of her confused, vulnerable state, and in the following scene, rapes her.

Clarkson thinks that Blanche never expected that from Stanley, because she believed that though he's "common," he would never betray Stella.

That's why she felt she can flirt with him all she wants. She's good at that. But suddenly the line gets crossed, unexpectedly. That's what destroys her. Someone finally takes her down, and it leaves her in this almost semi-conscious state where she just, I think, goes to the other side. She succumbs to just the despair and the hollowness and the emptiness in her life.

She has misjudged Stanley, and that is a tragic mistake. "She thought she could flirt her way to the finish line with him, but she got caught. You know, he does rape her at the end. People wondered, is she raped? Yes. And that rape breaks the camel's back."

THE YOUNG, YOUNG, YOUNG MAN

It may be the most controversial scene in the play, especially to contemporary audiences in the #MeToo era. In scene 5, Blanche is taken with a very young man who has come by to collect for the *Evening Star* newspaper.

Stella and Stanley, along with Eunice and her husband, Steve, have left Blanche alone for the afternoon, and she sinks into her chair with a drink in her hand. Williams writes, "Dusk settles deeper. The music from the Four Deuces is slow and blue." She drowses rather contentedly in her chair while "a little glimmer of lightning" is seen through her window. Suddenly, the young man rings the doorbell and she's awakened from her reverie. Seeing so attractive a youth, Blanche flirtatiously asks, "Well, well! What can I do for *you*?"

"I'm collecting for *The Evening Star*," he says.

"I didn't know that stars took up collections," Blanche replies. She explains she's not the lady of the house and continues to flirt with him, offering him a drink that he refuses and asking him to light her cigarette. To keep him there, she asks the time and then launches into a reverie:

"So late? Don't you just love these long rainy afternoons in New Orleans when an hour isn't just an hour—but a little piece of eternity dropped into your hands—and who knows what to do with it?"

Blanche teases him about his stopping into a soda fountain to have a cherry soda, saying, "You make my mouth water,"

touching his cheek lightly. Against the backdrop of a blues piano heard in the distance, she says, "Young man! Young, young, young man! Has anyone ever told you that you look like a young Prince out of the Arabian Nights?" and then she crosses and quickly kisses him on the mouth. She sends him away with, "It would be nice to keep you, but I've got to be good—and keep my hands off children."

It is a shocking, unexpected scene. Is he a "young man" or a child? Is Blanche again reliving her early love for Allan Grey? Or is she the seductress that Stanley makes her out to be at the end of the play? The entire scene—with the dim flashes of lightning, the muffled sound of a piano playing blues, the afternoon light, the rousing from a half sleep—has an unreal quality, as if it's something that Blanche has merely dreamed. But is it a dream that fantasizes or a dream that reveals?

"The moment can be either poignant or prurient," wrote Isherwood in his review, "an illustration of Blanche's innocence or her corruption (ideally, of course, it should partake of both)." In Isherwood's reaction, the scene as played by Clarkson tilts the play into a "seamy drama about the stripping away of a hypocrite's pretensions more than a tragedy of sensitivity despoiled." But that's not how Clarkson interprets it, or intended to play it.

She describes it as "actually a beautiful scene. I think it's about a moment of a woman [remembering] the young man she loved—and there he is, almost in front of her, for a moment." When Blanche says, "you young, young, *young* man,"

Clarkson says, "she's not being lascivious. She's just encountering a very handsome, lovely young man" who stirs up her love for her lost husband, whom she has earlier described "as a boy, just a boy."

She is flirty and sweet, and I don't think it's creepy. I think it's beautiful, an absolutely beautiful little pocket of a scene—one of the best little pocket scenes ever written. It's perfection. It depends on how you say the three "youngs."

It's hard to know if Tennessee Williams is playing with us in this strange little scene that can make us doubt Blanche's hold on reality, or her essential morality. Are her poetic evocations of poetry and kindness and propriety merely the hypocritical protestations of a sensualist, a transgressor? Or is she completely caught up in a dreamlike memory of her youthful husband, who loved her all too briefly? In this scene, time seems to have evaporated, and the feeling of eternity she speaks of has suddenly engulfed the room. In any case, not knowing just how we should judge Blanche makes her even more enigmatic—unforgettable.

We are still trying to solve the mystery of Blanche.

THE RESIDUE

"People have to remember that Blanche is [both] ferocious and extremely fragile. It destroys your life when you play that

part, you never really recover from it, and everybody who's ever done it knows. It's the Blanche language that you speak," Clarkson says, almost two decades after playing Blanche at the Kennedy Center.

To do eight shows a week—it will kill you. I lost ten pounds doing Blanche, and I never recovered. You just never recover from playing this character. It's so many shows a week living through her abject despair (though I do believe in the end she comes through all of this). You see the trauma and the true despair she lives with. And that brilliant, brilliant moment, which I never understood until I actually started to do Blanche, [when she says] "Sometimes—there's God—so quickly!" I went to the darkest place I've probably ever been as an actor.

Even talking about it is hard. It makes me very, very, very sad because it's a place that we'd never want to go, but sometimes we're required to, in order to fulfill the brilliance of great writing, and truth.

She credits Noah Emmerich, who played Mitch, with pulling her through each performance. "You have to have a great mentor," she says, "and if you don't have an [actor] who is with you at every step of that, you're absolutely screwed. And he was—a beautiful actor, just this big sweet man.

"After the rape, she's kind of lost in abjectness; she's in the lowest, most vulnerable place she ever thought she would find herself in. She can't handle it on any level. She doesn't have the tools. She has nothing." She easily slips into the fantasy

that's handed to her—that a gentleman caller is escorting her to a better place. "I think it's the truest thing she ever says in the play, 'I've always depended on the kindness of strangers.' It's an absolute moment of pure clarity that comes back to her." It's also the prayer of protection made, or thought, or spoken by all wild girls, promiscuous girls, fallen girls, abused girls—and women.

"I think it's a moment she comes back to herself," says Clarkson. "She can survive if she can get into a place where someone could really help her. I don't think all was lost. I mean, she's an exquisite human being, and they don't always go gently into that good night. I've never underestimated the power of Blanche."

THE TWO BLANCHES: CATE BLANCHETT

2009, 2013

[T]hat flame of inspiration that Blanche represents—that fragile, ephemeral poetry—is extinguished.

—Cate Blanchett

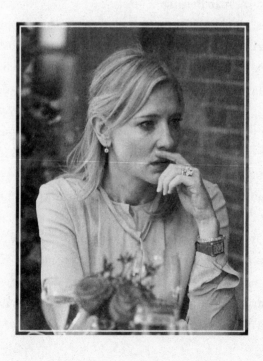

In November 2009, the Oscar-winning Australian actress Cate Blanchett undertook the role of Blanche in a notable, much-praised Sydney Theatre Company production. After debuting in Sydney, the play made its way from Australia to London, then on to the Kennedy Center in Washington, DC, and the Brooklyn Academy of Music in New York City, as a cultural exchange. It was one of the few productions of *Streetcar* directed by a woman—Liv Ullmann, the iconic actress best known for her work with the brooding, brilliant Swedish director Ingmar Bergman.

The idea for the production first came about when Blanchett and Ullmann were dining with their husbands in London. A planned film of Ibsen's *A Doll's House* had fallen through, but the two actresses were still interested in collaborating on a project. Someone suggested *Streetcar*, and Ullmann recalled how her "heart jumped in happiness . . . because if there's a perfect Blanche that I would know of, it would be her."

In an in-depth interview alongside Liv Ullmann on *The Charlie Rose Show*, Blanchett described *Streetcar* as "a gift of a play," and she felt that taking on the role of Blanche DuBois was inevitable—a project that somehow chose *her*. Indeed, she would end up playing the role twice—once in *Streetcar*, and a second time as a character based on Blanche DuBois in Woody Allen's 2013 masterpiece *Blue Jasmine*.

What's in a name, except in the odd similarity between "Blanchett" and "Blanche"? Perhaps that's one reason why the actress, on a subconscious level, felt destined to play her. "Blanchett, Blanche—the names seem fated for each other," Manohla Dargis wrote in a *New York Times* review of *Blue Jasmine.*

Blanchett was already drawn to Tennessee Williams because he had been influenced by Henrik Ibsen and Anton Chekhov, two towering playwrights she admired. Blanchett felt that the challenge would be to find a balance between a tendency to make the play "very camp or very melodramatic."

"Washington was our first port of call" as a kind of diplomatic exchange between America and the Sydney Theatre Company, Blanchett explained. It was the first time she had spent any significant time in DC, which she found invigorating, as so many cultural reference points suddenly came alive for her.

Reviews for the Kennedy Center production were mostly howls of praise. Adam Green wrote in *Vogue* that Blanchett "gives a performance as heartbreaking to endure as it is magnificent to behold. . . . I have seen several fine stage actresses try, and fail, to pin down this maddeningly essence of a moth-like creature . . . as it turns out, it took an Aussie to recapture the mercurial essence of a great American character." He's won over from the first glimpse of Blanche sitting on her trunk, dressed in finery, hoping to find her way to Elysian Fields.

She wears the "haunted look of a woman who knows that she has reached the end of the line."

Green also praises the Australian actor Joel Edgerton, who played Stanley as a boy-man yet a dangerous opponent, and Robin McLeavy's Stella, who "exudes guileless carnal longing for her husband." In this production, the conflict between the nostalgic gentility of the Old South and the new, post–World War II mentality is made clear. Green also singles out Tim Richards as the hapless, would-be suitor, Mitch, and attributes their success, in part, to Liv Ullmann's direction.

DC Theatre Scene, however, faulted the Australian production, directed by a Norwegian, for not capturing the essential Deep South milieu of the play. "It is as though a gifted artist had painted a landscape which had been described . . . over the telephone," wrote the critic, Tim Treanor. "It has all the required elements, but not the patina of authenticity."

Ullmann, however, had done her research, taking classes to learn about American blues and the culture of America's South in the mid-twentieth century. Ullmann told Rose that she felt her discoveries might have eluded an American director "because they wouldn't know that they didn't know. I knew." She also felt that coming from Norway with an Australian production, "we see things that are very interesting to us because it seems different. . . . I really think it's good for a play, like it's good for Henrik Ibsen, that foreigners do it. They put humor in where Norwegians don't really see the

humor. And then we can put humor into this where maybe Americans don't see that humor, because it's new for us."

She may have gotten the music right and the sprinkling of humor, but the visuals, by several accounts, did not evoke Elysian Fields, New Orleans, circa 1947. Rather, Ullmann explained, she looked to her favorite painter, Edward Hopper, to inform how the audience would see the play and the characters. Hopper's stark, brooding work does convey a searing loneliness, but not the humid airs of New Orleans, or the hothouse orchid that Blanche has become, making her last stand in a florid and filigreed city on the Gulf of Mexico.

Nor did Cate Blanchett's Southern accent ring true as either a New Orleans or—more accurately—a Mississippi accent, according to one of a handful of Southern actresses who had earlier taken on the role. Many actors rely on a generic Southern drawl without making distinctions between regions—folks from North Carolina, for example, sound distinctly different from folks from New Orleans (whose accent, incidentally, can sound more like a Bronx accent).

Ullmann made two interesting changes in the ending of the play. The psychiatric doctor who comes to claim Blanche for the mental institution that Stanley has arranged for her is a grim, no-nonsense figure rather than the courtly Southern gentlemen of earlier productions. And we don't see Blanche dressed in dilapidated finery as she's led away on his arm as if being escorted to a cotillion ball. Rather, she is barefooted, dressed in her white slip, her scrubbed face a hollow mask of what once was.

For Blanchett's Blanche DuBois, Treanor also has nothing but praise, calling her performance "magnificent" and "spot-on." The critic (also a novelist) notes how she "carried the whiff of doom from the play's very first moment, when she realizes that Stella's financial and social circumstances were not nearly as high as Blanche had come to believe. She knows, at that moment, as we do not until later on, that she is shipwrecked before she sets sail."

Treanor also notices the oddness of Blanche being allowed to wander into the street at the end of the play, dressed only in a slip and a shawl, and he sees that as proof of her madness. "Where I come from," he writes, "walking around the streets of New Orleans in your underwear is evidence that you are pretty disturbed."

BLANCHE AS QUEER ARTIST

The production then moved to the Harvey Theater at New York's Brooklyn Academy of Music for a sold-out, three-week run where it continued to garner raves, mostly for Blanchett's performance. As noted earlier, in *The New York Times* Ben Brantley wrote, "The genteel belle, the imperious English teacher, the hungry sensualist, the manipulative flirt: no matter which of these aspects is in ascendancy, Ms. Blanchett keeps them all before us." But rather than the "lyric, fading butterfly waiting for the net to descend" of many past portrayals, Blanchett brings to the role a tough instinct for survival,

as did Ann-Margret decades earlier. "There's a see-sawing between strength and fragility in Blanche, and too often those who play her fall irrevocably onto one side or another."

Reviewing the play for *The New York Review of Books*, the critic Hilton Als saw in this Blanche something new, describing her as a "queer artist," a version of the eternal outsider who nonetheless knows her strengths and the source of her endurance. Her longing for a respectable marriage—even to the unlikely Mitch—is really a longing for survival, a bid to finally stop struggling and find rest. Penury and loss have exhausted her. She has lost everything but her last scraps of youth and beauty and the moral support of her sister, though she is in danger of losing all of those, as she well knows. Als writes,

> Part of Blanche's tragedy is that even though she tries on conventionality when she takes up with Mitch, it doesn't fit: her intelligence and status as a defiant outsider keep getting in the way. . . . Williams lets us in on Blanche's difference by degrees, and by having her speak a recognizably gay language. Queer talk from a queer artist about a queer woman. Blanche to Stella: "I don't know how much longer I can turn the trick. It isn't enough to be soft."

Her love of beauty, poetry, and finery (including her worn-out Mardi Gras gowns) are genuine, but they set her apart in the claustrophobic world of Stanley and his beer-drinking, poker-playing friends. "If you talk about [the play] on the

metaphorical level, it is about the death of poetry and that it's crushed. That flame of inspiration that Blanche represents—that fragile, ephemeral poetry—is extinguished," Blanchett observed. Not only are Stanley and Blanche fighting an epic battle for the love and loyalty of Stella, their battle is also a jarring conflict between Stanley's mundane, macho world and Blanche's poetic view—the world by moonlight, the world softened by paper lanterns thrown over harsh lights. "I think [today]," Blanchett says, "an audience looks at the play and thinks about what we lost, that we actually lost those intangible, ephemeral parts. Where's the poetry in America, where's the idealism in America?"

In this production, we are in Stanley's domain, which literally has no room for Blanche and her moonlit fancies. He's the master of his domain, as he proudly asserts, quoting the populist politician Huey Long's declaration that "every man's a king" of his own home. He's not going to cede an inch of that control to his flighty, half-mad, provocative, and scarily intelligent sister-in-law, whom he suspects of cheating him—and laughing at him. In their battle over Stella, he must make sure he still has his wife's complete support and affection. Blanche—who is so foreign to him that he barely understands her—threatens that.

Ullmann understood that Stanley is indeed threatened by Blanche. "He calls her an intellectual. She's a teacher, she knows everybody, everything. And he's losing the respect of his wife, the respect of who he is." When Stanley overhears

Blanche describe him as an ape, that's the point of no return for him. Says Blanchett, "He really needs to feel he is the king of his little filthy castle—for him that was important."

BURDEN OF THE PAST

When asked if she was afraid of taking on such an iconic role, Blanchett admitted to being terrified. *Streetcar* exists as a masterpiece in cinema as well as theater, so she knew there was a long, available roster of superb performances throwing benign shadows over her performance. Additionally, she commented, "It's a very naked play, actually. And it's all about the moments when people attempt to see the mask and when they reveal it to themselves."

One mask that Blanche wears is the mask of respectable sobriety. We see early on that the opposite is true: she loves and needs her libations, the bourbon in her coke, the quick drinks stolen when no one is looking. She needs them as she needs her hot baths—to soothe her nerves, to let the sweetness of brief oblivion erase the furies of memory. It's a source of much of the play's humor—the secret tippler pretending to abstain from alcohol—but it's also what helps tip her into the past that she is trying desperately to escape. It's her way out, but it's also her way in. What Blanche reveals to herself is not so much that she's mad, but that—as Ullmann puts it, "she's a drunk."

I don't know when you become a drunk and when you're not, but she drinks a lot . . . and [when] you are so threatened, and nobody sees you, and when you then tell the truth . . . yes, I think you do the unspeakable things. Maybe we all have done that— rushed out of a house crazy, saying things crazy.

Ullmann and Blanchett recalled that they never talked about Blanche as a madwoman. For Blanchett, the pressure of trying to survive with poetry and idealism intact, in a more practical and even brutal age, was too much for Blanche. "I think it's very easy to play a mad person," she says, "but there's more pathos in watching somebody hold on to their sanity."

For Blanche, the burden of the past is not only the loss of Belle Reve, the loss of her girlish innocence, the loss of a world that recognizes and values "gifts of the mind," and the loss of her husband; it's also the loss—at the very end of the play—of her hope of ever finding another love. She has been driven into fantasy, which is the only place left where she can nourish her hopes and dreams. Memory and fantasy have become fused, their shared boundary evaporating like the mists after summer rain. Can she come back from this enchanted state?

Tennessee Williams thought that she might return, rested and healed from her incarceration, well enough to open a flower shop, perhaps, in the French Quarter of New Orleans. (I have imagined such a life for her in my invented obituary at the end of this book.) Perhaps that is the life he would have wished for Rose, who spent her entire adult life in mental hospitals.

Tennessee gave Blanche his own predilections—his love of poetry, his preference for the gentility of the Old South as experienced at his grandparents' gracious home (despite the South's depredations on Black souls, which he addresses obliquely in other plays). He also gave Blanche his own reliance on the enchantments of alcohol, with its ability to let one forget, and sometimes to let one remember. "My roots as a writer are directly related to having been a queer from birth, and then abused from an early age," he divulged in an interview with James Grissom. "I sought refuge in alternative realities, because my own was so hateful, untenable. This begins in play-acting, doll-playing, writing down what one has." Drink, of course, when indulged beyond reason, provides another alternative reality, sometimes soothing, sometimes necessary, ultimately—for most—devastating.

In her next incarnation of Blanche in Woody Allen's *Blue Jasmine*, drinking also plays a role in helping to push a wounded, vulnerable character over the edge.

BLUE JASMINE: BLANCHE AS TRAGEDY, BLANCHE AS COMEDY

Four years after embodying Blanche onstage, Blanchett took on a role based on Blanche DuBois in Woody Allen's 2013 film. Again, Blanchett's performance won her much critical acclaim, including the Golden Globe Award, the SAG Award, and the BAFTA Award for Best Actress. Crowning those

achievements, she won her second Academy Award for Best Actress.

Blanchett plays Jeanette "Jasmine" Francis, a socialite who has suffered a nervous breakdown and finds herself broke and reliant upon her less prosperous sister, Ginger (Sally Hawkins), who—like Stella—is involved with a rough but charming partner, a car mechanic named Chili, played by Bobby Cannavale. Instead of the working-class enclave of Elysian Fields, Jasmine arrives in her Park Avenue Chanel jacket and Hermès bag, dropped off by a taxi in the low-rent Mission District of San Francisco. Like Blanche DuBois, she is a fish out of water, out of place in her classy duds, disoriented, alone. She asks a passing stranger, "Where am I, exactly?"

Her plight also parallels the Bernie Madoff scandal and fall from grace. Alec Baldwin plays her husband, Hal, an investment banker who has robbed his clients and landed in prison, all their worldly goods confiscated by the FBI. Jasmine is left with not much more than her designer clothes, her refined ways, and her snobbery. Unlike Blanche, whose snobbery derives in part from her plantation-class background and in part from her education and knowledge of literature and poetry, Jasmine's snobbery has to do with the privileged life she'd led on Park Avenue and in the Hamptons. Like Blanche, Jasmine has no clue how to negotiate her new surroundings. "From the moment she appears on screen, she's broken, and her contradictions—along with the vodka she guzzles and the Xanax she pops—keep her in pieces," Dargis mentioned in her *New York Times* review. Like Blanche finding herself in

her sister's apartment, when Jasmine first enters her sister's shabby Van Ness home, she's appalled by its ordinary drabness, a sharp contrast to her golden former life on Park Avenue. Like Blanche, Jasmine is fluttery and nervous, needing to reinvent herself but haunted by her recent trauma, which has left her alone and penniless. And, like Blanche's sneaking belts of Stanley's liquor, Jasmine is too fond of her Stoli martinis. Like Blanche, "Jasmine is a snob and a liar, and, at times, delusional (she talks to herself), but, like Blanche DuBois, she's mesmerizing," David Denby wrote in his *New Yorker* review of the film.

Woody Allen's choice of the French-sounding name Jeanette Francis is a canny evocation of Blanche DuBois's French Huguenot background, and the nickname "Jasmine" evokes the scents of a New Orleans night, of night-blooming jasmine. It's a fragrance that Blanche is particularly fond of, though she doesn't name the brand of perfume that she wears, and it connects the contemporary milieu of New York's Upper East Side and San Francisco's Mission District with the lusher, redolent air of *Streetcar*'s New Orleans.

But because this is a Woody Allen film, comedy is laced through the tragedy of Blanche's fall from grace, mostly in the characters of Ginger's surly ex-husband, Augie (played by Andrew Dice Clay), and her boyfriend, Chili (Cannavale), in the Kowalski role. Their hairy-chested swagger and Italian-American accents make them comedic types. Chili "is nuts about [Ginger]," Denby writes, "and is excitable to the point of hysteria. Much of this plays as farce. . . . The miracle is that

we feel for Jasmine—or, at least, our responses to her are divided between laughter and sympathy."

Chili and Augie mistrust and dislike Jasmine but don't threaten her like Kowalski threatened Blanche. Indeed, the real villain of the piece is Hal, Baldwin's smooth-as-silk, womanizing investment banker. It's Jasmine's discovery of Hal's nineteen-year-old mistress and his desire to divorce Jasmine that prompts her to report him to the FBI, leading to his arrest, imprisonment, and eventual suicide. So Jasmine is partly responsible for her husband's death, just as Blanche believes that her scorning of her young husband led to his suicide outside a dance hall at the Moon Lake Casino. Could Jasmine have lived with Hal's treachery and infidelity to maintain her gilded life in Manhattan's upper crust? Could Blanche have lived with the knowledge of Allan Grey's homosexuality, in a time and place where it was scorned as a "depravity"—not to mention his inability to fully love his young bride? These were impossible choices, but—in the heat of betrayal—the choices were made.

The Louisiana-born critic Rex Reed, not surprisingly, had an insightful take on Jasmine-as-Blanche in his review for the *Observer*. He wrote,

> *Like Blanche in* Streetcar, *Jasmine is a mystic combination of purloined innocence and Krafft-Ebing's* Psychopathia Sexualis—*exasperatingly manipulative but meltingly vulnerable, always waiting for someone to save her. Enter the Mitch character, a wealthy businessman with political goals named*

Dwight (Peter Sarsgaard), who offers stability at last, until his cruel, unexpected rejection leads to Jasmine's ultimate break with mental balance. . . . As a mortgaged soul in the gradual stages of a nervous breakdown, she is heartbreaking and hypnotic.

Noting that the audience "laughs throughout *Blue Jasmine,* but at the heart of the film is this incredibly damaged woman," wrote journalist Steve Pond after interviewing Blanchett for The Wrap in May of 2013. He asked how she prepared for the role.

"I watched a lot of Woody's films before I made this," she said, "and one of my all-time favorites from his pantheon is *Crimes and Misdemeanors.* All of that stuff with Anjelica Huston [who plays a cast-off lover who is then murdered] is really painful and raw and brutal. Unlike any other filmmaker that I can think of, he's able to walk that line between absurdity and horror."

She also "did a lot of people watching. I drank my share of rosé. . . . [Jasmine] breaks so many times, but I wanted her to break in different ways depending on what particular cocktail she was on or what was the specific fear or moment of guilt that was spiking up."

Blanchett felt that there were many women like Jasmine, whom you sometimes see on park benches and wonder "How did they get there? That's someone's son or someone's daughter, and how did they end up there in that Chanel suit?"

THE ETERNAL BRIDE: JEMIER JENKINS

2018

[Tennessee] always wanted to see a major production of *Streetcar* with a cast of color.

—Emily Mann

In March 2018, the African American Shakespeare Company mounted a Black production of *Streetcar* at the Marines' Memorial Theatre in San Francisco, directed by L. Peter Callender, with Jemier Jenkins as Blanche DuBois. It was not the first African American production, which took place much earlier, in 1953, at Lincoln University in Jefferson City, Missouri, by the Summer Theatre Company. Two years later, the Ebony Showcase Theatre in Los Angeles produced *Streetcar* at the Broadhurst Theatre on Broadway.

The path to this latest Black production of *Streetcar*, however, was not smooth. In his book *When Blanche Met Brando*, Sam Staggs describes the African American actress Ellen Holly's attempt to play Blanche in a Joe Papp production at New York's Public Theater in the 1960s. A veteran of the Actors Studio and four Broadway plays, plus fifteen years on the soap opera *One Life to Live*, Holly cherished the hope of one day playing Blanche DuBois. In fact, she had won admittance to the prestigious Actors Studio with one of Blanche's monologues from *Streetcar*. Holly wrote to Tennessee Williams for his blessing.

In her autobiography, *One Life*, the actress argued that "a Blanche with a bloodline similar to mine might have a Belle Reve in her background," as Holly's maternal great-great-great-grandfather had been the master of the Arnold plantation in Greenville, South Carolina. But her imploring letter to Tennessee Williams received no reply, so she gave up the

idea. As Holly later wrote in her autobiography, "What would we have done with [*A Streetcar Named Desire*]? God knows. But as [B]lack players, we would have had something special to bring to the material. Quite apart from our skill, we bring our desperation."

Staggs does not read anything into the playwright's failure to answer Holly's letter, pointing out that at the time, years of pill and alcohol addiction had taken their toll on Williams. "It is important to add here," he notes, "that in the original preface to *A Streetcar Named Desire*, the playwright inserted a clause asking that the play not be acted in any theatre where discrimination was practiced."

ON BROADWAY

It would take over fifty years before *Streetcar* with a multiracial cast, including Nicole Ari Parker as Blanche and Blair Underwood as Stanley, arrived on Broadway in 2012. Its director, the actress and writer Emily Mann, knew from her friendship with Tennessee Williams that he had "always wanted to see a major production of *Streetcar* with a cast of color," and he had often granted permission for all-Black and multiracial theater companies to produce his play. As a Mississippian, Williams grew up surrounded by Black culture, and his beloved New Orleans was steeped in different ethnicities. As mentioned earlier, Mann observed, "He understood human beings, period, and he understood New Orleans society. And you can't

understand New Orleans and the South without understanding Black people."

Indeed, the playwright Martin Sherman—no stranger to outsider protagonists in his heralded 1979 play, *Bent*, about the persecution of gay prisoners by Nazis—has written about Tennessee's deep awareness of racial inequality in the Deep South. In his introduction to *Garden District*, Williams's collection of one-acts that includes *Orpheus Descending* and *Suddenly Last Summer*, Sherman praises the former as "a play of great political bravery." He writes, "Racism drives the play and ultimately destroys all its decent characters." He notes that the one-act is set "in the most venal and corrupt Southern town ever created, except, of course, it wasn't created: it was an accurate reflection of its time and place."

That time and place is informed by Columbus, Mississippi, where, ironically, Tom Williams would have witnessed racial injustice yet also experienced the most loving and secure times of his childhood, in his maternal grandparents' home. "The moment he stepped off the train and into the arms of his grandfather, he knew he was home," Leverich wrote in his biography of the playwright. "He was about to experience one of the happiest and most formative periods of his life." He carried his mixed feelings about the South throughout his life and his work, painfully aware of its continuing history of brutality toward Black people, but also feeling its proffered love and gentility. He also looked upon New Orleans as a kind of salvation. Compared to Columbus, it was a melting pot of races and cultures, but more important for Tennessee

it allowed him to be himself, to live as openly as he could in a colorful city tolerant of a broad, diverse spectrum of sexuality. He wanted to bring the mix of jazz and the music of street vendors to his incarnation of New Orleans, along with its exuberance, its working people living cheek by jowl but buoyed by so much the city had to offer. Emily Mann's 2012 production made good use of New Orleans' plentiful mix of jazz and blues performers, bringing in jazz composer Terence Blanchard to oversee the music—even staging a jazz funeral in the second act.

To preserve the class distinctions in Williams's play, Mann conceived of Blanche and Stella as inhabiting a lighter-skinned, upper echelon of Black society, whereas Stanley and his poker buddies are darker, working-class men. For the first time, as she notes,

> *class and ethnic references took on new racial dimensions. When Blanche referred to Stanley as an "ape," "sub-human" and "bestial" or Stanley derided Blanche's "lily-white fingers," the dialogue revealed a new layer of the interracial boundaries between the DuBois sisters and Stanley.*

Just six years later, in 2018, the African American Shakespeare Company of San Francisco successfully translated Tennessee's all-white, Southern milieu into one inhabited by an African American cast. Its director, L. Peter Callender, refocused the play on universal themes of class and gender disparities. Reviewer Gilad Barach, writing in "Millennial

Notes," hailed the production as spellbinding, "simply a masterpiece."

Callender first read *Streetcar* when he was a high school student at the Performing Arts School in New York.

> *I think we did some scenes from it, like every performing arts school. . . . I'd have done a scene with Blanche and Stanley, or Stanley and Stella, or Blanche and Mitch. I saw Kazan's film, and I read it in high school, and I went to Juilliard School where we studied it. I let it go for a while, as I thought, it's a Tennessee Williams play! I'll never get a chance to do it, but I love the play and will never miss a chance to see it.*

After moving to San Francisco in 1990, Callender was cast as one of the card players in an American Conservatory Theater production. As one of the only two actors of color in that production, he was delighted to be cast in *Streetcar*, and he held out hope that one day he could play Stanley, or even Mitch. He remembers thinking, "I would love to do this with a Black cast." After Emily Mann's production played on Broadway, he realized that it could be done, so when he was hired as the artistic director of the African American Shakespeare Company, he announced an all-Black production of *Streetcar*.

The reviews were mostly ecstatic:

> *L. Peter Callender's "Streetcar" goes beyond "Desire" to examine gender, alienation, class conflict, and sexual exploitation . . . a brilliant and painful lesson about listening respectfully to*

women. . . . "Streetcar," written in post-WWII America, em-
bodies triumph and heroism, directing our attention to the
working class, the "unsung"' heroes. The mostly African Amer-
ican cast masterfully gives new life to Williams's attack on class
privilege, challenging traditional U.S. prejudices and bullying.

CLASS, NOT RACE

It would be interesting to see a multiracial production cast the DuBois sisters as Creoles—free people of color, of European and African descent, many of whom would have spoken colonial French (Blanche is proud of her French name). Ellen Holly had suggested that idea in her autobiography. The Creoles of Louisiana had acquired education and wealth, and once held positions of power in New Orleans before being purged by white politicians through Jim Crow laws enacted at the turn of the twentieth century. Creoles were often light skinned and proud of their ancestry, tending to look down upon darker-skinned African Americans.

Callender doesn't reimagine Blanche and Stella as Creoles, but he very much sees them as part of the upper echelon of property-holding African Americans. Callender remarked that he was much influenced by the playwright Marcus Garvey, a friend of the director and the author of *This Will Not Stand*, a play set in New Orleans featuring women who "were very upper-class Black. They owned property. They owned land. They owned businesses. They ran businesses."

That was my impetus . . . to see this as real. I learned that there were people who were major property owners who lived in big houses and dressed beautifully and had their clothing made by tailors—so why not Blanche? Why not have Blanche live in Belle Reve, this beautiful mansion that her parents owned and that went into lien, and so on, but who says a Black family could not have owned that property? It was done in New Orleans, back in those days. To have Blanche, who ran the property when her folks died, realize she can't hold on to her life of privilege, of style, of grace, of grandeur! When all that crumbles, she has to figure out a way to keep money coming in, so she behaves in ways that were not ladylike—let me put it that way.

Jemier Jenkins, who played Blanche DuBois in Callender's production, first saw Nicole Ari Parker's portrayal on Broadway in 2013, soon after completing study at William Esper Studio in New York. "They were actually doing a colorblind casting of it, with Nicole Ari Parker and Blair Underwood." Jenkins remembers thinking,

Wow, I would love to play this role one day! All the tragedy that she endured, the appeal that she had to still have hope for her life. I would love to play this, but it is so unrealistic, you know, the question of how many productions are going to be made with an all-Black cast of this play. I thought about it, and I was like "you know, before I die I just want to do it," and then maybe four or five years later, I was presented with the opportunity.

Jenkins was impressed with Nicole Ari Parker's portrayal. "She's very, very fair skinned, and Blair Underwood is dark skinned, so what they explored was more of the color line, whereas [our production] portrayed it as a class divide."

With an enhanced emphasis on class distinctions, however, we have to face up to the fact that Blanche, as written, is a snob. Her main quarrel with Stanley—and with Stella for choosing him—is that he's not of their class. She constantly refers to him as common, uneducated, even bestial. Blanche rails against her sister for choosing a man who "acts like an animal, has an animal's habits! Eats like one, moves like one, talks like one! There's even something—sub-human—something not quite to the stage of humanity yet! . . . there he is—Stanley Kowalski—survivor of the stone age!"

Stanley overhears this attack on his manners and his very humanity, deepening his resentment of Blanche, whom he already suspects of cheating Stella over the loss of Belle Reve—and thus cheating him, by extension (under the Napoleonic Code, of course!). He knew when he married Stella that she outclassed him, but their strong sexual connection and romantic love overcame any hesitancy on her part—"I pulled you down off them columns!" he tells her, and she loved him for it. Now, Blanche constantly reminds her sister that in her view Stella has married beneath her. From then on, the battle between Blanche and Stanley over Stella's heart begins in earnest.

Just as 1940s audiences often sided with Stanley against

Blanche because they disliked her manipulative, flirtatious ways, the audience for this production could easily side with working-class Stanley against Blanche's sense of entitlement, her upper-class airs.

The audience's sympathy, however, seesaws between the two antagonists. Stanley—powerfully played by Khary Moye—may win us with "his dominating gait and his resistance to Blanche's beauty," according to Barach's review, but his drunken attack on pregnant Stella and of course his rape of Blanche at the end of the play repels us. Yet, as Barach points out, when he breaks down sobbing, begging Stella to return to him, he arouses our pity. It's to Williams's credit that we can feel both revulsion and pity for Stanley, and are irritated by Blanche yet weep for her unfolding tragedy.

Callender was aware of those shifting sympathies, and in the final analysis, he

> did not want Stanley . . . this man who would abuse his wife, who would cheat on his wife—to be the all mighty—I did not want to lift Stanley up. I wanted audiences to understand him, that this is where he comes from. He's this guy—he's not well educated, he's found this beautiful woman who loves him, he has faults—everyone has faults—he's made mistakes, everyone's made mistakes. I wanted us to understand Stanley, but not to praise him.

Another change Callender made in the text was to have Blanche and Stella dine, not at Galatoire's, but at a Black-

owned restaurant in the French Quarter. He discovered that Galatoire's, a Bourbon Street landmark specializing in French and Creole cuisine, did not admit Black patrons at the time.

BECOMING BLANCHE

For Jenkins, playing Blanche "was one of the highlights of my own career. It's hard to compare that to other works because we just don't have a lot of Black shows where you can come onto a cast and not feel like the minority all the time. When I talk about acting, why I'm passionate about theater, I almost always mention *A Streetcar Named Desire.*"

Jenkins worked hard with Callender to bring his vision of Blanche to life. In his notes to the actors, the director tells Jenkins to think of Blanche as fragile and mothlike, and indeed in her luminous dress Blanche seems spun out of moonlight, fatally attracted to flame. In his review, Barach praises Jenkins's magnetic beauty as well as her "neurotic allure," noting that she is radiant in a white dress, in contrast to Stella's (Santoya Fields) simpler black-and-white polka dots.

Indeed, Blanche is a night creature, fragile and mothlike, "attracted to a glow—not just the moon," Callender explains. "She wears a white dress and white gloves and a lovely white hat because she wants to be a bride. She's constantly looking for a husband, so she walks around veiled, in a white gown and white gloves!" Even more than a bride, Callender notes, Blanche wants the world to see her as virginal. "When

a woman has already been married, about to remarry, she doesn't wear a white dress again. But that rule doesn't apply to Blanche."

If we see her this way—spun out of moonlight, essentially fragile, hanging on by a thread to her sanity and her self-respect—can we forgive her pretentiousness and her lying? Desperate to preserve her fantasies about her youth, her beauty, and her past, she weaves a gossamer web of lies and half-truths. We understand her and we pity her, but in this production, do we forgive her class snobbery?

What keeps Blanche from being insufferable is her status as an outsider, a castaway with no home, nowhere to go, no funds, and no agency of her own. As Arthur Miller wrote in his introduction to the New Directions edition of *Streetcar*, "the hurt individual against a brutal society's injustices" moves *Streetcar* in the direction of social consciousness— ironically, perhaps, because the heroine is from the upper class and her antagonist is a working man. But Blanche is defined less by her lost status as a daughter of privilege than by her current status as a solitary woman with no way to make her way in the world, except by the two oldest professions— prostitution or marriage. Removed from the protections of home and husband (just about all that was allowed her in the 1940s in America), what she has left are her seductive wiles, her fantasies and memories, and her love of poetry—none of which are up to the task of saving her. Indeed, art, poetry, and

beauty have little value in Stanley's world, in the new, more egalitarian, postwar America—the world in which Blanche has by necessity come to live.

Blanche's outsider status is underlined by Jemier Jenkins's ethereal beauty, "as out of place as an orchid in a back alley," in reviewer Christine Okon's words. She is "practiced in the southern playbook of manners and gentility, but she wears them like a mask, a mask she desperately clings to because the truth is too painful." Her gentility and love of beauty—which seem phony to Stanley—are "the only thing keeping her from the depths of darkness and death."

"Jemier was fabulous in the play," recalls Callender. "She worked so hard on Blanche. She understood her. I remember her performance, and she was stellar. She's from the South—from Florida—so she knew the rhythms of the language, she knew the mentality, the walk, the talk. Her gesturing towards Stanley was just wonderful. She would dismiss him just by turning her head!"

But to see *Streetcar* primarily as a class struggle is to require a level of realism that Tennessee avoided in favor of the dreamlike quality that infuses the play. The miasmal vapors of New Orleans, the confusing structure of Stella and Stanley's Elysian Fields apartment, the highly poetic language throughout the play mitigate against realism. Yet Stanley pushes back against that, especially in the sad birthday party scene in which Blanche is stood up by Mitch. Referring to the

BLANCHE

baby that Stella is about to have, Blanche says, "Oh, I hope candles are going to glow in his life and I hope that his eyes are going to be like candles, like two blue candles lighted in a white cake!"

To which Stanley mockingly replies, "What poetry!"

Yet it is poetry that has attracted her only potential suitor, Mitch, to her—and her to him. Their mutual love of Elizabeth Barrett Browning, as revealed in the inscription on Mitch's cigarette box, lets in a ray of hope that Blanche might have found a soul mate, at best, or at least a way out of her current dilemma.

The big reveal that seals Blanche's fate is her sexual past, but was she working as a prostitute in order to survive and to pay the mounting bills of Belle Reve, or was she trying to reclaim the love she once had with her young, doomed husband?

"I think it's a little of both," Callender believes. "Her husband, who was younger, who was gay, and who killed himself . . . she loved him very much. When he committed suicide, she felt that it was her fault. That triggered something in her psyche. She wanted to prove to herself that she can be loved, and she can love a man, and she can be loving and faithful . . . she wanted to be desired," even enjoying the attentions of army soldiers stationed nearby who began to howl for her on the lawn of Belle Reve.

As she became more accepting of the attentions of those and other "gentlemen," Callender notes, the more she needed alcohol to numb the pride she should have had, "that sense of societal propriety" that was her birthright. "She behaves in

174

ways that were almost mirrorlike. She would stand in front of a mirror and would be one person outside of the mirror, but would see another person in the mirror. This is why too much light was no good for her, it exposed her."

THE SCENT OF BLANCHE DUBOIS

In Callender's interpretation, Stanley has not been faithful to Stella. "A man like Stanley, who traveled a lot in his business? He loves Stella, that's his wife, but his sexual prowess cannot be contained by one woman. I think when Stanley travels, he's out there. Yes, he comes home to Stella, and yes he loves her—but . . ."

Not only has Stanley not been faithful to Stella in the backstory of this production, one of the compelling subtexts is Callender's belief that Stanley and Blanche have met before. He seems to know the Flamingo Hotel, where Blanche held her trysts and became so notorious that she was asked to leave (if Stanley's friend is to be believed). So Stanley suspects, or remembers, or comes to know that Blanche is not the virginal Southern belle she pretends to be. Callender explains,

I believe strongly, and I believe it's in the text, she may have met Stanley. He probably made a pass at her and she rebuffed him, and he never forgot that. So when he next sees her, there's a memory that clicks. There was a moment I created when Stanley first saw Blanche . . . sitting there by herself, and there was a scent.

The connection between scent and memory has been well established, a connection Callender drew upon from his own life. He remembered that at Juilliard,

there was a young lady, a dancer, I was dating, and she wore a certain perfume. There was a certain scent about her, and I will never ever forget that scent. One day, here in the Bay area, thousands of miles away, on the street I smelled this scent—I didn't know what it was, but something inside of me said, wow—holy cow! My heart, my body went back thirty-five years ago to the Juilliard School. So I think Stanley [also remembered], and I have him look at her for a minute, and she at him, and there's a moment of, "I know you, I know you."

Indeed, one of the motifs in *Streetcar* is the power of scent to soothe the nerves by creating a kind of reverie, but to also trigger unwanted memories. Blanche spritzes her perfume around the room, and frequently takes scented baths. Blanche says she needs those baths to restore her nerves and to freshen herself in the wilting humidity of New Orleans, but frequent bathing is also a behavior of women who have been promiscuous or sexually abused, as a way to cleanse themselves and even, psychologically, to restore their virginity. It was believed that Venus, the Greek goddess of love, restored her virginity every time she bathed, and that balm has remained—especially for Blanche—as a kind of healing of psychic and sexual wounds. (Before the advent of shock therapy and tran-

quilizing drugs, mental institutions relied on hydrotherapy, immersing their manic patients in warm baths to calm them.)

What would Blanche's scent have been? At one point she tells Stanley that she wears an expensive French perfume (a hint for a birthday present!). The most popular French perfumes of the day were Chanel No. 5, Lancome's La Vie Est Belle, and Guerlain's Shalimar. Of these three, Shalimar would have best suited Blanche. Launched in 1925 by Guerlain, the oldest French parfumier, Shalimar was inspired by Emperor Shah Jahan's love for Princess Mumtaz Mahal, for whom he created the Taj Mahal and the gardens of Shalimar (a Sanskrit word meaning "temple of love"). The perfume's notes include sweet bergamot, vanilla, and iris, and the shape of the bottle—designed after the Shalimar garden pools by Raymond Guerlain himself—won first prize at the Paris Exhibition of Decorative Arts. Blanche would have been drawn to all of that—its exotic, flowery scent, its French provenance as a luxury brand, its love story, and the beauty of its design.

Callender also poses the question, what if Stanley had, in an earlier meeting, come on to Blanche, and had been rebuffed?

Until Blanche, no woman has ever turned down Stanley. So when this woman in Laurel, Mississippi, turns him down, he remembers. She's still playing this uppity, bourgeois bullshit in front of him, and still rebuffing him as an animal. "You're my wife's sister, yes, but you're in my house, and you treat me like an

animal, as when I first met you? Oh no. I'm going to take care of this!" And that's why it's important to Stanley to turn Stella against Blanche.

THE IMPORTANCE OF BEING STELLA

Callender also focused his direction on the relationship between the sisters. He admits that he wanted the audience to understand Blanche's fragility, but also the "blame game" she played on Stella, the accusation that if Stella had stayed behind with Blanche at Belle Reve, everything would have been all right. "Blanche could be horribly cruel to Stella, but that's what siblings do to each other. I wanted their sisterly relationship to be the main impetus for my production." He emphasized not just the sibling rivalry, but Stella's excitement at being reunited with her sister, knowing full well that Blanche would expect Stella to wait on her, knowing how accustomed is Blanche to Belle Reve, to owning property, to all markers of luxury—"the beautiful gloves, the hats!"

Stella, though younger, was the first to leave Belle Reve to make her own way in New Orleans. She would have remembered her sister as a demure young woman. In scene 8, after Stanley has cruelly gifted Blanche with a bus ticket back to Laurel, Stella chides him: "You didn't know Blanche as a girl. Nobody, nobody, was tender and trusting as she was."

For Blanche, Stella is not only her only surviving relative,

her best friend, but the only person alive who knew her as a fresh young girl, before the tragedy of her failed marriage and her husband's suicide, before the loss of Belle Reve and her plunge into notoriety and despair. She is Blanche's only link to the past—the past Blanche would like to remember.

Callender observes, Stella, with the greater freedoms of the younger sibling who is not pressed into service of aging parents,

> is out in the world . . . she loves sex, she loves to be touched. When Stanley comes home, she runs to him and wraps her legs around him! They go at it for a while even before Stanley takes a shower—that's Blanche's sister!

As for Stanley, "there was a rhythm to his life—he would come home, he would eat, he would make love to Stella, then he'd go bowling. Or he would go away for two weeks and when he returned, they would go at it for a week!" But this all changed during the five months of Blanche's visit. "I wanted the audience to *understand* that. Not to blame him. And to understand that Stella's rhythm has changed also."

Added to that long disruption is Blanche's disapproval of Stanley and her blaming Stella for marrying below her. Of course, Stella is torn between her passion for her husband and her sisterly love for Blanche. When Blanche begins to turn Stella to her way of thinking, Stanley becomes unhinged.

Callender believes that "if there were a *Streetcar Named Desire II*, Stella would have left Stanley." And instead of opening

a flower shop, Blanche—perhaps with Stella—would have opened a dress shop after leaving the sanitorium. "Clothes are my passion," she says, and her description of the clothes and accessories she wears on her last fateful day touchingly reveals Blanche's love of, and knowledge of, beautiful fabrics and accoutrements. When Eunice admires Blanche's "pretty blue jacket," Stella tells her it's "lilac colored," but Blanche corrects them both, describing the color as "Della Robbia blue. The blue of the robe in the old Madonna pictures."

By the end of the play, when Stella refuses to believe her sister's tale of being raped by Stanley, Blanche has lost her last remnant of safety. As Jenkins notes,

> *When the last dependable person she has in her life—her sister—is taken away from her, that last little sense of a safety net was completely removed. Blanche is seeking safety, and childhood was the last time she felt safe. Look at how far back she goes to reach for safety! Her childhood!*
>
> *She has also lost the last witness of whom she believes herself to be.*

BLANCHE AS COMEDY

Another aspect of *Streetcar* that Callender wanted to enhance was the play's humor, which often gets lost in the tragedy of Blanche. "I'm so tired of just seeing just the tragedy of the play!" he remembers. "When Stanley offers Blanche a drink

and she says, 'I hardly ever touch the stuff,'" the audience laughs because we've just seen Blanche take a deep and desperate drink. Callender "wanted the Black audiences who came to see the show to be reminded of the aunties that they have, the sisters that they have, the neighbor . . . I wanted the audience to enjoy, because if they laugh at certain times, they'll cry at certain times. I have to take them on this roller-coaster ride."

Even our first glimpse of Blanche, Callender believes, in her immaculate white dress, her immaculate white shoes, carrying an immaculate white suitcase, and wearing little white gloves, can be played for a certain comic effect.

She's dainty, she doesn't even want her shoes to touch the ground. She doesn't want the air to touch her face. She meets Eunice, and says, "This can't be the place where my sister lives! This can't be!" and then, when Eunice says, yeah, it's right here, the reaction from Blanche should be funny! It's not this tragic response—it's more like, "holy fuck!" The audience should have a moment of levity there. And she should take us on this journey of hilarity, and laughter, until it crashes, until we realize . . . she's in danger.

IS BLANCHE CRAZY?

As we've seen, Elia Kazan noted in his memoir that the more he read and lived with *Streetcar*, the more he became

convinced that Blanche is fundamentally sane. In her portrayal of Blanche, Jenkins tried out different interpretations.

Sometimes she played Blanche in ways that "didn't feel crazy at all. Blanche's sense of dignity would not allow anyone to drag her out like a crazy woman. That goes against everything that, at the core, she is." But there were also times when she played Blanche as someone completely disoriented, without her safety net, driven crazy by Stanley. In either case, playing Blanche took its toll on the actress, as it had for so many—Vivien Leigh, Ann-Margret, Jessica Lange, Patricia Clarkson. "I was very actively trying to release, release, release" the effect of playing Blanche when the run was over. "You know, just walking around as a Black woman, I already have so much going on that I was really practicing how to release those things."

DOES BLANCHE STILL MATTER?

When asked whether we still care about old-fashioned, sometimes cloying Blanche DuBois in our more modern age, Jemier Jenkins answered yes, because "we empathize with her hard life, and also because she's funny."

She moves through the world in this unsuspecting way, or in a nontraditional way, pretending. We, the audience, can see that she's pretending. We can empathize with that because we all

want more than what we have. It's part of the American Dream.
She's a mess, but she wants better. And I'm a mess, too, and I
kind of want a little bit better than what I have as well.

She also notes how Blanche helps us "unpack our varying definitions of feminism, that it doesn't belong to a certain type of person who behaves a certain way. Sex workers should be advocated for in the feminist space, just as much as anyone else."

After all, despite her upper-class pedigree, Blanche is disadvantaged in at least three ways—she has been a promiscuous woman and possibly a sex worker at a time when such women were condemned by society; she has lost all her property and her money; and in her early thirties, she is a single woman living without a husband, living off the borrowed goodwill of her sister. In midcentury America, especially in the South, "single women were not valued," Jenkins observes.

A married woman had more value in society than a single
woman did. If you can't have a man, that diminishes your value
as a woman in society. Someone as proud as Blanche would
want to be included in the societal norms of the time . . . people
with very great means who lose everything or are all of a sudden
outcast, they often take their own lives.

When asked the same question about Blanche's relevance, Callender answers that her significance is partly a reminder of where we've been as a culture.

We need Blanche, just as we need Lady Macbeth, just as we need Pinter and Chekhov and Ibsen, and Miller. We still crave to watch Death of a Salesman. *We still crave to watch* A Doll's House. *We always need to go back and say, Wow, look at her! She's fragile. She's flawed. She's genuine at times. She lies. She's manipulative. But we care about her. My show was sold out every time, the audience stood up every time, they came to their feet!*

However, Callender believes that if the play were written today, as is, for a contemporary audience, "there would be no Broadway production."

Would Rose Williams have recognized herself in Blanche DuBois? She certainly would have identified with Blanche's love of pretty clothes, flowers, and jewelry—perhaps even the note of jasmine in Blanche's perfume. She would probably have identified with Blanche's struggle to reconcile her sensuality and her sexual hunger with the prim strictures of her upbringing. She, too, had lost her first love—"a young, young, young man"—to an unexpected and early death. Perhaps if Rose had not been subjected to a lobotomy, she would have survived her incarcerations and returned to a more normal and acceptable life. And finally, after a long life with brief interludes of joy, perhaps death would have approached her in the form of a kind stranger, a gentleman caller with impeccable manners and a comforting, gracious smile.

TWO OBITUARIES AND A HANDFUL OF POEMS

ROSE'S OBITUARY

Given her importance to the playwright's life and imagination, it's worth taking a look at what became of Rose Williams, as outlined in Mel Gussow's obituary for Rose in *The New York Times* on September 7, 1996.

ROSE WILLIAMS, 86, SISTER AND
THE MUSE OF PLAYWRIGHT

Rose Williams, Tennessee Williams's sister, who was the model for Laura Wingfield, the shy, lame young woman in "The Glass Menagerie," died on Thursday at Phelps Memorial Hospital in Tarrytown, N.Y. She was 86, and had moved to the hospital from the Bethel Methodist Home in Ossining, N.Y.

The cause was cardiac arrest, said Michael Remer, a lawyer for the Tennessee Williams trust.

Ms. Williams was immortalized in fictional guise in her brother's work, first in his short story, "Portrait of a Girl in Glass." That story inspired "The Glass Menagerie," the memory play that was Mr. Williams's first Broadway success, in 1945. In his notes to the play, the playwright said that Laura "is like a piece of her own glass collection, too exquisitely fragile to move from the shelf."

In "Tom: The Unknown Tennessee Williams," Lyle Leverich, the playwright's authorized biographer, wrote, "Throughout his life, Tennessee Williams had two overriding devotions: his career as a writer and his sister, Rose."

Rose Isabel Williams was born in Columbus, Miss., in 1909, two years before her brother, Thomas (later Tennessee). The two grew up together. As a young woman, Ms. Williams was schizophrenic, and she underwent a prefrontal lobotomy and was institutionalized for the rest of her life.

In his "Memoirs," Mr. Williams said: "You couldn't ask for a sweeter or more benign monarch than Rose, or, in my opinion, one that's more of a lady. After all, high station in life is earned by the gallantry with which appalling experiences are survived with grace."

The playwright died in 1983. In Mr. Williams's will, most of his estate was left to the University of the South in Sewanee, Tenn., with the bulk of it to remain in trust for his sister during her lifetime. The University of the South announced that with Ms. Williams's death, the university would receive some $7 million. . . .

At the end of "The Glass Menagerie," Laura's brother, Tom, the character based on the playwright, leaves home to begin his own life and career. . . . He finds that he has been pursued by

his memory of her. "Blow out your candles, Laura," he says, and in the background Laura blows out the candles. The stage goes dark, and Tom says, "And so—goodbye!"

What if Blanche DuBois had had a life after being committed to a psychiatric hospital? I have imagined a post-hospitalization life for her, and my musings have taken the form of an obituary. After all, Blanche DuBois is one of those indelible characters who has entered our hearts and imaginations with the force of an actual being. In my own long love affair with literature, film, and theater, my engagement with the main characters has often taken the form of my continuing the story, imagining what might have happened next. To be sure, that's a sign that the characters created by the author have begun to truly live, off the page, and will not be forgotten. Suppose the leading New Orleans newspaper, the *Times-Picayune*, published the following obituary?

BLANCHE DUBOIS'S OBITUARY
THE TIMES-PICAYUNE, UNDATED

Blanche DuBois departed this earth on Sunday, from a brief illness of an undisclosed nature. A well-known and flamboyant denizen of the Vieux Carré, Miss DuBois, as she preferred to be called, owned a dress shop on Carrollton Avenue specializing in costumes for Mardi Gras balls and krewes, many of them imported from France. A former schoolteacher, she often delighted her patrons with quotations from Edgar Allan Poe, Elizabeth Barrett

Browning, and Edna St. Vincent Millay, usually dressed in one of her fanciful and extravagant costumes.

She is survived by her sister, Stella DuBois Kowalski, and her nephew, Stanley Kowalski, Jr. A memorial service will be held on February 14 at the Schoen Funeral Home on St. Charles Avenue. Before her death, Miss DuBois requested that in lieu of donations, please send flowers.

Miss DuBois was born in Laurel, Mississippi, though her date of birth is unknown, estimated to be around 1913. The DuBoises were a wealthy, landowning family at the turn of the century but had fallen on hard times as lands and wealth were lost due to gambling debts and mortgages on their ancestral home, a white-pillared plantation house alternately called "Bel Rive" ("beautiful riverbank") or "Belle Reve," a pidgin French term for "beautiful dream." It was finally lost in 1946, and Miss DuBois, the last of her family to reside there, took up residence at the Flamingo Hotel in Laurel, a hotel for transients and traveling salesmen.

An early marriage to the promising young poet Allan Grey ended tragically just a few months after the wedding when he committed suicide by gunshot. Miss DuBois never remarried.

Miss DuBois was forced to leave her job as an English teacher in Laurel, under a cloud of suspicion involving one of her students, a 17-year-old youth. Details were not available at the time of this writing. In 1947, she moved to New Orleans to be near her sister and only surviving relative, Stella DuBois Kowalski, staying with them for a time at their apartment in Elysian Fields.

As a result of a nervous breakdown, Miss DuBois was commit-

ted by her brother-in-law to Mandeville, a state institution for the insane.

After three years at Mandeville, where she underwent shock treatment and vocational rehabilitation, Miss DuBois was deemed cured. She subsequently became engaged to Dr. Cukrowicz, one of the doctors who treated her at Mandeville, and when the engagement was called off, she returned to New Orleans, where her sister, now divorced from Stanley Kowalski, still resided.

Miss DuBois and Mrs. Kowalski opened a flower shop, called The Two Sisters, which they eventually sold, and the proceeds allowed Miss DuBois to open Shalimar, her dress and costume shop, which became a highly successful tourist destination in the French Quarter. Due to her popularity in the Quarter, she was named the Queen of Muses at the annual Mardi Gras parade for three years in a row.

Such was her allure and sense of mystery that many thought she had inspired the imagination of the playwright Tennessee Williams, during the early years he'd spent living in the French Quarter, between the Desire projects and the Cemeteries. She seemed a creature made of moonlight and fancy, at times tender-hearted, at times shrewd and manipulative, at times playful, and always easily wounded.

Those whose path she crossed never forgot her.

SONNETS FROM LAUREL
BY ALLAN GREY

(Inspired by Elizabeth Barrett Browning's *Sonnets from the Portuguese*)

The back story of these poems is that Blanche idolized "the boy"—Allan Grey—in the haunted house of her memory, granting him an uncommon wisdom as he tries to understand the unspoken gulf between them. One can even be forgiven for wondering if Blanche herself might not have penned these verses—a twist befitting Tennessee's sometimes sly, sometimes mischievous creations.

SONNET I

Pale girl, how unalike we always were—
In hopes, in thoughts, in wished-for destinies.
You have your mansion and your gardens too, where
I am just a visitor, a poet who cries
For your lightest favors, your sweet niceties.
I think the sunlight of your tender ardor
Would cure me of my ills—perhaps forever.
Let me be your foolish man-child suitor
Decked out in motley, happy just to warm
Myself at your white center. Alien creature,
If I could span the gulf between us without harm,
Before Death brags he has me in his shadow,
I could be new born in your blue eyes
And lie with you beneath the cypress canopies.

SONNET II

Go from me, loved girl. You are too young
To know I suffer so. You tremble there
On some sweet threshold I have long
Ago crossed over. The unwashed grapes were
Pressed to summer wine, lingering on the tongue,
Just as you linger in my daytime dreams, where
Sunlight dazzles, chasing grief along
Enchanted ways. Those times I try to bear
My hopes to God, it's your white name
He hears, but gives no answer. O, let that sparrow
Sing his sparrow song! Let love and fame
Elude me in this life. Slender arrows
Of my fate do prick me now. Is this a game
We play at, love we only borrow?

SONNET III

Behold the jasmine you once gave to me
Cut from your garden that one summer past,
Still sweetening my memory! Let our love last
Through seasons cold and warm. If secrets be
Allowed between us, left unspoken, they may
Let us simply love like children, my hand resting
in your gloved hand. Your unwavering
trust in me delights my heart. On this sunlit day
You are the pretty flower of a dream. O love,

Be the one who walks awhile beside me
Among the garden's spreading greenery
That I dare wish to hold, dare wish to have—
Before the moon has chased away our glee
Before the night has sealed away our love.

SONNET IV

The world's appearance changed when I first saw you,
When your footsteps stole between the grave
And my young life. Shall we call it love
That taught us a new dance, that taught the blow-
ing wind a softer tune? If Heaven's blue
Can shine upon us now—the very blue that saves
Us from ourselves—will you please have
Me as your true companion, as if we drank anew
From some sweet spring? O my dear girl,
The Pleiades shine above us in the dark.
Let's have no secrets that can sometimes spoil
A budding love. Let's keep this glowing spark
Alive, gleaming like a deep-sea diver's pearl,
the song of springtime's ever rising lark!

SONNET V

Can it be right to give what I can't give?
Your willing face behind its veil of tears

Begs for my kiss, a sweet caress that lives
Locked in my breast. Your youthful hope tears
me apart. My sweetest girl, please don't grieve
My lack of kisses! My only fear
Is that I'll cease to live
In your good heart, in the long years
After I have left. Take this Venice-glass
For my remembrance. And when I'm finally dust
Let your healed heart love another. So, alas,
My gifts are mine, and though it seems unjust,
Not mine to give away. I too shall pass
From your beloved gaze—and so I must.

ACKNOWLEDGMENTS

Where to begin? Perhaps I should first thank all the living actresses who played Blanche DuBois who make up the substance of this book: Ann-Margret, Jessica Lange, Patricia Clarkson, Cate Blanchett, and Jemier Jenkins, who have all spoken eloquently about the challenges and repercussions of playing Blanche. Special gratitude goes to the director Peter Callender and the actresses Patricia Clarkson and Jemier Jenkins for their particularly insightful, bracing, and deeply informed interviews. Their perspectives—sometimes surprising—have greatly enriched this book.

A trio of friends and former colleagues kept up a chorus of encouragement: Susan Donaldson, whose area is Southern studies, suggested several texts that I found invaluable. Deborah Morse, a Victorian scholar with deep knowledge of the Brontë sisters, engaged me in many useful conversations about sisters, feminine and feminist sensibilities, and the fate

of the fallen woman. The poet and biographer Hilary Holla-day (author of *The Power of Adrienne Rich*) read and advised me on several early chapters of this book. Her insights were a boon, and the time she spent on those early pages was an act of generosity. My appreciation to Susan, Deborah, and Hilary!

Another good friend, the late Eva Burch, kindly offered keen observations on my invented poems attributed to Allan Grey at the end of this book, drawing on her deep knowledge and love of poetry.

I remain ever grateful to my patient and forbearing editor, Gail Winston, and the editor in chief of HarperCollins, Jona-than Burnham, who both immediately saw and embraced the possibilities of *Blanche: The Life and Times of Tennessee Wil-liams's Greatest Creation*, and to Sara Nelson, who steered the manuscript to safe harbor. My more-than-able agent, William LoTurco, was also an early supporter. A shout-out as well to Hayley Salmon, for her keen editorial eye, her patience, and her grace under pressure!

I should add that books of this kind rest upon the shoul-ders of biographers, essayists, and scholars who have gone before. Chief among them are James Grissom, John Lahr, Lyle Leverich, Donald Spoto, and Sam Staggs, whose thor-ough and insightful chronicles of Tennessee Williams's life and work were of inestimable value. A complete list of sources follows.

Finally—last but never least—Sam Kashner, for his coun-sel and encouragement, as always.

SOURCES

BOOKS

Ann-Margret, with Todd Gold. *Ann-Margret, My Story.* New York: G. P. Putman's Sons, 1994.

Brando, Marlon, with Robert Lindsey. *Songs My Mother Taught Me.* New York: Random House, 1994.

Brundage, W. Fitzhugh. *The Southern Past: A Clash of Race and Memory.* Cambridge, Massachusetts: Belknap Press of Harvard University Press, 2005.

Cash, W. J. *The Mind of the South*, with new introduction by Bertram Wyatt-Brown. New York: Vintage Books/Random House, 1941, 1991.

Cobb, James C., *The Most Southern Place on Earth: The Mississippi Delta and the Roots of Regional Identity.* New York: Oxford University Press, 1992.

Coleman, Terry. *Olivier.* New York: Henry Holt & Co., 1992.

Dunaway, Faye. *Looking for Gatsby.* New York: Simon & Schuster, 1995.

Entzminger, Betina. *The Belle Gone Bad: Southern White Women Writers and the Dark Seductress.* Baton Rouge: Louisiana State University Press, 2002.

Galloway, Stephen. *Truly, Madly*. New York: Hachette Book Group, 2022.

Groneman, Carol. *Nymphomania: A History*. New York: W. W. Norton, 2000.

Grossman, James. *Follies of God*. New York: Alfred A. Knopf, 2015.

Kazan, Elia. *A Life*. New York: Anchor Books, Doubleday, 1989.

Lahr, John, ed. *The Diaries of Kenneth Tynan*. New York and London: Bloomsbury, 2001.

———. *Tennessee Williams, Mad Pilgrimage of the Flesh*. New York: W. W. Norton, 2014.

Leverich, Lyle. *Tom: The Unknown Tennessee Williams*. New York: W. W. Norton, 1995.

McCarthy, Mary. *A Bolt from the Blue and Other Essays*. New York: New York Review of Books, 2002.

Mendelsohn, Daniel. *How Beautiful It Is and How Easily It Can Be Broken*. New York and London: Harper Perennial, 2009.

Olivier, Laurence. *Confessions of an Actor*. London: G. K. Hall, 1983.

Spoto, Donald. *The Kindness of Strangers*. New York and London: W. W. Norton, 2014.

Staggs, Sam. *When Blanche Met Brando*. New York: St. Martin's, 2005.

Strachan, Alan. *Dark Star: A Biography of Vivien Leigh*. London and New York: Bloomsbury Academic, 2019.

Williams, Tennessee. *27 Wagons Full of Cotton and Other Plays*. New York: New Directions, 1945.

———. *Collected Stories*. New York: New Directions, 1939.

———. *Memoirs*. New York: Doubleday & Co., 1972.

———. *Suddenly Last Summer*, in *Garden District*. New York: New Directions, 1947.

———. With an Introduction by Arthur Miller. *A Streetcar Named Desire*. New York: New Directions, 1947.

SOURCES

ARTICLES

Als, Hilton. "Cate Blanchett and Blanche DuBois." *New York Review of Books*, December 23, 2009.

Barach, Gilad. "Millennial Notes." Theatrius, March 8, 2018.

Barry, Ellen. "A Moment of Truth." *New York Times*, May 3, 2022.

Brantley, Ben. "A Fragile Flower Rooted to the Earth." *New York Times*, May 18, 2004.

Brody, Jane. "The Challenges of Bipolar Disorder in Young People." *New York Times*, July 6, 2021.

Cipriaso, Celena. "Multiracial Take on *A Streetcar Named Desire*." *The Root*, April 24, 2012.

Dargis, Manohla. "Pride Stays, Even After the Fall." *New York Times*, July 25, 2013.

Denby, David. "Timely Projects." *The New Yorker*, July 22, 2013.

Ebert, Roger. "A Streetcar Named Desire." *Chicago Sun-Times*, July 17, 1983.

Gerard, Jeremy. "CBS Playhouse '90s A Streetcar Named Desire." *Variety*, October 23, 1995.

Green, Adam. "Cate Blanchett in *A Streetcar Named Desire*." *Vogue*, November 2009.

Gussow, Mel. "Rose Williams, 86, Sister and the Muse of Playwright." *New York Times*, September 7, 1996.

Hill, Michael E. "Interview with Ann-Margret." *Washington Post*, March 4, 1984.

Isherwood, Charles. "A Streetcar Named Desire." *Variety*, May 16, 2004.

Janiak, Lily. "A Welcome Tennessee Williams Revisit by African-American Shakespeare." *San Francisco Chronicle*, February 27, 2018.

Kael, Pauline. "A Streetcar Named Desire." *New Yorker*, January 2, 2018.

SOURCES

Kim, Sophie. "African-American Shakespeare Company's 'A Streetcar Named Desire' Is on Track." *Daily Californian*, March 15, 2018.

King, Susan. "The Highs and Lows of Being Blanche." *Los Angeles Times*, October 29, 1995.

McShane, Julianne. "Queer 'Desire': New 'Streetcar' Features Trans Actor as Female Lead." *Brooklyn Paper*, May 2, 2019.

Miller, Kenneth. "Play Video." *AARP The Magazine*, July 18, 2017.

O'Connor, John H. "Ann-Margret Is Riveting as Blanche DuBois." *New York Times*, March 4, 1984.

Okon, Christine. "AASC Brings New Light to *Streetcar Named Desire*." Theater & Such, March 16, 2018.

Pond, Steve. "How Cate Blanchett Got Ready to Play a Boozer in Woody Allen's 'Blue Jasmine.'" The Wrap, July 26, 2013.

Reed, Rex. "Woody Is Back: *Blue Jasmine* Is a Triumphant Take on *A Streetcar Named Desire*." *Observer*, July 23, 2013.

Rich, Frank. "A Streetcar Named Desire: Alec Baldwin Does Battle with the Ghosts." *New York Times*, April 13, 1992.

Rogue Magazine. Interview with Patricia Clarkson. December 18, 2018.

Tim Treanor. *DC Theatre Scene*, November 2, 2009.

Walker, Julia. "The Birth of the 'Cool': Marlon Brando and the Afro-Aesthetics of 'Psychological-Realist Acting.'" *Studies in Theatre and Performance* 41, no. 1, 11–131.

NOTES

INTRODUCTION: **DOES BLANCHE DUBOIS STILL MATTER?**

3 "Williams would have loved": Alan Strachan, *Dark Star: Biography of Vivien Leigh* (London and New York: Bloomsbury Academic, 2019), 156.

7 "I wandered through it": Faye Dunaway, *Looking for Gatsby* (New York: Simon & Schuster, 1995), 238.

9 "It was a period of accumulation": Quoted in Donald Spoto, *The Kindness of Strangers* (New York and London: W. W. Norton, 2014), 68.

10 "It's the only time Blanche": https://en.wikipedia.org/wiki /Tallulah_Bankhead

11 "all actresses who have played actresses": Pedro Almodóvar's dedication to *All About My Mother*, IMDB, www.imdb.com/title /tt0185125.

11 "complex character and fight for love": Julianne McShane, "Queer 'Desire': New 'Streetcar' Features Trans Actor as Female Lead," *Brooklyn Paper*, May 2, 2019.

11 "The genteel belle, the imperious": Ben Brantley, "A Fragile Flower Rooted to the Earth," *New York Times*, December 2, 2009.

13 "Every Blanche who played it": Michael Kahn, on NPR's *Weekend Edition*, with Lynn Neary, March 15, 2008.

13 "I think because I was funny": Interview with Patricia Clarkson, May 21, 2022.

14 "It's the loneliest part to live through": Rosemary Harris on NPR, March 15, 2008.

14 "Blanche is still there": Sam Staggs, *When Blanche Met Brando* (New York: St. Martin's, 2005), xix.

14 "Everything I own": Tennessee Williams, *A Streetcar Named Desire* (New York: New Directions, 1947), scene 2, 41.

15 "Soft people have got to shimmer and glow": Williams, *A Streetcar Named Desire*, scene 5, 92.

15 "Thea Van Runkle": Dunaway, *Looking for Gatsby*, 241.

15 "in flimsy pastels": Dunaway, *Looking for Gatsby*, 241.

17 "beautiful dream": Daniel Mendelsohn, *How Beautiful It Is and How Easily It Can Be Broken* (New York and London: Harper Perennial, 2009), 42.

20 "Essentially he argued quite forcefully": Dunaway, *Looking for Gatsby*, 239.

22 "always wanted to see a major production": Celena Cipriaso, "Multiracial Take on *A Streetcar Named Desire*," *The Root*, April 24, 2012.

22 "He understood human beings": Cipriaso, "Multiracial Take on *A Streetcar Named Desire*."

CHAPTER ONE: PORTRAIT OF A GIRL IN GLASS: ROSE WILLIAMS

25 "Oh, Laura, Laura, I tried to leave": Quoted in Mel Gussow, "Rose Williams, 86, Sister and the Muse of Playwright," *New York Times*, September 7, 1996.

26 "With her romantically unreal": Lyle Leverich, *Tom: The Unknown Tennessee Williams* (New York: W. W. Norton, 1995), 61.

28 "on a block which also contained": Tennessee Williams, *Collected Stories* (New York: New Directions, 1939), 110.

29 "spacious yards, porches, and big shade trees": John Lahr: *Mad Pilgrimage of the Flesh* (New York: W. W. Norton, 2014), 36.

29 "a light and delicate appearance": Lahr, *Tennessee Williams*, 36–37.

29 "They stood for the small and tender": Quoted in Lahr, *Tennessee Williams*, 38.

30 "There is an adorable girl": Leverich, *Tom: The Unknown Tennessee Williams*, 71.

30 "She's like Isabel": Williams, *Collected Stories*, 273.

30 "the magical intimacy of our childhood": Ibid., 274.

31 "Tell Tom to keep": Leverich, *Tom: The Unknown Tennessee Williams*, 70.

31 "school for Southern young ladies": Leverich, Ibid., 68.

32 "It did not work out": Williams, *Collected Stories*, 110.

34 "Rose seems perfectly well": Leverich, *Tom: The Unknown Tennessee Williams*, 197.

34 "Certainly there is absolutely nothing": Ibid., 197.

34 "They can't seem to realize": Ibid., 197.

35 "seems anxious to get home": Ibid., 198.

35 "I hate to take it, especially as the trip": Ibid., 198.

36 "If you study Psychology": Ibid., 198.

36 "walking on eggs": Lahr, *Tennessee Williams*, 48.

36 "The old man has just now": Ibid., 48.

36 "As soon as she crossed": Leverich, *Tom: The Unknown Tennessee Williams*, 199–200.

37 "Monday Jan. 25 Tragedy": Ibid., 200.

37 "She has been raving on the subject": Ibid., 200.

37 "little eccentricities had begun": Ibid., 200–201.

38 "She exhibited open hatred": Ibid., 200.

38 "I'm quite worn out with it all": Ibid., 201.

38 "a hundred percent better": Ibid., 201.

38 "After all, one's sanity is worth": Ibid., 205.

39 "I want you to know": Ibid., 205.

39 "Of course I will write to Cornelius": Ibid., 206.

39 "R. will probably go to Sanitarium in Asheville": Ibid., 210.

39 "insisted upon going in": Ibid., 212.

40 "She is a metal forged by love": Ibid., 212–13.

43 "drove Mother to sanitarium to visit R.": Ibid., 222.

43 "first signs of madness": Lahr, *Tennessee Williams*, 54.

46 "if you're still alive after dying": Williams, *Suddenly Last Summer*, scene 4, in *Garden District* (New York: New Directions, 1947), 178.

46 "Rose. Her head cut open.": Quoted in Lahr, *Tennessee Williams*, 366.

47 "a literary motif, an invocation": Lahr, *Tennessee Williams*.

49 "Are you trying to ruin us?": Williams, *Suddenly Last Summer*, scene 3, 152.

49 "the truth's the only thing I have never resisted.": Williams, *Suddenly Last Summer*, scene 4, 169.

50 "was wracked with guilt": Introduction to Williams, *Suddenly Last Summer*, 127.

50 "high strung": Williams, *Suddenly Last Summer*, scene 3, 155.

50 "I think we ought at least to consider": Williams, *Suddenly Last Summer*, scene 4, 178.

51 "You disgust me": Lahr, *Tennessee Williams*, 367.

52 "That cool yellow silk": Williams, *A Streetcar Named Desire*, scene 11, 165.

CHAPTER TWO: THE UNBEARABLE WHITENESS OF BLANCHE DUBOIS: JESSICA TANDY

55 "The moment I read [*Portrait of a Madonna*]": Jessica Tandy, quoted in James Grissom, *Follies of God* (New York: Alfred A. Knopf, 2015), 114.

56 "When I first imagined a woman": Williams, quoted in Grissom, *Follies of God*.

56 "I was freest when I could live": Grissom, *Follies of God*, 70.

56 "tiny and alabaster white": Ibid., 91.

57 "a ghost recaptured": Lyle Leverich, *Tom: The Unknown Tennessee Williams* (New York: W. W. Norton, 1995), 212–13.

57 "titanic sprite": Grissom, *Follies of God*, 85.

57 "violently uneducated": Ibid., 90.

57 "an obsessive archetype": Ibid., 96.

57 "I have no needs": Ibid., 98.

58 "[Tennessee] truly believed": Ibid., 113.

59 "Mother was president of the anti-sex league": Leverich, *Tom: The Unknown Tennessee Williams*, 61.

59 "very much of her time": Grissom, *Follies of God*, 103.

59 "An ugly woman": Ibid., 104.

60 "I think Tennessee felt guilty": Ibid., 79–80.

61 "And the moment I read it": Ibid., 114.

61 "I'm the first to admit": Ibid., 114.

62 "No RADA or Central School": Ibid., 115.

62 "Respectfully dedicated to": Tennessee Williams, *27 Wagons Full of Cotton and Other Plays* (New York: New Directions, 1945), 87.

64 "I used to think": Ibid., *99*.

64 "they cooled the watermelons": Ibid., 93.

65 The timing was perfect": Elia Kazan, *A Life* (New York: Anchor Books, Doubleday, 1989), 340.

65 "The rehearsals of *Streetcar* were a joy . . .": Ibid., 342.

65 "my strange ducks out of the Studio": Ibid., 342.

66 "I was very fond of this man": Ibid., 343.

66 "She can do better": Ibid., 343.

67 "He hung around the back": Ibid., 344.

67 "Jessica is a very good actress": Marlon Brando, *Songs My Mother Taught Me* (New York: Random House, 1994), 122.

68 "awful woman": Kazan, *A Life*, 345.

68 "too shrill to elicit": Brando, *Songs My Mother Taught Me*, 124.

68 "a foolish character": Ibid., 124.

CHAPTER THREE: "DREADFULLY MAGNIFICENT": VIVIEN LEIGH

71 "Vivien Leigh gives one of those rare performances": Pauline Kael quoted in Alan Strachan, *Dark Star: A Biography of Vivien Leigh* (London and New York: Bloomsbury Academic, 2019), 166.

72 ". . . a bored nymphomaniac": Kenneth Tynan quoted in Strachan, *Dark Star*, 157.

72 "stale on the play, [and] needed a different actress": Kazan quoted in Sam Staggs, *When Blanche Met Brando* (New York: St. Martin's, 2005), 140.

73 "a mere $100,000": Staggs, *When Blanche Met Brando*, 141.

75 "in lambent soft focus throughout": Strachan, *Dark Star*, 151.

75 "the British had an inherent incapacity": Ibid.

76 "older man": Ibid., 153.

78 "STANLEY: [*He pulls open the wardrobe trunk*]": Tennessee Williams, *A Streetcar Named Desire* (New York: New Directions, 1947), scene 2, 33.

79 "If it hadn't been for me": Laurence Olivier quoted in Strachan, *Dark Star*, 154.

79 "our distinguished director": Strachan, *Dark Star*, 155.

79 "They went at it hammer and tongs": Ibid., 155.

80 "too well-bred to emote effectively on stage": Ibid., 151.

80 "A Vehicle Named Vivien": Staggs, *When Blanche Met Brando*, 111.

80 "You misapprehend the play": Terry Coleman, *Olivier* (New York: Henry Holt & Co., 1992), 218.

80 "shaking like an autumn leaf": Strachan, *Dark Star*, 158.

81 "tipped her into madness": Staggs, *When Blanche Met Brando*, 119.

81 "Of all her roles": Strachan, *Dark Star*, 159.

81 "Why then, in 1949, did Olivier": Coleman, *Olivier*, 214.

81 "for being an actress": Ibid., 214–15.

82 "several of whom had been to see the play": Strachan, *Dark Star*, 159.

82 "We don't see Blanche depressed": Staggs, *When Blanche Met Brando*, 119.

83 "The more I work with the character of Blanche": Kazan quoted in Staggs, *When Blanche Met Brando*, 118.

85 "many intimacies with strangers": Williams, *A Streetcar Named Desire*, scene 9, 146.

85 "by loneliness and the isolation": Strachan, *Dark Star*, 159.

88 "Vivien Leigh gives one of those rare performances": Pauline Kael quoted in Strachan, *Dark Star*, 166.

89 "For the first time the idea of suicide": Laurence Olivier, *Confessions*, 239.

CHAPTER FOUR: **KITTEN WITH A WHIP: ANN-MARGRET**

91 "We were taught manners": Michael E. Hill, "Interview with Ann-Margret," *Washington Post*, March 4, 1984.

94 "she may seem a peculiar choice": John H. O'Connor, "Ann-Margret Is Riveting as Blanche DuBois," *New York Times*, March 4, 1984.

94 "Tennessee Williams wanted me": Hill, "Interview with Ann-Margret."

95 "I zeroed in on this woman": Hill, "Interview with Ann-Margret."

96 "I . . . met one of Tennessee Williams's good friends": Ann-Margret, *Ann-Margret, My Story* (New York: G. P. Putnam's Sons, 1994), 309.

96 "By the time the production arrived": Ibid., 309.

96 "I froze": Ibid., 310.

97 "She knew she was dying": Tennessee Williams, *A Streetcar Named Desire* (New York: New Directions, 1947), scene 3, 58.

98 "I like you to be exactly the way": Williams, *A Streetcar Named Desire*, scene 6, 103.

98 "He was a boy, just a boy": Williams, *A Streetcar Named Desire*, scene 6, 114.

99 "there was something different": Williams, *A Streetcar Named Desire*, scene 6,

99 "I saw! I know! You disgust me . . . !": Williams, *A Streetcar Named Desire*, scene 6, 115.

99 "You need somebody": Williams, *A Streetcar Named Desire*, scene 6, 116.

100 "I can smell the sea air": Williams, *A Streetcar Named Desire*, scene 11, 170.

101 "Well, Stella—you're going to reproach me": Williams, *A Streetcar Named Desire*, scene 1, 20.

102 "You mustn't wait on me!": Williams, *A Streetcar Named Desire*, scene 5, 92.

102 "I like to wait on you, Blanche": Williams, *A Streetcar Named Desire*, scene 5, 92.

103 "You didn't know Blanche as a girl": Williams, *A Streetcar Named Desire*, scene 8, 136.

104 "Nymphomania is a metaphor": Carol Groneman, *Nymphomania: A History* (New York: W. W. Norton, 2000), xxii.

104 "bags of pounded ice": Ibid., 11–12.

104 "mild nymphomania": Ibid., 12.

104 "a nymphomaniac's fate": Ibid., 11.

105 "There was some physical likeness": Lyle Leverich, *Tom: The Unknown Tennessee Williams* (New York: W. W. Norton, 1995), 149.

106 "*Streetcar* [is] the finest role": Roger Ebert, "A Streetcar Named Desire," *Chicago Sun-Times*, July 17, 1983.

106 "plunged into the part so deeply": Hill, "Interview with Ann-Margret."

106 "I was losing it": Hill, "Interview with Ann-Margret."

107 "I had just stepped on stage": Ann-Margret, *Ann-Margret, My Story*, 310–11.

CHAPTER FIVE: MOONLIGHT BECOMES YOU: JESSICA LANGE

109 "When you get down to the core": quoted in Susan King, "The Highs and Lows of Being Blanche," *Los Angeles Times*, October 29, 1995.

110 "There has never been a part": Ibid.

110 "I think maybe for a man it's 'Hamlet'": Ibid.

110 "lack of stage technique": Frank Rich, "A Streetcar Named Desire: Alec Baldwin Does Battle with the Ghosts," *New York Times*, April 13, 1992.

111 "Actors have to be half-mad to star": Ibid.

111 "unequal partner in unhinged desire": Ibid.

111 "woman who has endured": Ibid.

111 "It's a very haunting character to play": King, "The Highs and Lows of Being Blanche."

112 "This is what actors do this for": Ibid.

112 "I hate not getting performances right": Kenneth Miller, "Play Video," *AARP The Magazine*, July 18, 2017.

112 "let everything settle in": Miller, "Play Video."

113 "Because of the intimacy of doing it on film": King, "The Highs and Lows of Being Blanche."

113 "he understood the play very well": Ibid.

113 "She would do stuff and I would be": Ibid.

113 "being off camera and watching Jessica and Alec": Ibid.

115 "that's like Irish, isn't it": Williams, *A Streetcar Named Desire*, scene 1, 16.

115 "Death is expensive, Miss Stella!": Williams, *A Streetcar Named Desire*, scene 1, 22.

115 "I just got in the habit of being quiet around you": Williams, *A Streetcar Named Desire*, scene 1, 13.

115 "You men with your big clumsy fingers": Williams, *A Streetcar Named Desire*, scene 2, 37.

116 "A woman's charm is 50 percent illusion.": Williams, *A Streetcar Named Desire*, scene 2, 41.

116 "at no Galatoire's,": Williams, *A Streetcar Named Desire*, scene 2, 29.

117 "poker should not be played": Williams, *A Streetcar Named Desire*, scene 3, 63.

117 "a wonderfully lumpy Mama's boy": John H. O'Connor, "Ann-Margret Is Riveting as Blanche DuBois," *New York Times*, March 4, 1984.

119 "I like you to be exactly the way": Williams, *A Streetcar Named Desire*, scene 6, 103.

120 "Isn't she extraordinary?": King, "The Highs and Lows of Being Blanche."

120 "Lange gives this wounded creature": Jeremy Gerard, "CBS Playhouse '90s A Streetcar Named Desire" *Variety*, October 23, 1995.

121 "It's doubtful whether any but hardcore": Gerard, "CBS Playhouse '90s A Streetcar Named Desire."

121 "gets under your skin": King, "The Highs and Lows of Being Blanche."

121 "has so much texture, so many layers": Ibid.

122 "Whoever you are—I have always depended": Williams, *A Streetcar Named Desire*, scene 11, 178.

122 "Blanche! Blanche! Blanche!": King, "The Highs and Lows of Being Blanche."

122 "This game is seven-card stud": Ibid.

122 "loved me with everything but": Quoted in John Lahr, ed., *The Diaries of Kenneth Tynan* (New York and London: Bloomsbury, 2001), 118.

122 "narcotized sleep": Lahr, *The Diaries of Kenneth Tynan*, 120.

122 "a mutant breed, a person who": Ibid., 118.

NOTES

CHAPTER SIX: A MARTINI AT A SODA FOUNTAIN: PATRICIA CLARKSON

125 "It destroys your life": Patricia Clarkson interview in *Rogue Magazine*, December 18, 2018.

127 "I didn't grow up in a white-column house": Transcripts of Sam Kashner's interviews with Patricia Clarkson.

127 "Have you ever had bourbon, ginger, and orange?": Clarkson interview.

127 "I understood the beauty of him": Clarkson interview.

128 "many, many things at this point": Clarkson interview.

129 "can shift this. I mean": Clarkson interview.

129 "wry, dry and ruefully self-aware": Ben Brantley, "It's 'Streetcar,' But Blanche Has a Sly Side," *New York Times*, May 18, 2004.

129 "exceptionally bright woman": Clarkson interview.

130 "sleep with everybody": Clarkson interview.

130 "knowing, flinty quality to her performance": Charles Isherwood, "A Streetcar Named Desire," *Variety*, May 16, 2004.

131 "immensely touchingly": Ibid.

132 "hang back with the brutes!": Tennessee Williams, *A Streetcar Named Desire* (New York: New Directions, 1947), scene 4, 83.

132 "Stella's last cries of remorse": Isherwood, "A Streetcar Named Desire."

132 "she's still got her fineries": Clarkson interview.

132 "Clothes are my passion": Williams, *A Streetcar Named Desire*, scene 2, 38.

132 "They're everything to her": Clarkson interview.

134 "When you grow up in the South": Clarkson interview.

136 *"Voulez-vous coucher avec moi ce soir?"*: Williams, *A Streetcar Named Desire*, scene 6, 104.

136 "You are not the delicate type": Williams, *A Streetcar Named Desire*, scene 6, 106.

136 "I weigh two hundred and seven pounds": Williams, *A Streetcar Named Desire*, scene 6, 107.

137 "stuck the revolver into his mouth, and fired": Williams, *A Streetcar Named Desire*, scene 6, 115.

138 "clean enough to bring in the house": Williams, *A Streetcar Named Desire*, scene 9, 150.

138 "Flamingo? No! Tarantula": Williams, *A Streetcar Named Desire*, scene 9, 146.

140 "Dusk settles deeper. The music": Williams, *A Streetcar Named Desire*, scene 5, 96.

140 "a little glimmer of lightning": Williams, *A Streetcar Named Desire*, scene 5, 97.

140 "Well, well! What can I do for *you?*": Williams, *A Streetcar Named Desire*, scene 5, 97.

140 "I'm collecting for *The Evening Star*": Williams, *A Streetcar Named Desire*, scene 5, 97.

140 "I didn't know that stars took up collections": Williams, *A Streetcar Named Desire*, scene 5, 97.

140 "So late? Don't you just love": Williams, *A Streetcar Named Desire*, scene 5, 97–98.

140 "You make my mouth water": Williams, *A Streetcar Named Desire*, scene 5, 98.

141 "Young man! Young, young, young man!": Williams, *A Streetcar Named Desire*, scene 5, 99.

141 "The moment can be either poignant or prurient": Isherwood, "A Streetcar Named Desire."

141 "seamy drama about the stripping away": Ibid.

141 "actually a beautiful scene": Clarkson interview.

142 "She is flirty and sweet": Clarkson interview.

142 "People have to remember that Blanche": Clarkson interview, *Rogue Magazine*.

143 "To do eight shows a week—it will kill you.": Clarkson interview.

143 "Sometimes—there's God—so quickly!": Williams, *A Streetcar Named Desire*, scene 6, 116.

143 "You have to have a great mentor": Clarkson interview.

143 "After the rape, she's kind of lost in abjectness": Clarkson interview.

144 "I think it's a moment she comes back to herself": Clarkson interview.

CHAPTER SEVEN: THE TWO BLANCHES: CATE BLANCHETT

145 "That flame of inspiration": Cate Blanchett interview on *The Charlie Rose Show*, December 11, 2009.

146 "heart jumped in happiness": Liv Ullmann interview on *The Charlie Rose Show*, December 10, 2009.

147 "very camp or very melodramatic.": Blanchett interview, *The Charlie Rose Show*.

147 "gives a performance as heartbreaking": Adam Green, "Cate Blanchett in 'A Streetcar Named Desire,'" *Vogue*, November 2009.

148 "exudes guileless carnal longing": Ibid.

148 "It is as though a gifted artist": Tim Treanor, "*A Streetcar Named Desire*. Cate Blanchett as Blanche DuBois—magnificent. Superb. Spot-on," *DC Theatre Scene*, November 2, 2009.

148 "we see things that are very interesting": Ullmann interview, *The Charlie Rose Show*.

150 "carried the whiff of doom": Treanor, "*A Streetcar Named Desire*. Cate Blanchett as Blanche DuBois—magnificent. Superb. Spot-on."

150 "walking around the streets of New Orleans": Ibid.

150 "the imperious English teacher": Ben Brantley, "It's 'Streetcar,' But Blanche Has a Sly Side," *New York Times*, May 18, 2004.

151 "Part of Blanche's tragedy": Hilton Als, "Cate Blanchett and Blanche DuBois OK," *New York Review of Books*, December 23, 2009.

151 "If you talk about [the play]": Blanchett interview, *The Charlie Rose Show.*

156 "From the moment she appears": Manohla Dargis, "Pride Stays, Even After the Fall," *New York Times,* July 25, 2013.

157 "Jasmine is a snob and a liar": David Denby, "Timely Projects," *New Yorker,* July 22, 2013.

157 "is nuts about [Ginger]": Ibid.

158 "Like Blanche in *Streetcar,* Jasmine": Rex Reed, "Woody Is Back: *Blue Jasmine* Is a Triumphant Take on *A Streetcar Named Desire,*" *Observer,* July 23, 2013.

159 "I watched a lot of Woody's films": Steve Pond, "How Cate Blanchett Got Ready to Play a Boozer in Woody Allen's 'Blue Jasmine,'" *The Wrap,* July 26, 2013.

159 "did a lot of people watching": Blanchett interview, *The Charlie Rose Show.*

159 "How did they get there?": Blanchett interview, *The Charlie Rose Show.*

CHAPTER EIGHT: THE ETERNAL BRIDE: JEMIER JENKINS

161 "[Tennessee] always wanted to see": Emily Mann, quoted in Celena Cipriaso, "Multiracial Take on *A Streetcar Named Desire,*" *The Root,* April 24, 2012.

162 "a Blanche with a bloodline similar to mine": Ellen Holly quoted in Sam Staggs, *When Blanche Met Brando* (New York: St. Martin's, 2005), 286.

163 "What would we have done": Staggs, *When Blanche Met Brando,* 287.

163 "It is important to add here": Ibid., 287.

163 "He understood human beings": Cipriaso, "Multiracial Take on *A Streetcar Named Desire.*"

164 "a play of great political bravery": Martin Sherman, introduction to Tennessee Williams, *Garden District* (New York: New Directions, 1947), 8.

164 "in the most venal and corrupt Southern town": Sherman, introduction to Williams, *Garden District*, 6.

165 "class and ethnic references": Cipriaso, "Multiracial Take on *A Streetcar Named Desire*."

166 "simply a masterpiece": Gilad Barach, *"Millennial Notes,"* *Theatrius*, March 8, 2018.

166 "L. Peter Callender's 'Streetcar' goes beyond 'Desire'": Barach, *"Millennial Notes."*

167 "were very upper-class Black. They owned property": Author's interview with Peter Callender, February 2, 2022.

168 "They were actually doing a colorblind casting": Author's interview with Jemier Jenkins, February 24, 2022.

169 "She's very, very fair skinned": Jenkins interview.

169 "acts like an animal, has an animal's habits": Tennessee Williams, *A Streetcar Named Desire* (New York: New Directions, 1947), scene 4, 83.

169 "I pulled you down off them columns!": Williams, *A Streetcar Named Desire*, scene 8, 137.

170 "his dominating gait and his resistance to Blanche's beauty": Barach, "Millennial Notes."

170 "did not want Stanley": Callender interview.

171 "was one of the highlights": Jenkins interview.

171 "neurotic allure": Barach, *"Millennial Notes."*

173 "as out of place as an orchid": Christine Okon, "AASC Brings New Light to *Streetcar Named Desire*," *Theater & Such*, March 16, 2018.

173 "Jemier was fabulous in the play": Callender interview.

174 "Oh, I hope candles are going to glow": Williams, *A Streetcar Named Desire*, scene 8, 133.

174 "What poetry!": Williams, *A Streetcar Named Desire*, scene 8, 134.

176 "there was a young lady, a dancer": Callender interview.

177 "Until Blanche, no woman has ever turned down": Callender interview.

NOTES

178 "You didn't know Blanche as a girl": Williams, *A Streetcar Named Desire*, scene 8, 136.

180 "pretty blue jacket": Williams, *A Streetcar Named Desire*, scene 11, 169.

180 "When the last dependable person": Jenkins interview.

182 "didn't feel crazy at all": Jenkins interview.

182 "I was very actively trying to release, release, release": Jenkins interview.

INDEX

Page numbers of photographs appear in italics.
Key to abbreviations: TW = Tennessee Williams;
Streetcar = *A Streetcar Named Desire*

Actors' Lab, Los Angeles, 65
Actors Studio, 109, 120, 162
African American Shakespeare
 Company, San Francisco
 all-Black *Streetcar* (2018), 2, 161,
 162–63, 165–84
Ahmanson Theatre, Los
 Angeles, 7
Aldwych Theatre, London, 82
 Streetcar (1949), 12–13, 72, 75,
 78–81
All About My Mother (Almodóvar),
 10–11
Allen, Woody, 3, 146, 155, 157,
 159
Almodóvar, Pedro, 10–11
Als, Hilton, 2, 3, 19, 151
American Conservatory Theater,
 San Francisco, 166
Anderson, Gillian, 12
Ann-Margret, 93, 96
 as Blanche DuBois, 11, 12, 21, *91*,
 92–107, 115, 182

Armory, Mark, 79
Atkinson, Brooks, 19

Babe: Pig in the City (film), 3
Baldwin, Alec, 3, 110, 111, 123,
 156, 158
Ballard, Lucinda, 15, 76
Bankhead, Tallulah, 10, 12, 13, 16,
 127
Barach, Gilad, 165–66, 170
Beauty Queen of Leenane, The
 (McDonagh), 126
Belle Reve (in *Streetcar*, Blanche's
 lost home), 15, 17, 52–53, 73,
 77, 78, 85, 101–2, 104, 115,
 116, 129, 131, 154, 174
Ben Greet Academy, 62
Bent (Sherman), 50, 164
Bergman, Ingmar, 146
Bethel Methodist Home, Ossining,
 N.Y., 53, 185
bipolar illness, 21, 33, 81–83, 93,
 104, 111

Birds, The (film), 70
Blackwood, Caroline, 82
Blanchard, Terence, 165
Blanchett, Cate
 as Blanche DuBois, 2, 3, 11, *145*, 145–55
 in *Blue Jasmine*, 3, 146, 155–59
Bloom, Claire, 12–13, 23
Blue Jasmine (film), 3, 146, 155–59
Blue Sky (film), 111
Bonnie and Clyde (film), 15
Braden, Bernard, 79
Brando, Marlon, 20, 65–68, 69, 72, 93, 111, 122–23
Brantley, Ben, 11, 19, 129, 150
Broadhurst Theatre, New York
 multiracial cast *Streetcar* (2012), 2, 163, 165, 166, 168–69
Brooklyn Academy of Music (BAM)
 Streetcar (2009), 2, 3, 11, 146
Browning, Elizabeth Barrett, 18, 83, 97, 118, 174, 190
Buras, La., 5, 6
Burton, Richard, 12

Caesar and Cleopatra (film), 81
Callender, L. Peter, 2, 162
 African American *Streetcar* and, 165–68, 170–71, 173–81, 183–84
 changes to TW's text, 170–71
Cannavale, Bobby, 156, 157
Carnal Knowledge (film), 94, 96
CBS TV *Playhouse 90*
 Streetcar (1995), 112–23
Charlie Rose Show: Ullmann and Blanchett interview, 146, 148–49

Chicago Sun-Times: Ebert interviews Ann-Margret, 106
Cholodenko, Lisa, 126
Clarksdale, Miss., 28, 30
Clarkson, Jacqueline Brechtel, 133
Clarkson, Patricia
 as Blanche DuBois, 11–12, 13, 16, 21, *125*, 125–44, 182
 career, awards, films, plays, 126–27
Clay, Andrew Dice, 157
Clift, Montgomery, 47, 48
Close, Glenn, 12
Coconut Grove Playhouse, Fla.
 Streetcar (1955), 10
Coleman, Terry, 81
Columbus, Miss., 8, 28, 164, 186
Confessions of an Actor (Olivier), 78–79, 89
Cook, Alistair, 69
Cooper, Bradley, 127
Cooper, Lady Diana, 80
Coward, Nöel, 80
Crimes and Misdemeanors (film), 159
Cronyn, Hume, 61, 62, 65, 66, 67, 69, 70, 130
Crumm, Mary Emily, 91, 95

Dakin, Walter E. (TW's grandfather), 28, 31, 33, 38, 122, 164
D'Angelo, Beverly, 94, 96, 102, 115
Danner, Blythe, 12, 16
Dargis, Manohla, 147, 156
Dark Star (Strachan), 75, 81
Dawson, Bumble, 76
DC Theatre Scene: review of Ullman's *Streetcar*, 148, 150
Denby, David, 157–58

Dent, Alan, 80
Diagnostic and Statistical Manual of Mental Disorders, 46
Driving Miss Daisy (film), 70
DuBois, Blanche (*Streetcar* character), 98–99, 158
 actresses who never played the role, 13, 56–59, 60
 actresses who played the role (overview), 2–3, 4, 6–7, 10, 11–14, 15, 16, 20 (*see also specific actresses*)
 as alter ego of TW, 18, 83, 105, 155
 Ann-Margret as, 11, 12, 21, *91*, 92–107, 115
 Black actresses as, 2, 12, 21–22, 162–84
 Blanchett as, 2, 3, 11, *145*, 145–59
 Blue Jasmine character based on, 146, 155–59
 Clarkson as, *125*, 125–44
 compared to Miss Lucretia in *Portrait of a Madonna*, 63
 compared to Scarlett O'Hara, 74, 93
 costumers for, 15, 76, 133
 credibility of, as theme, 51–52, 87–88, 103
 critics' views of the character, 18
 dresses of, 132–35
 in Emily Mann's 2012 multiracial cast production, 165
 enduring appeal of, 2, 4, 14, 182–84
 famous lines, 3–4, 15, 85, 87, 88, 122, 134, 135
 impact of the role on actresses, 21, 69–70, 80–81, 96–97, 106–7, 111–12, 125, 142–44, 182

 inspirations for, 9, 10, 40 (*see also* Williams, Rose Isabel)
 interpretations (*see specific actresses and productions*)
 Jenkins as, 1, 12, *161*, 162–63, 165–84
 Lange as, 2, 11, 12, *109*, 109–23
 Leigh as, 4, 10, 11, 12, 21, *71*, 71–89, 103, 106, 120–21
 meaning of her name, 2, 57
 "Obituary," 23, 187–89
 Parker as, 2, 22, 163, 168–69
 played as tragedy and comedy, 10–11, 79–80, 155–59, 180–81
 in popular culture, 3–4
 promiscuity and, 83, 84–85, 103–6, 119, 138–39, 183
 public's perception of, 18–19
 sanity of, 12, 20–21, 82–83, 93, 101, 104, 119–21, 150, 181–82
 scent of, 175–78
 Southern actresses as, 16, 127
 Southern womanhood and the eternal feminine, 16–17, 53, 132–35
 Tandy as, 2, 4, 10, 11, *55*, 62, 65–70, 93, 130
 trunk of, character revealed by contents, 14–16, 76–78, 116
 TW's sister Rose as model for, 26, 40, 51–52, 53, 184
 "unwashed grape" aria by, 100
 the very young man scene, 140–42
 Williams's favorite Blanche, 13
 See also Grey, Allan; Kowalski, Stanley; Kowalski, Stella; Mitchell, Harold "Mitch"

Dunaway, Faye, 6–7, 12, 15, 16, 20, 127
Dylan, Bob, 3–4

Ebert, Robert, 106
Ebony Showcase Theatre, Los Angeles
 Streetcar (1955), 21–22, 162
Edgerton, Joel, 148
"Elegy for Rose" (TW), 40, 57
Elephant Man, The (play), 127
Elysée Hotel, New York, 14
Emmerich, Noah, 143
Erman, John, 92, 93, 96, 107
Ethel Barrymore Theatre, New York
 Streetcar opens (1947), 2, 4, 57, 67
 Streetcar revival (1992), 110–12
Everybody's All-American (film), 113

Feldman, Charles K., 72
feminism, 16–17, 183
"Field of Blue Children, The" (TW), 9
Fields, Santoya, 171
Fire Over England (film), 81
Flaubert, Gustave, 105
Fleming, Renée, 2
Flynn, Gillian, 126
Follies of God (Grissom), 56
Frances (film), 111
Freeman, Walter J., 44, 45
Fryer, Dr. John, 46

Garden District (TW), 47
 Sherman's introduction, 50, 164
Garvey, Marcus, 167
Gerard, Jeremy, 120–21
Gielgud, John, 56, 62, 70, 75
Gish, Lillian, 13, 56–59, 60, 62

Glass Menagerie, The (TW), 28, 36, 186–87
 London production, 75
 TW's sister Rose as model for Laura, 25, 29, 33, 40, 51, 185
Goddard, Paulette, 74
Gone with the Wind (film), 73, 74, 81
Goodman, John, 113, 117–19
Green, Adam, 147
Greenwood, Jane, 133
Grey, Allan (*Streetcar* character), 18, 76, 98–99, 105, 110, 135, 137, 158, 174
 as reflection of TW, 51
 "Sonnets from Laurel," 190–93
Grissom, James, 56, 57, 59, 60, 155
Groneman, Carol, 104
Group Theatre, 65
Gussow, Mel, 185

Hardwick, Elizabeth, 82
Harper, Valerie, 13
Harris, Rosemary, 12, 14
Hartzog, Annabeth, 117
Hawkins, Sally, 156
Hayes, Helen, 75
Hedren, Tippi, 70
Hepburn, Katharine, 46, 47
High Art (Cholodenko), 126
Hill, Michael E., 94, 106
Hitchcock, Alfred, 70
Holly, Ellen, 162–63, 167
homosexuality
 Asilah, Morocco and gay men, 46
 character of Allan Grey and, 51, 76, 105, 110, 137, 158
 classified as mental illness, 38, 46
 movie's Hayes Code and, 46
 New Orleans gay culture, 8, 16
 in *Suddenly Last Summer*, 47–50

Tallulah Bankhead and gay audience for *Streetcar*, 10
TW and, 7, 9, 16, 18, 19, 27, 31, 38, 46, 47, 51, 105, 155
Hooper, Edward, 149
Hunter, Kim, 72
Huston, Angelica, 159
Hynes, Garry, 126, 128, 131

Isherwood, Charles, 130, 132

Jamison, Kay Redfield, 82
Jenkins, Jemier, 2, 12, *161*, 162, 168–69, 171, 173–83
Jordan, Glenn, 113, 114, 120, 123

Kael, Pauline, 71, 88
Kahn, Michael, 13
Kazan, Elia, 65, 121
 on Blanche's sanity, 82–83, 93, 181–82
 on Gish, 57, 60
 linking Blanche and TW, 18
 Method Actors and, 65
 Portrait of a Madonna and, 61, 65
 on Stella, 122
 Streetcar film, 4, 12, 15, 72, 73, 88, 92, 93, 96, 106, 110
 Streetcar on stage, 4, 15, 61, 65–68, 72, 75, 76
 Streetcar rehearsals, 65
 See also Brando, Marlon; Lange, Jessica; Leigh, Vivien
Kazin, Alfred, 15
Keaton, Diane, 3
Kennedy Center
 Streetcar (2009), 147–50
 A Streetcar Named Desire in Two Acts (2005), 126
King, Susan, 110

Kitten with a Whip (film), 93
Knight, Shirley, 12
Kowalski, Stanley (*Streetcar* character), 4, 19–20, 22, 85, 97, 103, 106, 115–17, 130, 131–32, 138–39
 abuse of Stella, 86–87, 123, 132
 audience's sympathy for, 20, 66, 68, 123, 169–70
 Baldwin as, 110, 111, 114, 123
 Blanche's rape by, 20, 52, 69, 87, 93, 96, 103, 110, 123, 139
 Blanche's trunk and, 14, 77–78, 116, 134–35
 Brando as, 20, 65–68, 69, 72, 111, 122–23
 Callender's all-Black cast and, 169–70, 173–80, 182
 Edgerton as, 148
 Moye as, 170
 as "Ralph" in earlier version of *Streetcar*, 122
 Rothenberg as, 126
 Ullmann's interpretation, 152–53
 Underwood as, 22, 163, 168, 169
 Voight as, 20
Kowalski, Stella (*Streetcar* character), 52, 73, 78, 83, 86–87, 101–3, 114–16, 122, 123, 130–32, 134, 139, 140, 150, 152, 156, 169–70, 173–74
 Blanche's rape and, 103, 123
 in Callender's all-Black cast, 167, 170–71, 175, 178–80
 D'Angelo as, 94, 102, 115
 Fields as, 171
 Hunter as, 72
 Lane as, 113–14, 115
 Madigan as, 110, 113
 in Mann's multiracial cast, 165

Kowalski, Stella (*cont.*)
McLeavy as, 148
Ryan as, 126, 131
Kraepelin, Emil, 41

Lahr, John, 19, 46–47, 122
Lampkin, Marguerite, 95
Lane, Diane, 113–14, 115
Lange, Jessica, 2, 11, 12, *109*,
109–23, 182
other roles playing disturbed,
complicated women, 111
in *Streetcar* Broadway revival
(1992), *109*, 110–12, 119, 121
in *Streetcar* CBS *Playhouse 90*
production, 112–23
Leigh, Vivien
Academy Awards, 73, 74, 88
affairs and misadventures, 82, 86
bipolar illness and, 21, 81–83
as Blanche DuBois, 4, 10, 11, 12,
21, *71*, 71–89, 95, 103, 106,
111, 120–21, 182
Gone with the Wind, 73, 74, 81
Leverich, Lyle, 26, 29, 105, 164, 186
Life, A (Kazan), 65
Lincoln University, Jefferson City,
Mo., 21
Littell, Philip, 2
lobotomy, 44–46
in *Suddenly Last Summer*, 48,
49, 50
of Rose Williams, 20–21, 44, 50,
105, 184
Looped (stage play), 13
Los Angeles Times: Lange interview,
110
Louisiana State University, Baton
Rouge, 5–6, 7
Lowell, Robert, 82

Madigan, Amy, 110, 113
Malden, Karl, 72, 93
Mankiewicz, Joseph L., 47
Mann, Emily, 2, 22, 161, 163–64,
165, 166
Mayer, Louis B., 68
McCarter Theatre, Princeton,
N.J., 13
McCarthy, Mary, 19
McDonagh, Martin, 126
McLeavy, Robin, 148
Meachum, Anne, 49
Memoirs (TW), 186
Mendelsohn, Daniel, 17
Metairie, La., 5, 7
Mielziner, Jo, 76
Miles, Richard, 30
"Millennial Notes": review of Mann's
2012 *Streetcar*, 165–66, 170
Miller, Arthur, 172
Mitchell, Harold "Mitch" (*Streetcar*
character), 72, 78, 79, 83–86,
94, 97–102, 116, 117–19, 130,
135–37, 174
Cronyn as, 69, 130
Emmerich as, 143
Goodman as, 113, 117–19
Quaid as, 94, 96, 98
Richards as, 148

Moniz, Dr. Egas, 44
Moye, Khary, 170

National Theater, Britain, 12, 79
New Orleans, La., 4–9, 16
Audubon Park and Zoo, 4, 6
Black people and, 164, 165
Cemeteries bus, 7, 100
Clarkson as native of, 127–29
Desire Streetcar, 6–7, 85, 92, 100

different ethnicities in, 163
Elysian Fields housing project, 6
French Quarter, 6, 7, 8, 22,
 128–29
Galatoire's, 102, 116, 170–71
Garden District, 47, 48, 117
Mann's *Streetcar* and, 165
Schoenberger living in, 7–8
Schoenberger's childhood visits, 6
as *Streetcar* setting, 6, 12, 128–29
Tipitina's, 117
TV *Streetcar* movie and, 92–93, 96
TW and gay culture in, 8–9, 16,
 165
TW inspired by, 8–9, 22, 163
Ullmann's *Streetcar* and, 149
New Yorker: Blue Jasmine review,
 157–58
New York Review of Books: Als on
 Blanche as "queer artist," 19,
 151
New York Times
 obituary for Rose Williams, 185
 review of Ann-Margret as
 Blanche DuBois, 94
 review of Blanchett in *Blue
 Jasmine,* 147, 156
 review of Blanchett/Ullmann
 Streetcar (2009), 11, 150
 review of Lange as Blanche
 DuBois, 110
Nichols, Mike, 94
Nicholson, Jack, 115
Nye, Carrie, 12, 13, 16, 127
nymphomania, 72, 79, 93, 104
Nymphomania (Groneman), 104

O, Pioneers! (TV movie), 113
Observer: Blue Jasmine review
 158–59

O'Connor, John H., 94
Okon, Christine, 173
Olivier, Laurence, 12, 74, 75–80,
 81, 86, 88–89
Omnibus (TV show), 69
Orpheus Descending (TW), 164

Paredes, Marisa, 10–11
Parker, Nicole Ari, 2, 22, 163, 168–69
Peck, Russell, 11
Perez, Leander, 5
Pond, Steve, 159
"Portrait of a Girl in Glass" (TW),
 28, 32, 33, 186
Portrait of a Madonna (TW), 55, 57,
 60, 61, 62–64
 at Actors' Lab, Los Angeles, 65
 dedication to Gish, 62
 as precursor to *Streetcar,* 57, 58
 Tandy in, 55, 62–64
Previn, André, 2
Psychiatrie (Kraepelin), 41

Quaid, Dennis, 117
Quaid, Randy, 94, 96, 98

Reed, Rex, 158–59
Reese, Sam, 95
Remer, Michael, 185
*Resemblance Between a Violin Case
 and a Coffin, The* (TW),
 30–31, 33
Rich, Frank, 19, 110
Richards, Tim, 148
Richardson, Natasha, 12
Roethke, Theodore, 82
Rothenberg, Adam, 126
Runkle, Thea Van, 15
Russell, Ken, 94
Ryan, Amy, 126, 131

St. Louis, Mo., 7, 28
San Francisco Opera
 Streetcar (1995), 2
Saul, Oscar, 100
Schoenberger, Betty Beydler, 5, 6
Schoenberger, Nancy, 4–7
Schoenberger, Sigmund Bernard,
 4–6
Selznick, Irene Mayer, 72, 75–76,
 79
Sharp Objects (HBO series), 126
Shepard, Sam, 3
Sherman, Martin, 50, 164
 on TW's racial awareness, 164
Simpsons, The (TV show): "A
 Streetcar Named Marge," 3
Six Feet Under (HBO series), 127
Sleeper (film), 3
Smith, Roger, 107
Something Unspoken (TW), 47
Songs My Mother Taught Me
 (Brando), 67–68
"Sonnets from Laurel" (attributed
 to Grey), 190–93
Sonnets from the Portuguese
 (Browning), 18, 190
 Sonnet XLIII, 97
Staggs, Sam, 14, 73, 82, 162
Story magazine: TW story in, 9
Strachan, Alan, 75, 81
Streetcar Named Desire, A (TW)
 ABC TV movie (1984), 21, *91*,
 92–107
 African American productions,
 21–23, 161–84
 Age of Blanche vs. Age of
 Stanley and, 121–22
 as a ballet and opera, 2
 BAM production (2009), 2, 3, 11,
 146, 149–55

Blanche's rape portrayed in, 20,
 52, 69, 87, 93, 96, 103, 110,
 123, 139
Broadway production (1947), 2,
 4, 19, 57, 65–68, 72, 76, 86
Broadway revival (1992), 110–12
CBS TV *Playhouse 90* production
 (1995), 112–23
costumers for, 15, 76, 133
critical responses, 19
Desire streetcar, 6–7, 85, 92, 100
as a drama for two sisters, 130–32
dreamlike quality vs. realism,
 173
film version (1951), 4, 12, 15, 72,
 73–74, 86–87, 88, 92, 93, 96,
 106
frequency of productions, 2
Kennedy Center production
 (2004), 126, 128–44
Kennedy Center production
 (2009), 147–50
last line of play, 121
London production (1949), 12–13,
 72, 75–76, 78–81
longevity of, 121
men winning the war of the
 sexes, 123
Miller's introduction to, 172
motif of power of scent, 175–78
original cast, 65–67
Portrait of a Madonna as
 precursor, 57, 58
productions (overview), 2, 3, 6–7,
 10–11, 12, 13 (*see also specific
 productions*)
set design, 76
setting of, 6, 12, 77, 128–29
Sydney Theatre Company
 production (2009), 146, 147

title of an earlier version, 122
TW's original preface, 163
women directors, 1, 22, 126, 146, 161
See also Dubois, Blanche; Grey, Allan; Kowalski, Stanley; Kowalski, Stella; Mitchell, Harold "Mitch"
Suddenly Last Summer (TW), 20–21, 46, 47–51, 95, 117, 164
film version (1958) and cast, 47–50
stage performance, 49
themes (homosexuality, lobotomy, credibility of Cathy), 47–52
TW's sister Rose as model for Cathy Holly, 40, 50–51
Summer Theatre Company
first African American Streetcar (1953), 162
Sydney Theatre Company
Streetcar (2009), 146, 147

Tandy, Jessica
as Blanche DuBois, 2, 4, 10, 11, 55, 61–70, 72, 93, 111, 130
Portrait of a Madonna and, 55, 61–64
See also Cronyn, Hume
Taylor, Elizabeth, 47, 48, 95
Taylor, Rod, 70
Tennessee Williams (Lahr), 46–47
"Things Have Changed" (Dylan), 3–4
This Will Not Stand (Garvey), 167
Times Picayune: "Blanche Dubois's Obituary" 23, 187–89

Tommy (film), 94
Tom: The Unknown Tennessee Williams (Leverich), 26, 29, 186
Treanor, Tim, 148, 150
Treme (TV series), 115
Tynan, Ken, 12, 72, 79–80, 82

Ullmann, Liv, 3, 11, 146, 148
Underwood, Blair, 22, 163, 168, 169

Variety
review of Clarkson's Blanche, 130, 132
review of Lange's Blanche, 120
"Vengeance of Nitocris, The" (TW), 27–28
"Victims on Broadway II" (Mendelsohn), 17
Vidal, Gore, 47, 48
Visconti, Luchino, 18
Vogue: review of Blanchett's Blanche, 147–48
Voight, Jon, 20

Warner, Jack, 72
Washington Post: Ann-Margret interview, 94
Weisz, Rachel, 12
When Blanche Met Brando (Staggs), 14, 82, 162
William Esper Studio, New York, 168
Williams, Cornelius (TW's father), 26–28, 30–31, 33, 34, 35–38
alcoholism of, 26, 33, 42
sexual abuse by, 41–43, 47, 51, 53
TW's hatred for, 36, 43

Williams, Edwina (TW's mother),
 26, 29–30, 56
 attractive appearance, 59
 puritanism, 26, 59
 role in TW's emotional life, 59
 Rose's institutionalizing and,
 33–43
 Rose's lobotomy and, 50, 51
 in TW's writing, 59–60
Williams, Rose Isabel (TW's
 sister), 9, 20–21, 25, 25–46, 56
 alleged sexual abuse of, 41–43,
 47, 51, 53, 103, 105
 Blanche DuBois and, 26, 40,
 51–52, 53, 154, 184
 character of Laura and, 29, 33,
 51, 185, 186–87
 childhood in Clarksdale, 28, 30
 credibility of, as theme in TW's
 writing, 51–52, 87
 death of, 53, 185
 diagnosis of dementia praecox, 41
 in Farmington State Hospital,
 43–44
 first romance, 31
 fragility of, 28
 glass objects collected by, 29
 hypersexuality of, 9, 37, 105
 lobotomy, 20–21, 44, 50, 105,
 184
 mood swings, nervousness,
 32–33
 obituary in the *Times*, 185–87
 parents' marriage, stressful
 homelife, 26–27, 32–33, 36–38
 "Portrait of a Girl in Glass" and,
 28, 32, 33, 186
 *The Resemblance Between a Violin
 Case and a Coffin* and, 30–31
 in St. Louis, Mo., 28–29

 in Saint Vincent's, 39, 40, 43
 schools attended, 29, 31–32
 sanity and institutionalization,
 33–43, 103, 185
 sent to her Aunt Ella, 34–35
 as troubled, rebellious, 29–30, 33
 TW and, 9, 20–21, 28–31, 33,
 36, 37, 38, 39–40, 43, 46–47,
 50–51
 TW's lifelong care of, 53, 186
 in TW's writing and as muse,
 25, 26, 29, 30, 32, 33, 40, 46,
 47, 50–51, 63
Williams, Tennessee, 4, 8
 actress Lillian Gish and, 56–58
 adopts "Tennessee" as name, 9
 African American productions of
 Streetcar and, 22, 163
 alcohol and addictions, 155, 163
 Ann-Margret and, 94
 aunts, Ella and Isabel, 33–35, 38,
 39, 42, 50
 Belle Reve and, 17
 Blanche as alter ego, 18, 155
 on Blanche's future, 23, 154
 childhood and early years, 8, 9,
 26–27, 164
 death of, 14, 94, 186
 favorite actress as Blanche, 13
 hatred of his father, 36, 43
 homosexuality and, 7, 9, 16, 18,
 19, 27, 31, 38, 46, 47, 51, 105,
 155
 hyperventilation episodes, 83
 literary influences, 147
 London *Streetcar* and, 75–76, 79
 madness as a theme and, 20–21
 mother's role in emotional life, 59
 "nervous break-downs," 36
 New Orleans address, 8

New Orleans and gay culture, 8, 16

New Orleans and his writing, 8–9, 22, 127, 128–29

Old South and, 16, 53, 155

parental strife and, 26–27

poetry and, 64

racial injustice and, 164–65

in St. Louis, Mo., 7, 28–30, 36

sexual experience and, 59

sister Rose, as muse, 9, 20–21, 26, 36–38, 40, 46, 47, 50–51, 63

sister Rose, devotion to, 28, 29, 53

sister Rose, mental illness of, being haunted by, 21, 26, 37, 38, 39–40, 43, 46–47, 50–51, 154

on women, ix, *1*, 59

Williams, Tennessee: works

brief poem on Rose, 46

"Elegy for Rose," 40, 57

"The Field of Blue Children," 9

Garden District, 47, 164

The Glass Menagerie, 25, 28, 33, 36, 40, 185, 186–87

Memoirs, 186

Orpheus Descending, 164

"Portrait of a Girl in Glass," 28, 32, 33, 186

Portrait of a Madonna, 55, 57, 60, 61, 62–64

The Resemblance Between a Violin Case and a Coffin, 30–31, 33

Something Unspoken, 47

Suddenly Last Summer, 20–21, 40, 46, 47–51, 95, 117, 164

"The Vengeance of Nitocris," 27–28

See also Streetcar Named Desire, A

Williams, Treat, 96, 102

Williams, Walter Dakin, 27, 37, 59

Windham, Donald, 36

Wonder Boys (film), 4

Wood, Audrey, 30

Wood, Natalie, 13

Works Progress Administration, Federal Writers' Project, 8

Wrap, The: Blanchett interview, 159

Zanuck, Darryl, 72

PHOTO CREDITS

Page 25: Rose Isabel Williams, the playwright's sister and muse. *(University of Texas, Austin, Archive)*

Page 55: Jessica Tandy was the first to play Blanche DuBois, in 1947. *(Photofest)*

Page 71: Vivien Leigh is forever identified with Blanche DuBois in Elia Kazan's searing 1951 film adaptation. *(Alamy Stock Photo)*

Page 91: Ann-Margret, in a surprisingly resilient and moving portrayal. *(Alamy Stock Photo)*

Page 109: Jessica Lange redeemed an overlooked stage performance in a powerful filmed adaptation. *(Brigitte Lacombe/ Playbill)*

Page 125: One of the few Southern women to portray Blanche DuBois, Patricia Clarkson brought out *Streetcar*'s wit and humor. *(Photofest)*

Page 145: Cate Blanchett, directed onstage in *Streetcar* by Liv Ullmann, directed on film in Woody Allen's *Blue Jasmine*. *(Maximum Film/Alamy Stock Photo)*

Page 161: Blanche arrives at Stella's Elysian Fields apartment, in Jemier Jenkins's much-lauded stage performance. *(Lance F. Huntley)*